MFA
HIGHLIGHTS american painting

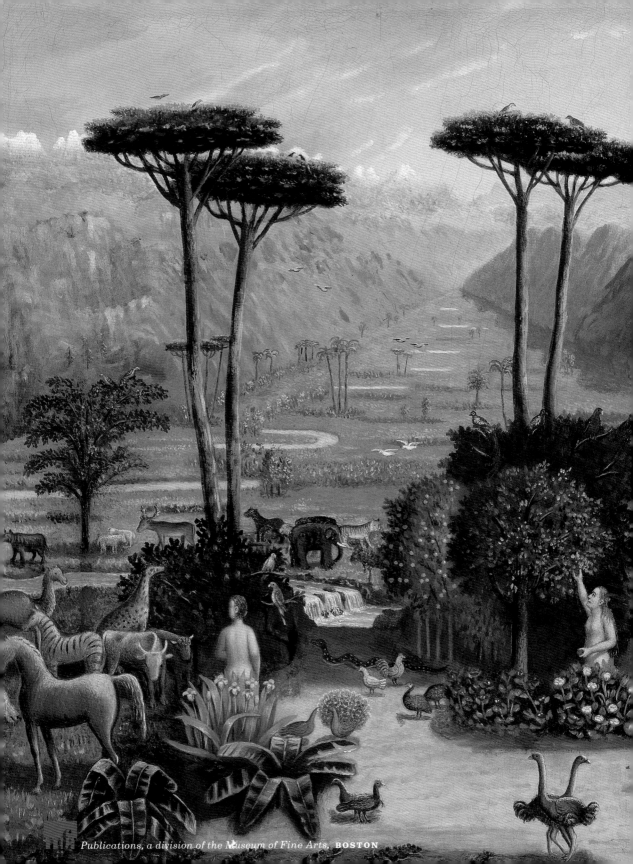

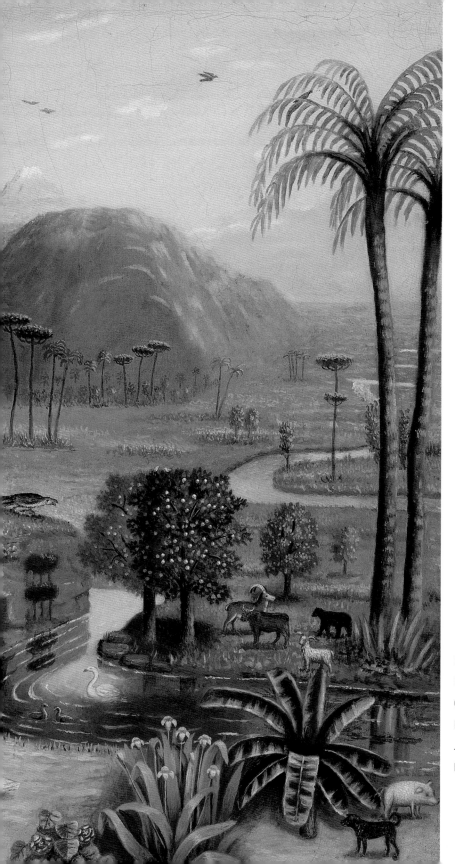

MFA
HIGHLIGHTS american painting

Elliot Bostwick Davis

Erica E. Hirshler

Carol Troyen

Karen E. Quinn

Janet L. Comey

Ellen E. Roberts

MFA Publications *a division of the Museum of Fine Arts, Boston*
465 Huntington Avenue
Boston, Massachusetts 02115
Tel. 617 369 3438 Fax 617 369 3459
www.mfa-publications.org

Generous support for this publication was provided by Mortimer and Mariann Appley and by the Ann and William Elfers Publications Fund.

© 2003 by Museum of Fine Arts, Boston
ISBN 0-87846-660-6
Library of Congress Control Number: 2002115255

Frontispiece: Erastus Salisbury Field, *The Garden of Eden*, about 1860 (p. 94)

Page 5: Charles Caryl Coleman, *Still Life with Azaleas and Apple Blossoms*, 1878 (p. 115)

Page 6: Jacob Lawrence, *Café Comedian*, 1957 (p. 203)

All photographs are by the Department of Photographic Services, Museum of Fine Arts, Boston.

Design and formatting by Heather Watkins and Lucinda Hitchcock
Typesetting by Fran Presti-Fazio
Manuscript edited by Sarah E. McGaughey
Printed and bound at CS Graphics PTE LTD, Singapore

Trade distribution:
Distributed Art Publishers/ D.A.P.
155 Sixth Avenue, 2nd floor
New York, New York 10013
Tel. 212 627 1999 Fax 212 627 9484

First edition
Printed in Singapore

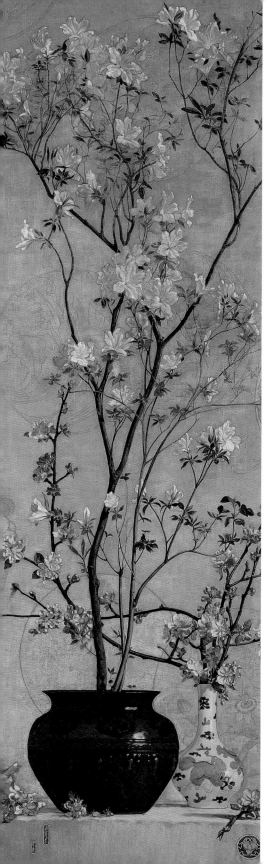

Contents

Director's Foreword

Art is for everyone, and it is in this spirit that the MFA Highlights series was
conceived. The series introduces some of the greatest works of art in a manner
that is both approachable and stimulating. Each volume focuses on an
individual collection, allowing fascinating themes—both visual and textual—
to emerge. We aim, over time, to represent every one of the Museum's major
collections in the Highlights series, thus forming a library that will be
a wonderful resource for the understanding and enjoyment of world art.

It is our goal to make the Museum's artworks accessible by every means
possible. We hope that each volume of MFA Highlights will help you to know
and understand our encyclopedic collections and to make your own
discoveries among their riches.

Malcolm Rogers
Ann and Graham Gund Director
Museum of Fine Arts, Boston

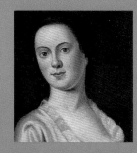

The Independent Spirit of American Painting

The story of American painting reflects the independent spirit and fortitude that created our nation. From nascent beginnings in New England, American artists pursued their vision with creativity and perseverance. The Puritans, who traveled to the New World in search of religious freedom, brought with them familiar European traditions, which they adapted liberally to serve their own ends. In response to Samuel Willard's impassioned sermons from the pulpit of Boston's Old North Church, the Puritans firmly rejected religious images, which were then considered the noblest form of painting. They did, however, tolerate commemorative depictions of their departed brethren. Thus, the appearance of portraiture in the colonies marked the first step toward a new tradition of American painting. Predictably, the earliest surviving seventeenth-century portraits drew heavily upon European models, but as time passed, artists cultivated increasingly distinctive styles. As aspiring artists in search of greater opportunities made their way to the American shores, the painterly tradition the Puritans had set into motion flourished, reaching well beyond its modest origins.

Artists working in colonial America needed to be self-sufficient. Patrons were few and far between, and artists were forced to develop a variety of skills to support their profession. At the beginning of the eighteenth century no colonial town could sustain a full-time portrait painter. For many years, even well into the nineteenth century, American artists continued to supplement their income by practicing a range of trades, including japanning furniture; selling pigments, prints, and art supplies; painting coaches, signs, and houses; glazing windows; and even making saddles or shoes.

Along with the difficulty of securing patronage went the arduous task of acquiring basic skills in painting and drawing. The scarcity of opportunities to obtain adequate artistic training at home persisted from the earliest years of the colonies until the latter part of the nineteenth century. Early American artists nonetheless demonstrated a remarkable resourcefulness in making use of the

materials at hand. John Singleton Copley, for instance, consulted the various British drawing books that had been imported to the colonies. From his stepfather, who was an engraver, he learned the basics of anatomical drawing, and he created his first ambitious history paintings by copying prints (fig. 1). Similarly, Charles Willson Peale copied embroidery patterns for his earliest attempts at drawing. Employment as an artist's apprentice was virtually nonexistent, and many aspiring painters gleaned whatever they could from print shops, making engravings and popular lithographs. Even Rembrandt Peale, who had the good fortune to study with his father, Philadelphia painter Charles Willson Peale, lamented the reluctance of established artists to assist younger colleagues, as they were wary of training their future competitors. The younger Peale recalled, "It was seldom that a student could purchase or procure the means of learning what was then called 'the Art and Mystery of Painting,' for much of it, in all ages, was kept a mystery." He sought to remedy this situation by writing *Graphics*, one of the most popular early-nineteenth-century American drawing books. The manual was later used in the Philadelphia schools by the young Thomas Eakins, who became one of the foremost American painters of the late nineteenth century. When all else failed, early-nineteenth-century painters often resorted to subterfuge: Henry Dexter cannily scraped together enough money to pay for a likeness by Boston artist Francis Alexander just so he could watch how a portrait was produced.

The absence of established academies that could otherwise provide a comprehensive foundation for artistic study left early American artists free to pursue their goals as they saw fit. Benjamin West and Copley were determined to create history paintings, which occupied the highest echelon in the hierarchy established by the French Academy. Copley followed West to England, where both artists sought to hone their skills, having exhausted the resources available to them at home. West received critical acclaim for his scene of Roman virtue, *Agrippina Landing at Brindisium with the Ashes of Germanicus* (1768, Yale University Art Gallery), a painting that solidified his reputation abroad. Unfettered by the rigid academic constraints to which many European artists were bound, he proceeded to establish a new style of history painting combining classical poses with modern-day costumes, as in his *Death of General Wolfe* (1770, National Gallery of Canada). Copley soon followed suit. His grand-scale *Watson and the Shark* (1778, p. 49) recalls the great religious works of the Italian Renaissance — such as Raphael's tapestry cartoons of the life of Saint Peter — and triumphantly depicts a contemporary event of personal rather than religious or historical significance. In 1772 West achieved international recognition

as the official painter to King George III, a remarkable accomplishment for an American artist who was largely self-taught. In London he supported the endeavors of his colleagues, and his studio became a mecca for American painters seeking to further their artistic education abroad.

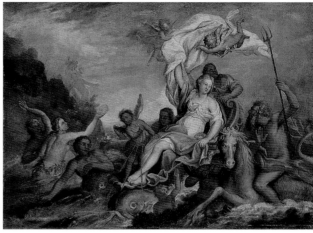

fig. 1. John Singleton Copley, *Galatea*, about 1754.

Knowing firsthand the challenges of acquiring suitable training, many early American painters dedicated themselves to establishing and administering art schools. With the support of fellow artists working in London, West successfully petitioned King George III to establish England's Royal Academy of Arts. Inspired by the instruction available at the Royal Academy, Charles Willson Peale returned to Philadelphia and founded the first art academy in the United States in 1794. Known as the Columbianum, the institution faltered a year later owing to lagging membership and financial deficits. By the early nineteenth century, however, other American artists and their patrons were successful in founding the New York Academy of the Fine Arts (1802), the Pennsylvania Academy of the Fine Arts (1805), New York's National Academy of Design (1826), and Boston's Lowell Institute (1836). Although these fledgling academies provided far greater opportunities for study than ever before, they still suffered from a lack of steady governmental support. Thus, until the last quarter of the nineteenth century, American artists continued studying abroad in even greater numbers, as many of the nation's art schools struggled to keep their doors open.

As American academies gradually became viable, nineteenth-century painters became less beholden to European modes of expression. As Ralph Waldo Emerson stated in his 1837 Cambridge address on the American scholar, "Our day of dependence, our long apprenticeship to the learning of other lands, draws to a close." Following the lead of Thomas Cole, American landscape painters celebrated the sublime beauties of nature in a movement later known as the Hudson River School, their voices as uniquely American as the Edenic scenery that inspired them. During the Age of Jackson, the common man became an object of virtue, and the beauties of common life subjects of admiration. Self-taught folk painters like Susan Catherine Moore Waters and William Matthew Prior innovated their own expressive language of bold forms, bright colors, and abstract patterns to create original and beguiling portraits of the emerging

class of prosperous merchants. Winslow Homer (fig. 2) and Thomas Eakins, two of the greatest painters of the nineteenth century, worked and studied abroad yet chose to portray genre scenes that reflected a distinctly American ideal of agrarian life, individual types, and modern leisure pursuits. In 1875 the American novelist and art critic Henry James summed up Homer as follows: "He is almost barbarously simple, and, to our eye, he is horribly ugly; but there is nevertheless something one likes about him." James expressed his exasperation with the readily identifiable American features of Homer's paintings and the artist's unmistakable stamp. In contrast, James greatly admired the work of the expatriate painter John Singer Sargent. For his part, Sargent self-consciously drew on the great painters of the past but nevertheless made original and masterful works, such as the unconventional portrait *The Daughters of Edward Darley Boit* (p. 145).

The efforts of American painters to forge a national style, however, often flew in the face of a burgeoning middle class eager to demonstrate its sophistication in art matters. During the 1840s and 1850s, several factors contributed to a sense that popular taste was becoming abominable. By 1849 the American Art-Union boasted 18,490 subscribers from around the country. For the price of five dollars, members were entitled to receive engravings after American paintings owned

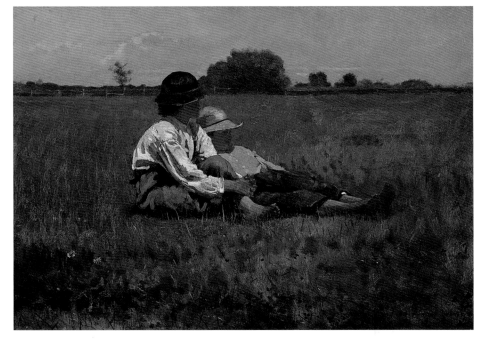

fig. 2. **Winslow Homer,** *Boys in a Pasture,* 1874.

by the Art-Union, a subscription to the *Bulletin*, and a chance to win a canvas by an American artist. Before the institution was declared illegal for operating a lottery, the American Art-Union had infiltrated the parlors of Americans aspiring to possess and flaunt good taste. Lithographs that could be colored by hand, thus providing a semblance of oil paintings, were also in demand, and the name Nathaniel Currier, who founded his printing firm in 1837 and later teamed up with James Ives, became synonymous with decorative prints for the home. Charles Dickens recalled that when he visited the United States in 1842, every boarding house and tavern proudly featured the same colored scenes of Washington and the sentimental partings of sailors and their lovers, a reference to the ubiquitous Currier prints. But it was Phineas T. Barnum and his promotion of the American Museum that epitomized the prevailing sense that taste had compromised notions of morality. At his American Museum in New York City, Barnum titillated the public with displays of preserved artifacts culled from several natural history collections (including the remnants of Charles Willson Peale's museum), exotic animals, and freaks of nature. Barnum claimed that his exhibitions were "conducted with the utmost propriety." But the press took a dim view, pronouncing the spectacle "melancholy proof of a depraved public taste."

Along the East Coast, a devoted cadre of collectors who were joined by several artists sought to elevate popular taste by establishing the first comprehensive art museums. Art critic and collector James Jackson Jarves had promoted the concept of an art museum devoted to the history of all styles in his book *The Art-Idea* (1864). Although connoisseurs began establishing public collections well before the Civil War, their efforts came to fruition in 1870, when the Museum of Fine Arts, Boston, the Metropolitan Museum of Art in New York, and the Corcoran Gallery of Art in Washington, D.C., were incorporated. The founders of the Metropolitan Museum of Art sought to humanize, educate, and refine the public through the display of great works of art, goals expressed by their president, Joseph Choate. Similarly, the MFA, which opened the doors of its original building in 1876, served to foster art, education, and industry, as inscribed on the three interlocking rings of its original seal. The Museum inaugurated its art school in 1877, demonstrating its support for the training of artists. In conjunction with the widespread introduction of drawing in Massachusetts public schools, the Museum and its school sought to refine public taste and ultimately to bolster a greater appreciation and demand for domestically produced household goods, textiles, and architectural designs of the highest quality, which could compete successfully with their European counterparts.

The opening of comprehensive art museums in the United States and the increased opportunities for American artists to study abroad (especially in Paris and Munich) inspired a greater awareness and emulation of artistic styles from a range of historical periods and cultures. The Gilded Age of the last quarter of the nineteenth century was characterized by a range of revival styles broadly defined as the Aesthetic Movement, a term conveying artists' and artisans' desire to create objects of beauty. The Aesthetic Movement inspired American artists to explore a wide range of media, including stained glass, ceramics, metalwork, illustration, and bookbinding, often considered minor arts. Some American painters, such as Homer, Edwin Austin Abbey, J. Alden Weir, William Merritt Chase, Elihu Vedder, and John Henry Twachtman, belonged to a group called the Tile Club, which met regularly for almost ten years to decorate tiles, socialize, and take excursions. When the club was founded in 1877, the original members purportedly declared: "This is a decorative age; we should do something decorative, if we would not want to be behind the times." Many American painters produced works that were intended to be decorative in and of themselves or integral to carefully designed decorative interiors. James Abbott McNeill Whistler, one of the leading painters of the Aesthetic Movement, installed his Japanese-inspired painting *Princess of the Land of Porcelain* (1864, Freer Gallery of Art) within an elaborate blue-and-gold interior filled with peacock motifs that were inscribed on the shutters, walls, and ceiling. Painters such as John La Farge and Charles Caryl Coleman became fascinated with the East, particularly Japan, and incorporated objects from their personal collections of Asian decorative arts into their own still-life paintings (see pp. 114 and 115). La Farge was one of many American painters who became actively engaged in the decorative arts, producing a substantial body of stained glass. His contemporary Louis Comfort Tiffany worked freely in a range of media, including painting, metalwork, mosaic, glass, jewelry, and textiles. In 1879 Tiffany joined forces with Samuel Colman, Lockwood de Forest, and Candace Wheeler to found Associated Artists, one of the leading design firms of the age, which concentrated on coordinated schemes for interiors commissioned by wealthy clients. Often painters' decorative impulses manifested themselves as large-scale mural programs. Expatriates Mary Cassatt and Mary MacMonnies, for example, designed elaborate life-size murals (now lost) of *Modern Woman* and *Primitive Woman* for the 1893 Woman's Building of the World's Columbian Exposition. And in the twentieth century, Sargent completed several major American mural projects, including those for the Boston Public Library and the MFA (see p. 134), bringing to fruition the desire to create decorative works of great beauty, which had been the driving force of the Aesthetic Movement.

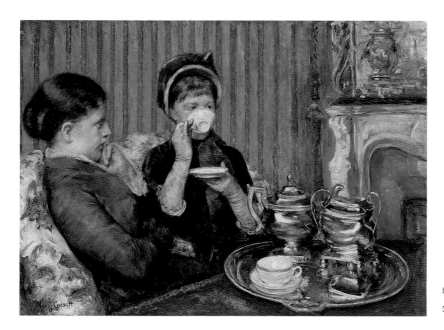

fig. 3. **Mary Cassatt,**
The Tea, about 1880.

Although American artists drew freely on world cultures during the Aesthetic Movement, many felt compelled to assimilate the lessons of Paris, which remained the influential capital of the art world. Painters from Russia, Norway, Sweden, Denmark, and the United States who traveled to France during the 1880s became captivated by the innovations of the French Impressionists, whose works were becoming better known outside their native country. Following smaller shows in Boston, the 1886 exhibition at New York's National Academy of Design to raise funds for the base of the Statue of Liberty focused American attention on French Impressionism as never before. Cassatt, who had been invited to exhibit with the Impressionists in 1877, became one of the foremost advocates of French painting in the United States (fig. 3). Determined to bring great works of Old Master and contemporary French painting to America, Cassatt provided counsel and advice to the vanguard of American collectors who were actively buying works by many of her French colleagues, including Edgar Degas, Edouard Manet, and Claude Monet. The new American patrons had a significant impact on the careers of several French artists. Monet, for instance, was able to realize his vision of painting the extensive gardens and water lily pond surrounding his home in Giverny owing to the strong support of American collectors. Beginning in the mid-1880s, Giverny was a popular destination for American painters, and Impressionism became a great inspiration to early-twentieth-century artists as diverse in their approaches as the elegantly refined

painters of the Boston School and members of the so-called Ashcan School, known for their seamy portrayals of American life.

In 1891, when American painter Robert Earle Henri returned from Europe, he was determined to draw on his experiences abroad to create a new style of realist painting. Henri combined elements of the Old Masters' and the French Impressionists' styles and injected his scenes of modern life with the keen observation found in works by contemporary French painter-printmakers Honoré Daumier, Paul Gavarni, and Henri de Toulouse-Lautrec. Sympathetic to leftist politics, Henri became the ringleader and influential teacher of a young group of like-minded artists later known as the Ashcan School, who championed the poor and the commonplace by depicting a coarse side of urban life in America. Many of Henri's circle of artists and writers established a vital bohemian community in New York City's Greenwich Village, harking back to the artistic climate of Montmartre in Paris (see fig. 29, p. 167). They were resolved to present the reality of the modern American city in their midst — widespread industrialization, tenements and slums, street life, and urban leisure — in scenes with a distinctly American accent and colored by the Old World traditions of newly arrived immigrants. Agitating against the academies and their exhibitions selected by reactionary juries, Henri insisted on free exhibitions without judges. In 1907, when a jury rejected paintings by George Luks, a member of the group, Henri and his colleagues responded by organizing an exhibition of their own works. The authority of the academies was successfully challenged, and American artists of the new century were free to select their own contributions for public display.

While the realists were depicting vital American subjects, Alfred Stieglitz and his friend Edward Steichen were rapidly introducing a new vision for American painters by establishing a succession of galleries in New York City. Stieglitz, who became acquainted with the Parisian art collectors Leo and Gertrude Stein in 1907, provided American artists with access to the foremost movements in modern French painting, from the Post-Impressionist period to the latest contributions of Fauvism, Cubism, Futurism, and Synchronism. Beginning in 1909, his Little Galleries of the Photo Secession (also called 291) featured the rising stars of American modernism, the majority of whom had studied in Paris. Just as the Ashcan artists were introducing the public to their initially somber palette, Stieglitz's artists, especially Alfred Maurer and Max Weber during his early period, introduced the expressiveness of pure color inspired by the French Fauves. In 1912 Cubism became a major tenet of American modernism and a point of departure for John Marin's views of the Woolworth Building and

Joseph Stella's many versions of the Brooklyn Bridge. Marin, a close friend of Stieglitz, expressed the newfound energy of modern art in his writings of 1913: "You cannot create a work of art unless the things you behold respond to something within you. Therefore if these new buildings move me, they must have life. Thus the whole city is alive; buildings, people, all are alive; and the more they move me, the more I feel them to be alive." Marin's words reflect an openness to new ideas and experiences among American artists, who were actively engaged in drawing inspiration from a plethora of European movements to evoke their own personal vision of the modern city.

Following the defeat of Woodrow Wilson's universal idealism at the end of World War I, American culture and its distinctive characteristics were re-examined. In the face of widespread foreign immigration, an intense preoccupation with the colonial past and its Anglo-American traditions dominated the period between the world wars. Displays of American decorative arts from the seventeenth and eighteenth centuries were featured prominently in new museum additions of period rooms (including many at the MFA) and reflected the prevailing taste of the Colonial Revival. In contrast to the elegant refinement of the Art Deco style and the sleek designs of the machine age, hand-wrought objects and naive paintings by early American folk artists also attracted a devoted following of connoisseurs and collectors.

During the 1930s, scenes of the American heartland and the style of American Regionalism embodied widespread public sentiment. Although the ranks of American artists increased by sixty-two percent during the 1920s, compared with a sixteen percent increase in the U.S. population during the same period, the stock market crash of 1929 cut their dynamic trajectory short. Artists, along with the rest of the populace, were thrust into the depths of the Depression and a sense of increasing isolation and despair. The ravages of unemployment and bread lines found relief in Franklin D. Roosevelt's New Deal for social reform, and in August 1935 the president announced the most comprehensive art program in the nation's history. Under the auspices of the Works Progress Administration (WPA, renamed the Works Projects Administration in 1939), Federal Project Number One sponsored four divisions dedicated to theater, music, writing, and art. The Federal Art Project (FAP), which supported the visual arts — including murals, graphic arts, and photography — received more than eighty million dollars from the U.S. government, and for the first time men and women worked for equal pay. The WPA is most frequently associated with Social Realist images in the form of large-scale murals or photographs of sharecroppers that documented the American scene; however, the project also sponsored a

wide range of abstract art. Holger Cahill, the national director of the FAP, hoped to erode the sense of marginalization American artists experienced and to integrate their work into democratic society. Cahill greatly expanded the definition of the professional class of artists to embrace women, the young, and the unknown, many of whom did not have extensive exhibition histories. The painter Stuart Davis, an active member of the Graphic Arts Division and secretary of the American Artists' Congress, eloquently expressed the need for artists to unite with other groups, particularly other laborers: "Even if we were to rally all of the American artists to our cause, we would achieve little working in an isolated group. But we have faith in our potential effectiveness precisely because our direction naturally parallels that of the great body of productive workers in American industrial, agricultural, and professional life." Painters, photographers, and printmakers sponsored by the FAP enjoyed an unprecedented freedom to create and believed that by documenting the plight of workers and the American scene, they could improve the prevailing economic and social conditions of their time.

fig. 4. Steve Wheeler, *Man Menacing Woman*, about 1943.

By the Second World War, American isolationism and celebration of the American scene gave way to a new generation of painters whose course was guided by the inner life. As European avant-garde artists fled fascism and reestablished themselves in the United States, the international center of the art world shifted from Paris to New York City. Strains of Surrealism joined the mix of Fauvism, Cubism, Futurism, and Synchronism to generate a richly creative atmosphere in which American artists relished the opportunity to probe new realms of the unconscious and to invite the spontaneity of chance (see, for example, fig. 4). In a 1943 letter to the *New York Times*, the painters Adolph Gottlieb

and Mark Rothko maintained that "to us art is an adventure into an unknown world, which can be explored only by those willing to take the risks," and that "this world of the imagination is fancy-free and violently opposed to common sense." Jackson Pollock, one of the leading figures of a new movement known as Abstract Expressionism, acknowledged that, as an American, his painting would naturally be qualified by that fact, yet he considered his work part of a far greater context. Pollock observed: "The idea of an isolated American painting, so popular in this country during the thirties, seems absurd to me just as the idea of creating a purely American mathematics or physics would seem absurd." He embodied the generation of Abstract Expressionists for whom the act of painting became a powerful, liberating force signaling a new era, in which American artists were the vanguard of international contemporary art.

Today, the American collections at the Museum of Fine Arts, Boston, represent one of the most comprehensive and important assemblages of artworks produced in the United States, from the earliest years of British colonization to the present. The unique character of the American paintings collection is a testament to the community in which it was formed. From the Museum's inception, Boston's civic-minded citizens have magnanimously supported purchases of American paintings by subscriptions and gifts. Martin Brimmer, president of the Museum from 1870 until 1895, declared that "a Boston collection would be singularly deficient if it did not contain a full representation of Copley and Stuart, of Allston and Crawford, of Hunt and Rimmer." These are only a few of the artists in the collection with strong ties to the city. The concerted efforts of the trustees of Brimmer's time ensured that major works by all of these artists would enter the Museum. During the twentieth century, two couples, Martha and Maxim Karolik and Saundra and William H. Lane, pursued their distinctive tastes and made donations that have contributed overwhelmingly to the superb quality of the MFA's American paintings collection.

The oft-told tale of the Karoliks comprises three parts. Their love of American art first led them to create an outstanding collection of high-style eighteenth- and early-nineteenth-century American decorative arts (including the magnificent period rooms from Oak Hill, the Derby-West mansion in Danvers, Massachusetts), which they gave to the Museum in 1922. In 1949 they followed this with their splendid assemblage of 232 American paintings, predominantly landscapes produced between 1815 and 1865, to which a bequest in 1964 added another 101. The third Karolik collection, formed largely after the death of Martha in 1948, represented a new direction charted by Maxim Karolik. He

donated some three thousand works of art, ranging from American drawings and watercolors to folk paintings, sculptures, decoys, and weather vanes, before many of these objects became widely accepted by major museums. All told, the Karolik collections, and especially the American paintings, have influenced numerous scholars, curators, and connoisseurs. Their breadth and depth are largely responsible for reclaiming the important contributions of artists like Thomas Cole, Fitz Hugh Lane, and Martin Johnson Heade and for bringing to light large groups of works by unknown artists (see, for example, p. 95), many of which have become icons of American painting.

Massachusetts industrialist William H. Lane began collecting in 1951, when the art world had become firmly established in New York City. The conservative figural tradition of the Boston School painters sustained itself well into the twentieth century, and collectors who appreciated the new generations of American modernists were few and far between in Massachusetts. Lane traveled to New York City in his station wagon, and if a picture did not fit in his car, he did not buy it. Favoring direct, bold, and sophisticated works, he declared, "I was not interested in one of everything. I picked out artists I really liked, and endeavored to collect their work in depth." He assembled major holdings by several key painters, concentrating on artists in the circle of Alfred Stieglitz, including Georgia O'Keeffe, Arthur Dove, Marsden Hartley, and Charles Demuth. Lane also collected works by Charles Sheeler and Stuart Davis, along with later Abstract Expressionist paintings by Hans Hofmann and Franz Kline. Enhanced by a significant group of related works on paper, the Lane Collection entered the Museum in 1990. Along with his wife, Saundra, William dramatically transformed the character of the MFA's twentieth-century painting collection and ultimately expanded the continuum of American artists who are represented in great depth in the Museum, from Copley's time through Sheeler's.

The comprehensiveness of the MFA's collection lends itself to a broad overview of the major movements of American painting and their cultural context, from the earliest surviving Puritan portraits of 1670 to Abstract Expressionist works of 1960. (Although American painting embraces many traditions and peoples, we have used the term here to describe painting of the United States that carries forward a predominantly European artistic heritage.) Over the span of three centuries, American painters drew upon a wide range of sources to develop their own distinctive contribution to the history of art. By focusing on one hundred of our most important objects from the more than two thousand American paintings in the Museum, we hope to broaden your appreciation of the entire collection and to enhance your enjoyment of our nation's unique artistic

identity. Taken together, these highlights trace the prevailing themes of American art through portraiture, history painting, folk art, genre painting, and still life. Examined individually, they serve to enrich the mind and nourish the eye. The story of American painting as told in Boston is an inspiring one, driven by the independence, resilience, and creativity of the American spirit.

Many friends and colleagues helped to bring this project to its successful completion. We are indebted to Malcolm Rogers, Ann and Graham Gund Director, for conceiving the Highlights series and for his continued support of the project. I am especially grateful to Erica E. Hirshler, Croll Senior Curator of Paintings, Art of the Americas, for her editorial contributions and to all the members of MFA Publications, especially our editor, Sarah E. McGaughey, Mark Polizzotti, and Emiko K. Usui. Carol Troyen, John Moors Cabot Curator of American Paintings, generously assembled the resources for further reading, and Karen Quinn, Assistant Curator of American Paintings, coordinated photography for our department. We are grateful to Gerald W. R. Ward, Katharine Lane Weems Senior Curator of American Decorative Arts and Sculpture, Amy Beeaker, Courtney Peterson, Patrick McMahon, Gerald Reilly, Kathleen Mrachek, and Gilian Shallcross for their research and editorial assistance; Jim Wright, Eyk and Rose-Marie van Otterloo Conservator of Paintings, and the Paintings Conservation staff for their observations about many of the paintings in the book; Andrew Haines (whose knowledge about the frames of several of these pictures was extremely helpful) and Leane DelGaizo for preparing and transporting works of art; Terry McAweeney and Kim Mullins-Mitchell for coordinating photography; and in the Museum's photography studio, Thomas Lang and Gary Ruuska for creating the beautiful photographs that enliven the volume. In addition, we are indebted to Mortimer and Mariann Appley and to the Ann and William Elfers Publications Fund for their generous support of this publication.

Elliot Bostwick Davis
John Moors Cabot Chair, Art of the Americas

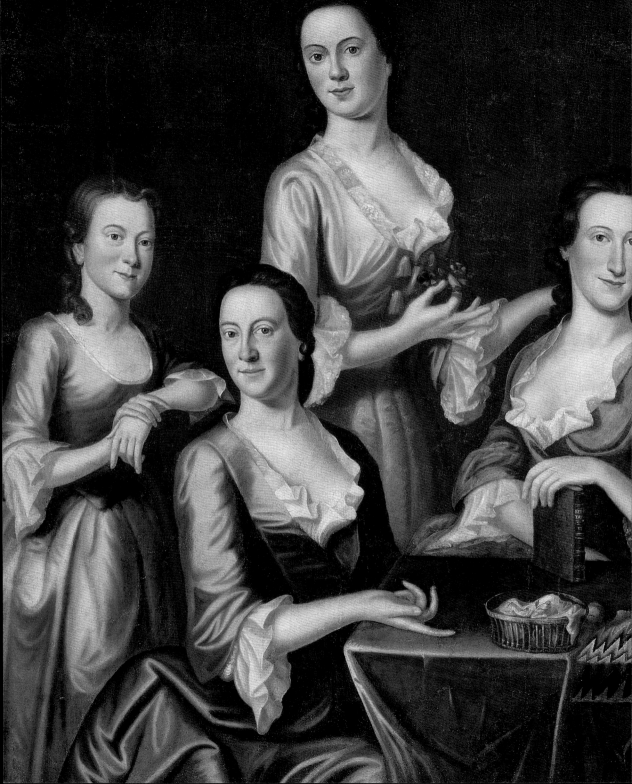

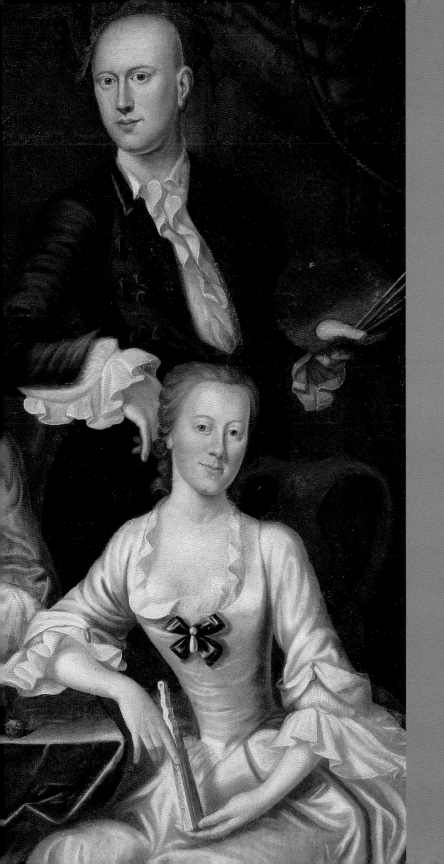

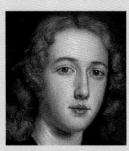

Colonial and Federal America: The Rise of the New Nation

Portraiture in the Colonial Era

The art of the colonies that became the United States was born of traditions brought from the Old World to the New. The earliest explorers were Spanish, but soon French, Dutch, and English settlers followed them. By the early eighteenth century, the English dominated those territories that would eventually become the first states of a new nation. Politically and culturally tied to Europe, these colonists based their society largely on English models, acknowledging little (if anything) of either the New World's Native American civilizations or the traditions imported from Africa. Instead they sought to re-create British culture, and because painting in England consisted almost entirely of portraits, portraiture was the primary form of painting in the colonies until after the Revolution.

In 1620, when the English Pilgrims first settled Massachusetts, survival was paramount, and thus little thought was given to the arts. However, within a remarkably short time, learning and cultural pursuits were encouraged. In 1636 Harvard College was established, and in 1640 the first colonial book was printed. By mid-century a few New Englanders had attained sufficient wealth through commerce to commission portraits. Puritan culture, though intensely pious, also tended toward materialism. Relying on Calvinist doctrine, Puritans believed in fulfilling their secular duties to the best of their abilities, trusting that a strong work ethic not only would please God but also would be rewarded with prosperity. Thus, commissioning a portrait and including attributes of wealth in the resulting painting would indicate not only the affluence of the sitter but also his or her good standing in the eyes of God (see, for example, p. 28).

Traditionally, European portraiture was of royalty, nobility, and the clergy, providing a kind of visual genealogy in which indications of rank were key. With the rise of the mercantile class in the Netherlands and England during the seventeenth century, middle-class patrons began to commission portraits that emphasized individual character and likeness. Portraits in the American colonies tended to combine the two functions. Artists sought both to indicate

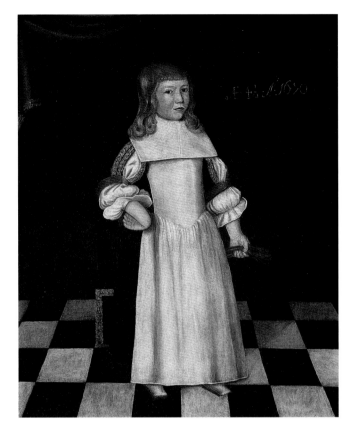

fig. 5. Unidentified artist (Freake-Gibbs painter), *Robert Gibbs at 4 ½ Years*, 1670.

the sitter's social status through costumes, settings, and attributes and to preserve the likeness of the sitter for future generations. Of the fewer than fifty portraits that survive from the seventeenth century, most were painted in Boston, although several were produced in the New York area. The majority of the artists who painted them have not been identified, and many were untrained. Several learned their craft in the outlying provinces of England (see fig. 5). There they were taught an older Elizabethan manner, a linear style characterized by bright colors, patterns, and minimal modeling of facial features. Portrait painters were considered craftsmen rather than artists and often needed to do other work, such as sign painting or gilding, to supplement their income.

During the first decades of the eighteenth century, trade between the Old and New Worlds flourished, and merchants in America began to accumulate great wealth. Typically, members of this prosperous, urban, and mercantile class could afford to have their portraits painted. They often ordered portraits to celebrate a specific event such as getting married, receiving an inheritance, or achieving a noteworthy office. Colonists also commissioned portraits to decorate formal rooms in their newly erected mansions, to exchange as gifts

of friendship, or as tokens in memory of a family member. Portraits of children were especially important in an age when so many died before reaching adulthood.

Early colonial artists had limited examples from which to learn the art of painting. There were no art academies or museums, and the artists had access to only a few British portraits of kings and queens, paintings by fellow Americans of colonial governors in council chambers, and prints of English portraits from which to study. In 1729 this situation changed with the arrival in Boston of the Scottish artist John Smibert. He had trained with the great seventeenth- and early-eighteenth-century English portraitist Godfrey Kneller, had taken the grand tour of Europe, and had studied the art treasures in Italy for three years. He was thus well acquainted with British and Continental art and had made copies of many works by such Old Masters as Raphael, Titian, Anthony van Dyck, and Peter Paul Rubens. These copies, together with Smibert's collection of prints and his own paintings, became a treasury of models for John Greenwood, John Singleton Copley, John Trumbull, Washington Allston, and many other aspiring artists. Even these resources, however, rapidly became inadequate, and beginning in 1760 many American artists crossed the Atlantic Ocean to study in the academies and museums of Europe.

In the roughly 130 years between the landing of the Pilgrims and the ascendancy of the great colonial painter Copley, portraiture in the colonies evolved from a flat, linear, Elizabethan-derived mode that emphasized pattern to a more fully rounded Baroque manner with modeling to simulate three-dimensionality (see, for example, p. 33). Likewise, the status of the artist began to change from that of a craftsman skilled in a variety of tasks to a professional who could earn a living by portrait painting alone. Evidence of this enhanced position can be found in the rare, proud self-portrait painted by Robert Feke (fig. 6), and in Greenwood's inclusion of his own likeness, with a palette, in a group portrait of his family (p. 31).

fig. 6. Robert Feke, *Self-Portrait*, about 1741–45.

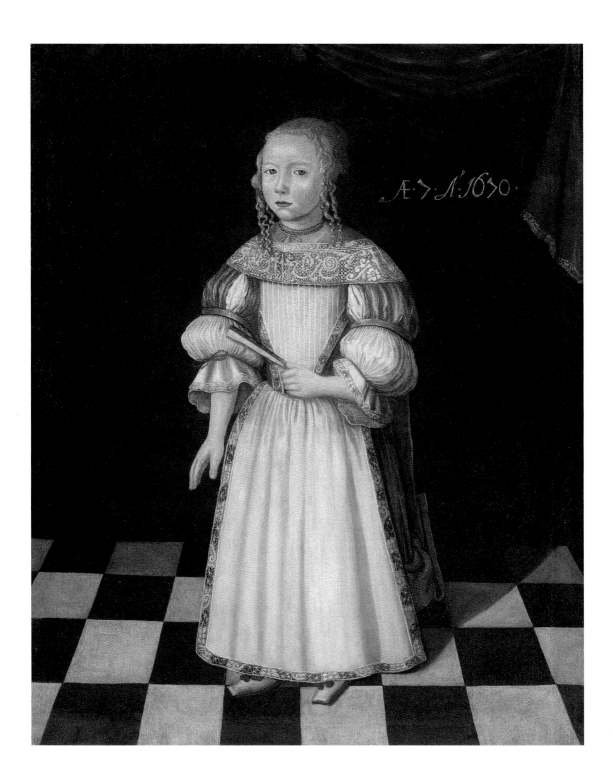

Unidentified artist (Freake-Gibbs painter)
Active late 17th century
Margaret Gibbs, 1670

Executed not long after Boston was settled, *Margaret Gibbs* is one of the finest of the few extant portraits painted by New England artists in the seventeenth century. The artist, who also painted portraits of Margaret's brothers — Robert, age four and a half (fig. 5, p. 26), and Henry, age one and a half (Sunrise Museum, Charleston, West Virginia) — is unknown. However, it is thought that he created the likenesses of John Freake and Elizabeth Freake and their baby Mary (in two portraits now at the Worcester Art Museum) in 1674. He is thus known as the Freake-Gibbs painter and is considered one of the most skilled portraitists of the seventeenth-century colonies, possessing an exceptional sense of design and an admirable feel for color. Probably trained in provincial England, he painted in a flat style derived from Elizabethan art, which emphasized color and pattern.

Margaret Gibbs was the oldest child of Robert Gibbs, an English gentleman who had emigrated from England to Boston in 1658. Robert married Elizabeth Sheafe of Cambridge, Massachusetts, in 1660, and in the same year Elizabeth inherited considerable property from her grandfather. A successful merchant, Robert had their three children's portraits painted in 1670. The depictions of Margaret and her brothers in all their finery are evidence of the materialism and prosperity of the Gibbs family and the remarkable growth of the city of Boston.

In this portrayal of Margaret, the Freake-Gibbs painter has meticulously rendered the seven-year-old's lace, needlework, silver necklace, and red drawstrings and bows. Her sleeves have the single slash allowed by Puritan sumptuary laws. Such finery was permitted by Massachusetts law only if the man of the house possessed either a liberal education or sufficient annual income. Margaret's fan indicates her gender, as children of both sexes were dressed similarly until the age of seven or eight and an attribute was needed to differentiate between images of boys and girls. The pattern on the floor is either black-and-white tile or, more likely, a wooden floor or floor cloth painted to simulate tiling. This pattern, the dark neutral background, and the inscription of the year and age of the sitter are indications of seventeenth-century Dutch influence on English and subsequently American art. The period frame of the picture is painted black and is made from eastern white American pine, thus indicating that it was crafted in New England.

Oil on canvas
102.9 x 84.1 cm (40½ x 33⅛ in.)
Bequest of Elsie Q. Giltinan 1995.800

John Smibert

Born Scotland, 1688–1751

Daniel, Peter, and Andrew Oliver, **1732**

By the 1720s Boston, a thriving port whose population had more than doubled in the preceding two decades, was in need of an able portrait painter to commemorate members of its wealthiest families. In 1729 the forty-year-old Scottish artist John Smibert arrived in the city, intending to stay in Boston only long enough to fill his coffers with earnings from portrait commissions before leaving to teach painting and architecture at a college planned for Bermuda. (The college never received funding from Parliament, and Smibert stayed in New England until his death.) Having trained and worked successfully in London and spent three years in Italy, Smibert brought with him knowledge of the latest British and Continental styles. He rapidly attracted an eager following, and his work was in great demand. Patrons traveled from as far away as Newport and Albany to sit for him, and he became the first colonial portraitist able to make a living from commissions in one city for several years, although he also sold artists' supplies in his "color shop" in Boston to supplement his income. In 1740 Smibert traveled to New York, Philadelphia, and Burlington, New Jersey, where prosperous patrons also commissioned portraits. Smibert's cosmopolitan background and his 1730 marriage to the daughter of a physician and a schoolteacher elevated his social status and raised the standing of artists in the colonies.

The Olivers were among Smibert's most faithful patrons, commissioning eleven portraits from him. *Daniel, Peter, and Andrew Oliver* was probably the second group portrait painted in the colonies. The first was Smibert's masterpiece *The Bermuda Group* (1729–31, Yale University Art Gallery), a portrait of Bishop George Berkeley (the man who encouraged him to come to the colonies) and his family, which served as a model for subsequent group portraits. In the Oliver painting, as in *The Bermuda Group*, the figures are arranged around a table, are placed close to the picture plane, and fill up the entire canvas, giving the portrait a bold, sophisticated presence. Smibert's ability to convey believable poses, the sitters' individualized features, and their costly yet unostentatious clothing far surpassed that of any previous colonial painter.

The sons of Daniel Oliver, a prosperous merchant and member of the Governor's Council, and Elizabeth Belcher Oliver, Governor Jonathan Belcher's sister, all graduated from Harvard. In addition to the challenge of depicting three brothers on one canvas, Smibert had to borrow the image of the eldest son, Daniel (who had died of smallpox five years earlier in London), from a 1727 miniature painted by an unidentified English artist. Although Smibert depicted Daniel, on the left, in a rather wooden manner that is typical of a posthumous likeness, he succeeded in capturing the personalities of the other two brothers. The youngest son, Peter, in the center, confronts the viewer with an air of confidence and worldly sophistication. Andrew, reportedly a serious student during his Harvard days, is portrayed on the right in a contemplative pose, his hand to his head and his elbow resting on a book.

Oil on canvas
99.7 x 144.5 cm (39¼ x 56⅞ in.)
Emily L. Ainsley Fund 53.952

John Greenwood

1727–1792

The Greenwood-Lee Family, about 1747

When Smibert's health began to fail in the early 1740s and Boston was once more in need of a competent portrait painter, John Greenwood, along with Robert Feke, stepped in to fill the void. The American-born son of a Harvard graduate, Greenwood was forced at age fifteen to apprentice with Boston engraver Thomas Johnston after his father died, leaving the family short of funds. After three years, Greenwood turned to painting. A man of ambition, he would ulti-mately complete some fifty-five commissions from sitters in Boston and Salem, Massachusetts. However, he seemed to realize that his career and fortune would be limited in the colonies, and he emigrated first to Surinam in 1752 and later to Amsterdam and London, where he became a prominent auctioneer.

At the age of twenty, Greenwood undertook the extraordinary challenge of painting this imposing group portrait of his family. Group portraits were rel-atively rare in mid-eighteenth-century America because they were both more difficult to compose than single-figure canvases and more costly. The models for Greenwood's project were Smibert's famous *Bermuda Group*, then on view in Smibert's Boston studio, and Feke's *Isaac Royall and His Family* (1741, Harvard Law School Art Collection). As in these two paintings, Greenwood's figures are arranged around a table. They are united through a lyrical arrangement of hand gestures, and their heads are tilted rhythmically, producing a charming, if naive, ensemble. The basket of needlework and the flame-stitch canvas work displayed on the table suggest the accomplishments of the women. Their literacy and sophistication are implicit in the volume of the *Spec-tator*, the popular early-eighteenth-century English periodical written by Joseph Addison and Sir Richard Steele. The linearity of Greenwood's style and the abrupt modulations between light and dark undoubt-edly reflect his earlier training as an engraver.

The artist has portrayed himself standing behind the woman on the right, with palette and brushes in hand and a velvet turban protecting his shaved head from the cold, as he was not wearing a wig. Although a nineteenth-century note attached to the back of the painting indicates that the figure in the center was Greenwood's betrothed, it is more likely that the woman in front of the artist is Elizabeth Lee, his cousin and fiancée. Her white dress and blue bow complement Greenwood's jacket, and furthermore, his hand is intimately juxtaposed with her head. The other figures are — from left to right — the artist's youngest sister, Hannah; his mother, Mary Charnock Greenwood; his sister, either Mary or Elizabeth; and his cousin Martha Lee.

Oil on canvas

141 x 175.6 cm (55½ x 69⅛ in.)

Bequest of Henry Lee Shattuck in memory of the late Morris Gray 1983.34

Robert Feke
About 1707–about 1751
Isaac Winslow, about 1748

Feke proved to be the most talented native-born painter prior to Copley. He was also a major influence on Copley himself, who would become the greatest American artist of the colonial period. Feke was born about 1707 in Oyster Bay, Long Island, and worked in Newport, Philadelphia, and Boston. Although he had no formal training, his style demonstrates the direct influence of Smibert and an awareness of contemporary British and Continental painting. Approximately sixty paintings by Feke are known today, of which twelve are signed and dated. This portrait of Isaac Winslow is representative of his linear style, rococo palette, and accurate characterization of his sitters.

The commissioning of likenesses was a Winslow family tradition; Isaac's father, Edward Winslow, a distinguished Boston silversmith, had sat for

Smibert, as had his older brother, Joshua. After graduating from Harvard in 1727, Isaac apprenticed in the counting room of merchant James Bowdoin, another Feke patron, before entering the shipbuilding and import-export business with his brother. The MFA owns three portraits of Isaac, painted by the leading colonial artists of his day — Feke, Joseph Blackburn (p. 33), and Copley.

Feke's portrait probably commemorated Winslow's 1747 marriage to Lucy Waldo, whose pendant portrait by Feke is in the Brooklyn Museum. Winslow's father-in-law, General Samuel Waldo (whose full-length painting by Feke is at the Bowdoin College Museum of Art), soon brought Winslow into the Kennebec Proprietorship, a group that owned vast tracts of land in Maine. Feke portrayed Winslow in a dignified pose, pointing to a harbor with a ship in the distance and a small boat with two figures landing at the shore. This background may refer both to Winslow's efforts to settle the Maine properties and to his mercantile business.

Feke captured the richness of Winslow's clothing, lavishing attention on his fashionable ivory-colored satin waistcoat embroidered with metallic thread. Feke's ability to convey the status of his sitters through stately poses, elegant attire, and pastel-colored background vistas led to the commissioning of numerous portraits by Boston's elite during his visit there in 1748.

Oil on canvas
127 x 101.9 cm (50 x 40⅛ in.)
Gift in memory of the sitter's granddaughter (Mary Russell Winslow Bradford 1793–1899) by her great grandson, Russell Wiles 42.424

Joseph Blackburn

Born England, working in America
1753–1763

Isaac Winslow and His Family, **1755**

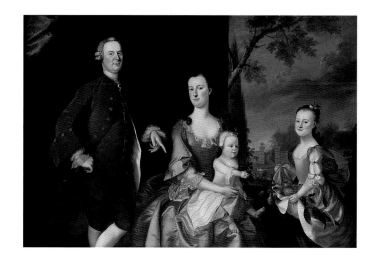

After Greenwood and Feke, the painter who portrayed Boston's increasingly wealthy citizens was the British-born Joseph Blackburn. Blackburn, who was probably trained in England, came to Boston in 1755 by way of Bermuda and Newport. He brought with him a rococo palette of pale colors, a repertoire of graceful poses and compositions from recent English portraiture, and a talent for capturing lace and other materials in paint. He arrived in Boston at an opportune time — Smibert had died in 1751, Feke and Greenwood had departed, and Copley was only seventeen. Blackburn painted more than thirty portraits over the next four years, flattering his sitters with graceful gestures and exquisitely painted costumes.

Winslow, a member of Boston's mercantile elite who had been painted by Feke just seven years earlier (see p. 32), was wealthy enough to afford this stylish group portrait of his family. Although Blackburn had little interest in expressing the character of his sitters, he produced an accomplished painting in the latest London style, with pleasing likenesses and elegant, undulating drapery. He presented Winslow as a proud paterfamilias, in a cross-legged pose of studied nonchalance, deferring to his wife, Lucy Waldo Winslow, and family. By way of lighting, color, and placement, the figures of Mrs. Winslow and the children become the focus of the composition. The mother holds a coral-and-bells teething toy for Hannah, one of the livelier babies of pre-Revolutionary painting, who sits on her lap. Hannah has distinctively babylike feet and reaches intently for the fruit held by her sister, Lucy. Behind the elder girl stretches an idealized garden with a swan pond, alluding to the family's prosperity.

Blackburn displayed his talent for depicting lace and shimmering, rose-colored satin in Mrs. Winslow's informal gown. Neither Mrs. Winslow nor her daughter Lucy is dressed in contemporary fashion, thus giving the portrait a timeless quality. Mrs. Winslow's dress, simple hair style, and pose are reminiscent of English artist Godfrey Kneller's early-eighteenth-century portraits, and Lucy's dress, with its swagged sleeves and floating drapery, would not have been seen in Boston in the 1750s. The fruit Lucy holds in her apron was a common attribute for girls in the eighteenth century, a symbol of abundance.

By 1758 Copley had absorbed the vocabulary of Blackburn's lighthearted rococo style and began to move beyond it to become Boston's premier portraitist. It may be for this reason that Blackburn moved to Portsmouth, New Hampshire. He worked there for five years before returning to England, where he continued to paint portraits until at least 1778.

Oil on canvas
138.4 x 201.3 cm (54½ x 79¼ in.)
A. Shuman Collection 42.684

Portraiture and the American Revolution

Portraiture would remain the primary outlet for colonial artists in the era of the American Revolution and its aftermath. The substantial demand for likenesses in the mid-eighteenth century sustained the careers of a number of painters working in the urban centers along the East Coast. The flourishing market for portraits even encouraged several English artists, Blackburn among them, to venture across the Atlantic to set up studios in the colonies, hoping to emulate Smibert's success earlier in the century. However, formal academic study in the arts was still unavailable in America, and few collections of art provided models. Artists were self-taught or trained as apprentices. Some aspiring native-born painters, including Benjamin West and Charles Willson Peale, left to study abroad. West created what was in effect the first American school, training his countrymen in his London studio; he would never return. Peale came back to Philadelphia and thus established a major pattern for American artists that lasted for almost two centuries — training in Europe and returning to the United States to launch a career.

By the 1760s one painter, John Singleton Copley, had begun to dominate the fledgling American art scene. Copley was the preeminent artist of the pre-Revolutionary years, and his success eventually drove other painters, including possibly Blackburn, out of New England. Copley grew up in Boston and learned his craft by studying prints, reading artists' manuals, and gleaning what he could from the occasional artist who came to his native city. He aspired to be a painter in the European tradition, making his name with grand history subjects, but found no demand for them in the colonies. Thus he relied on portraiture for his livelihood. Well acquainted with reproductions of European paintings, Copley used poses and props borrowed from English prints depicting the nobility. American sitters conspired with him to portray themselves as the aristocrats of the New World, borrowing symbols of power and wealth from their European antecedents. In *Rebecca Boylston* (fig. 7), for example, the subject wears

lush satins, velvets, and lace — expensive materials imported to the colonies, which underscore her status as a member of one of the most prosperous merchant families in Boston.

In the years prior to the Revolution, Americans were deeply divided on the increasingly complex issues that they faced in their dealings with England. Copley, who knew better than to compromise his livelihood by taking sides, painted memorable images of Loyalists and Patriots alike. It is for the latter that Americans now know him best. Copley's most famous likeness, *Paul Revere* (fig. 8), is unprecedented in colonial portraiture. Whereas Copley usually posed his finely attired sitters at leisure as he did with *Rebecca Boylston*, here he depicts the accomplished silversmith in his work clothes and with an undecorated teapot in his hand. Copley may have been alluding to Revere's talent as a craftsman, but the choice of a teapot may also have provocative political implications, as Revere was an active leader in the Patriot cause. This painting was made a year after the passage of the much-despised Townshend Acts, which imposed duties on tea and other imports.

The escalation of political tensions in the 1770s had a negative impact on the arts, as colonists focused on their safety and postponed cultural enrichment. Copley's commissions declined, and he finally left the colonies for good in 1774,

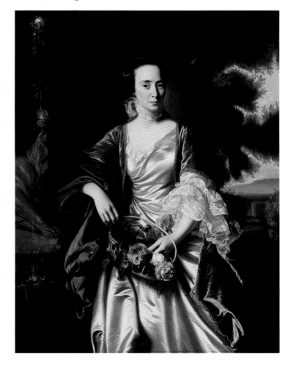

fig. 7. **John Singleton Copley,** *Rebecca Boylston*, 1767.

fulfilling his ambition to study art in Europe and to create history paintings on an international stage. He would become a leading painter in London. In America, with the exception of prints and broadsides, contemporary events of the Revolution were rarely alluded to in artistic representations during the war (although they would become popular subjects later).

When the hostilities ended in 1783, the founders of the United States began to work toward establishing a distinct national identity. In addition to such projects as shaping a new democratic government, they recognized the need for cultural independence. The first American museums appeared in a number of cities, the earliest of them showcasing a broad range of materials, including geological specimens, taxidermy, and Native American relics. In 1784 Charles Willson Peale founded his own museum of natural history and American portraiture

in Philadelphia. A decade later, in 1794, he helped organize the country's first art academy, called the Columbianum, also in Philadelphia. The institute offered art classes and hosted the first major group exhibition in this country, but it dissolved within a year. The New York Academy of the Fine Arts (later the American Academy of the Fine Arts), a forum for both exhibition and instruction, was established with much greater success in 1802 (it lasted more than forty years). Back in Philadelphia, the Pennsylvania Academy of the Fine Arts (which still exists) was founded in 1805. Boston, too, took part in this promotion of the arts. The Boston Athenaeum, incorporated as a library in 1807, began its long history of presenting art exhibitions in 1826, the first New England institution to do so. These new resources pro-

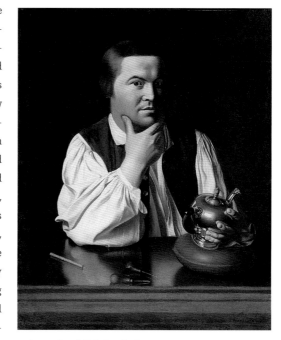

fig. 8. **John Singleton Copley,** *Paul Revere,* 1768.

vided American artists with the opportunity to study and exhibit in their own country, setting the stage for the rise of distinctive national styles in the nineteenth century.

Portraiture continued to dominate American painting well past the Revolution. Peale recorded the prominent citizens of Philadelphia and trained several of his children — whom he optimistically named after the Old Masters — to become artists. In Boston, Gilbert Stuart inherited Copley's mantle. Stuart, trained in England, brought a sophisticated grace to his many portraits of the citizens who helped shape the United States. By depicting the great citizens of the new republic, artists placed these American heroes within a longstanding iconographic tradition of individuals of great virtue.

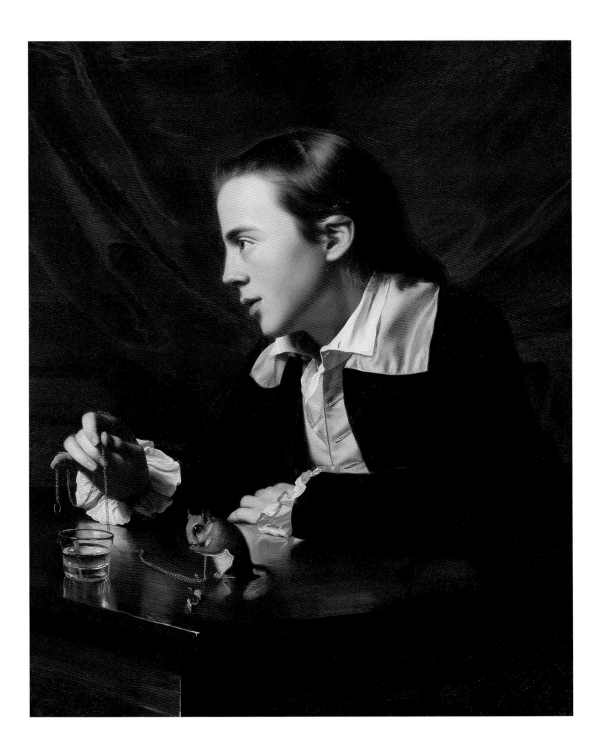

John Singleton Copley

1738–1815

Henry Pelham (Boy with a Squirrel), 1765

Copley grew up in Boston before formal artistic training was available anywhere in this country. Largely self-taught, by the mid-1760s he was the most sought after portraitist in New England. He aspired, however, to more than provincial success and wanted to know how his work would be gauged by sophisticated English standards. To find out, in 1765 he painted a portrait of his stepbrother, Henry Pelham, not as a commission but rather for exhibition in London.

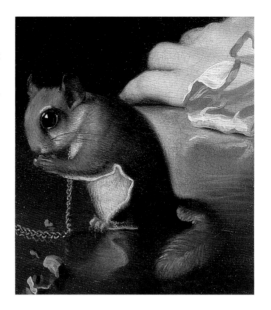

Henry Pelham (Boy with a Squirrel) was calculated to demonstrate everything Copley could do. It differed markedly from his commissioned portraits in its subtly complex composition. Here, Copley chose to paint a profile of his sitter rather than using his typical frontal likeness, and he placed Pelham behind a table that seemingly juts out into the viewer's space. Pelham, lips parted, dreamily gazes upward, as if in a reverie. Copley masterfully unified the composition with his use of color: the rich reds of the drapery and the mahogany table are echoed in the boy's ruby lips and the tones of his face, as well as in the pink collar. Most brilliant of all, perhaps, is Copley's ability to depict a variety of textures — for example, the boy's skin and the soft fur of the squirrel, the highly polished table, and the reflections of the glass of water.

Copley sent *Henry Pelham (Boy with a Squirrel)* to London for exhibition in 1766. It garnered much praise, perhaps most importantly from Sir Joshua Reynolds, one of the leading English artists, who called the painting "a very wonderfull [*sic*] Performance." Reynolds's words were both encouraging and condescending; he wrote that Copley could be "one of the first Painters in the World," but he

tempered his enthusiasm by adding that to ensure such a result, Copley must receive proper training by studying abroad before his "Manner and Taste were corrupted or fixed by working in [his] little way at Boston." Copley was encouraged by the positive response *Henry Pelham* received, and he aspired to travel to Europe for proper training. However, he remained in Boston until 1774, when he finally left the colonies for good.

Oil on canvas
77.2 x 63.8 cm (30⅜ x 25⅛ in.)
Gift of the artist's great granddaughter 1978.297

Charles Willson Peale
1741–1827
Timothy Matlack, about 1790

One of the most acclaimed painters of eighteenth-century America, Peale was as important to Philadelphia as Copley was to Boston. In 1767 he became one of the first students of the expatriate West in London. There he studied contemporary portraiture, including the work of West and the leading British painters Joshua Reynolds and Allan Ramsay, and he incorporated the delicate color and graceful poses that characterized the British style into his own work. Returning to America in 1769, he produced portraits in Annapolis, Baltimore, and Philadelphia. He also served in the Continental army for three years, and then finally settled in Philadelphia in 1778. In addition to painting, Peale organized exhibitions and helped found the Columbianum, the country's first art academy. The patriarch of a large, extended

family, he also encouraged eight of his children, his brother, four nieces, one nephew, and three grandchildren to find careers in the fine arts. Beyond the art world, Peale pursued his interests in natural history, paleontology, and taxidermy. He was truly a man of the Enlightenment — that great age of science and reason, which in the United States spawned such accomplished intellectual leaders as Benjamin Franklin and Thomas Jefferson.

Peale's portrait of Timothy Matlack honors the sitter's distinguished public career. A radical Whig, Matlack played an active role in Revolutionary events in and around Philadelphia: he was the engrosser who hand-lettered the original Declaration of Independence; he led a rifle battalion at Trenton and Princeton; and he was elected to the Continental Congress. The items with which he is shown reflect his role in forging the new nation and include the great seal of Pennsylvania and the constitution of that commonwealth, which he helped draft. Also included are law books, which attest to his political life, and a Bible, which may refer to his activity in founding the Society of Free Quakers, an alternative form of Quakerism whose followers had been expelled from the pacifist Religious Society of Friends for participating in the Revolutionary War.

Oil on canvas
121.9 x 101.6 cm (48 x 40 in.)
Gift in memory of Martha Legg McPheeters, M. Theresa B. Hopkins Fund, Emily L. Ainsley Fund, Juliana Cheney Edwards Collection, and A. Shuman Collection 1998.218

Anna Claypoole Peale

1791–1878

Richard M. Johnson, 1818

Philadelphian Anna Claypoole Peale painted this dashing miniature portrait of Richard Mentor Johnson (who would become the ninth vice president of the United States) during a visit to her uncle, artist Charles Willson Peale, who was working in Washington, D.C. Female artists were as rare in the United States as elsewhere, and few women had the opportunity to become artists unless they were related or married to one. Peale had apprenticed under her father, James, who painted miniatures (popular keepsakes) in addition to full-size portraits. She built her own reputation solely on miniatures, exhibiting her first groups of works at the Pennsylvania Academy of the Fine Arts in 1814. Peale's unusual approach ensured her popularity: she used rich, dark colors — such as the luscious red of Johnson's jacket — which resemble oil paints rather than the pale washes of watercolor that were more typical of miniatures.

When Peale painted this portrait, Johnson was a hero of the War of 1812 and was serving in the House of Representatives. A native of Kentucky, he had studied law and been admitted to the bar in 1802. He served in Congress for three decades, in both the House (1807–19, 1829–37) and the Senate (1819–29). A war hawk, he had supported the War of 1812 and fought brilliantly with a mounted regiment of Kentucky riflemen against the British and Native Americans at the Battle of the Thames, in Ontario. Johnson was severely wounded there, but he may have killed the great chief Tecumseh, who perished in the battle. In keeping with the function of the miniature as a personal memento, here Peale presents the private man rather than the public persona, showing none of the symbols associated with his career.

In addition to the portrait of Johnson, Peale was commissioned to paint James Monroe, Henry Clay, and Andrew Jackson while she was in Washington. Upon her return to Philadelphia, she wrote to her cousin, "I have so much work to do that I hardly know what to do with myself." She was elected an academician at the Pennsylvania Academy of the Fine Arts in 1824 and exhibited there regularly until 1842, when she married for a second time and ended her career.

Watercolor on ivory
7 x 5.5 cm (2¾ x 2⅛ in.)
Emma F. Munroe Fund 68.619

Gilbert Stuart

1755–1828

George Washington, **1796**

Martha Washington, **1796**

At the time that Stuart painted these portraits of George and Martha Washington, he was America's foremost portraitist, in effect the unofficial painter of the new nation. He portrayed many leading political figures and wealthy citizens, and his sitters included James Monroe, James Madison, and John Adams. Born in Rhode Island, Stuart had studied with West in London, developed a fluid painting style based on contemporary English portraiture, and then successfully competed for commissions with British artists. He returned to the United States in 1792 and established studios in both Philadelphia and Washington, D.C. He also worked in New York before permanently settling in Boston in 1805.

This most famous image of George Washington was commissioned from Stuart along with its pendant of Martha Washington shortly before the president retired from public service. Both portraits were painted in Germantown, just outside Philadelphia, in 1796. Stuart never delivered the portraits; apparently Martha Washington was not satisfied with the likenesses, and they remained unfinished. Washington's popularity as a national hero increased after his death, and Stuart used this painting as the model for the numerous replicas ordered from him over the years. One French visitor to the new United States commented, "Every American considers it his sacred duty to have a likeness of Washington in his home, just as we have images of God's saints." Stuart, however, reportedly referred to the image irreverently as his hundred-dollar bill — the price he charged for one copy. More than sixty copies survive, and the portrait ultimately became the source for Washington's face (in reverse) on one-dollar bills.

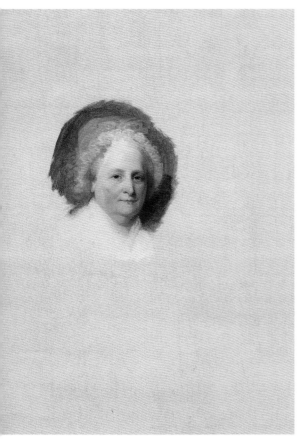

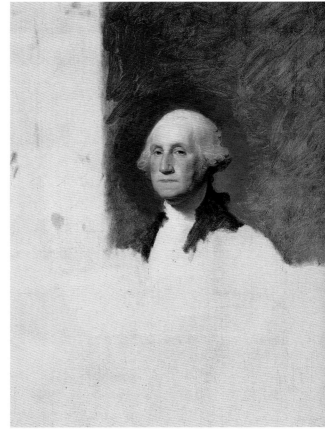

Martha Washington

Oil on canvas

121.9 x 94.3 cm (48 x 37⅛ in.)

William Francis Warden Fund, John H. and Ernestine A.
Payne Fund, Commonwealth Cultural Preservation Trust.
Jointly owned by the Museum of Fine Arts, Boston, and the
National Portrait Gallery, Washington, D.C. 1980.2

George Washington

Oil on canvas

121.3 x 94 cm (47¾ x 37 in.)

William Francis Warden Fund, John H. and Ernestine A.
Payne Fund, Commonwealth Cultural Preservation Trust.
Jointly owned by the Museum of Fine Arts, Boston, and the
National Portrait Gallery, Washington, D.C. 1980.1

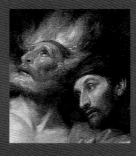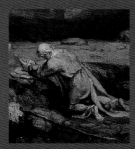

History Painting

In the last half of the seventeenth century, the term *history painting* had been defined by the French Academy, the influential national art school in France, as depictions of scenes from biblical or classical history. The Academy ranked history painting at the top, followed, in descending order, by portraiture, animal subjects, landscape, and still life. This ranking became standard throughout Europe. Depictions of more recent events were acceptable only if they were symbolically represented as classical scenes, with, for instance, figures clothed in Greco-Roman drapery rather than contemporary dress. This approach was viewed as more "correct" than the faithful replication of realistic details, for it was felt to provide subjects with the proper sense of decorum and good taste. History paintings were supposed to educate and inspire the viewer with moral purpose. The Renaissance painter Raphael and the Baroque artist Nicolas Poussin (fig. 9) were held up as the masters of this heroic style, called the Grand Manner. In the late eighteenth century, when the art of ancient Greece and Rome was once again revived and popularized in a movement known as Neoclassicism, history painting became even more stylized in its moral lessons.

History painting met with little success in colonial America. Artists such as Copley dreamed of painting important historical subjects, but the market for such images was limited. Scenes from classical history seemed irrelevant in the New World, and few grand public buildings could accommodate these works, which were often large. Biblical subjects were regarded with suspicion in Protestant colonies, and the church played virtually no role in commissioning such images.

At the end of the eighteenth century, the rigid doctrine governing history painting began to change in the hands of Benjamin West. West, who had left his native Pennsylvania in 1760 to study abroad, settled in London and became renowned for his sober historical compositions painted in a Neoclassical style. He earned a prestigious place in London's art world in 1768 as painter to the king

fig. 9. Nicolas Poussin, *Discovery of Achilles on Skyros*, about 1650.

and was instrumental in founding the Royal Academy of Arts (the English equivalent of the French Academy) with Sir Joshua Reynolds, the leading British artist. By 1771 West had begun to challenge conventional taste. In his *Death of General Wolfe* (National Gallery of Canada, Ottawa), West depicted a scene from the decisive Battle of Québec during the French and Indian War, in which the British capture of Québec City in 1759 ultimately ended French rule in North America. In traditional history-painting style, West referred to Old Master compositions (Wolfe, for example, expires like Christ in the arms of his men). But West's soldiers wear modern uniforms rather than togas, and his scene is distinctly contemporary. The inclusion of a Native American figure identifies the setting as North America. West's success in combining contemporary themes with traditional decorum played a crucial role in winning acceptance for a new kind of subject — contemporary history painting.

Contemporary history painting began to find an audience in the United States during the first decades of the new nation. Artists and patrons sought to commemorate the struggle for independence and to elevate the fledgling history of the republic by associating it with traditional images of the past. John Trumbull, for example, planned a series of Revolutionary War pictures, studies that would have patriotic appeal and would thus, he hoped, lead to commissions. In 1817 he was invited by the federal government to produce four large canvases for the new Capitol building in Washington, D.C. The decoration of the Capitol and other buildings in Washington became one of the foremost opportunities for American artists to portray the nation's history, and scenes from the Revolution would continue to inspire artists throughout the nineteenth century (fig. 10).

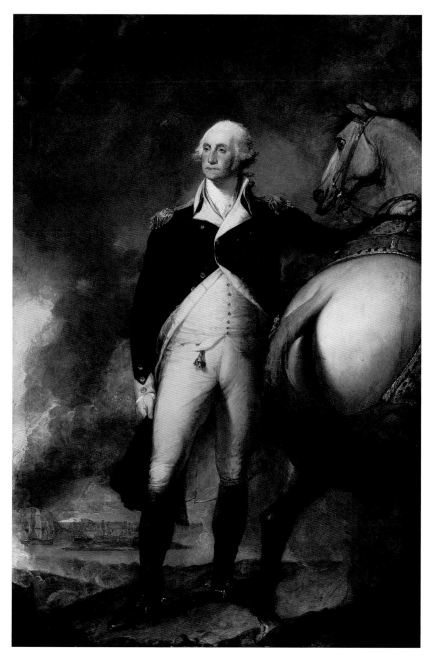

fig. 10. Gilbert Stuart, *Washington at Dorchester Heights*, 1806.

John Singleton Copley
1738–1815
Watson and the Shark, 1778

Copley departed Boston in 1774 and traveled to Europe, where he spent a year studying Renaissance and Baroque paintings and classical sculpture. After settling in London in 1775, he continued to paint portraits, but he also attempted more complex compositions. *Watson and the Shark* was the first large-scale history painting he executed. This dramatic image depicts the attack of a shark on fourteen-year-old cabin boy Brook Watson in the waters of Havana Harbor in 1749. The heroic rescue was ultimately successful, but only after the youth lost the lower part of his right leg; Watson went on to become a prosperous merchant and to hold numerous important political posts in London. Copley's choice of subject was innovative, for tradition held that history painting was limited to themes from the Bible, ancient times, or mythology. Even when artists selected subjects outside the bounds of religious or classical narrative,

they typically celebrated events of national rather than personal significance, such as military victories.

Copley's boldness paid off, and *Watson and the Shark* established his reputation in England. His dramatic rendering of the climax of Watson's story — the sailor thrusting a boat hook at the shark, which is lunging with jaws agape at the helpless, terrified boy in the water while other sailors struggle to reach him — appealed to the English public. That Copley drew on Old Master paintings by Raphael and Rubens for his composition likewise found favor with his contemporaries. He was elected to full membership in the Royal Academy in 1778. The popular painting, now in the National Gallery of Art, Washington, D.C., was made into a print for wider distribution in 1779, and, proud of his accomplishments, Copley made a second full-scale version that he kept in his studio for the rest of his life. That version is the painting at the MFA.

Oil on canvas
183.5 x 229.6 cm (72¼ x 90⅜ in.)
Gift of Mrs. George von Lengerke Meyer 89.481

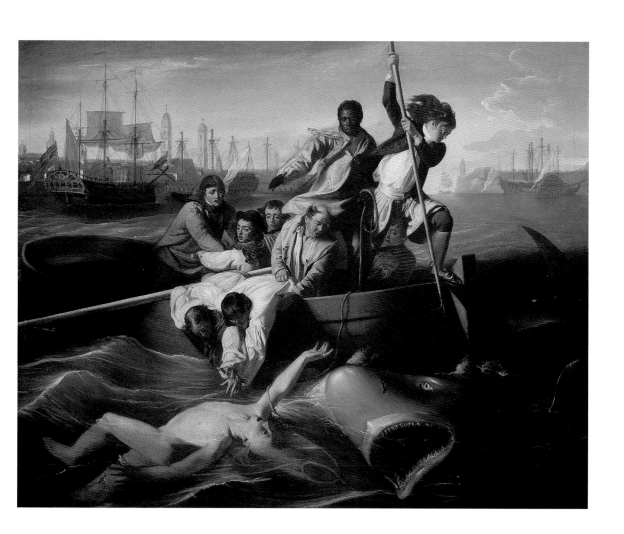

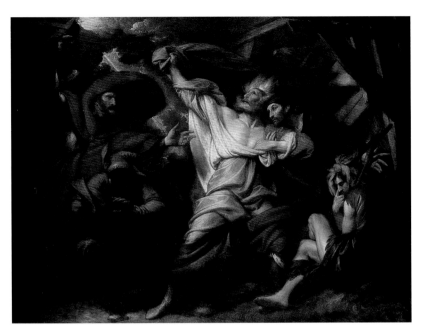

Benjamin West

1738–1820

King Lear, 1788–1806

This depiction of Shakespeare's *King Lear* is representative of the variety of new subjects that West, among others, introduced to history painting. When West left Pennsylvania for Europe in 1760, he was the first American-born artist to train abroad. He spent three years studying in Rome and then settled permanently in London in 1763. He was quickly acclaimed for his ancient Greek and Roman subjects executed in a sober, Neoclassical style, and he also became a popular portraitist. Appointed history painter to King George III, he served as president of the Royal Academy from 1792 until his death. Generations of aspiring American artists came to London to study with him, and his studio became known as the first American school for painters. His own history paintings ranged from traditional biblical and classical subjects to near-contemporary events to literary themes taken from Shakespeare and more modern authors.

In this painting for John Boydell's popular Shakespeare Gallery in London, which promoted the play-wright and contemporary history painting, West illustrated act 3, scene 4, of Shakespeare's tragedy. King Lear, rather than accept the begrudging hospitality of his two scheming daughters, takes leave of them to wander around the moor as a violent storm rages and his insanity begins to set in. Here, supported by the loyal earl of Kent, Lear thrusts his body forward and flings his head back, eyes lifted skyward. He curses both the storm and his offspring. At the right, the earl of Glouces-ter's son Edgar crouches half naked and disguised as a madman. The Fool squats on the ground to the left, at the foot of Gloucester himself, whose torch illuminates the disturbing scene. The fury of the storm underscores different levels of madness — innate in the Fool, feigned by Edgar, and encroaching upon Lear.

King Lear marked a turning point in West's oeuvre, a divergence from the restrained style that had established his reputation. Here, a Neoclassical, friezelike arrangement of a group of figures was painted in a cool palette and bathed in a clear light. He expressed the pathos of the tragic story through the frenzied gestures and wild, windswept garments of his players. He heightened the effect by using theatrical color and dramatic contrasts of highlight and shadow. West's new, dynamic approach makes a powerful emotional appeal to the viewer and anticipates the Romanticism of the next decades.

Oil on canvas
271.8 x 365.8 cm (107 x 144 in.)
Henry H. and Zoë Oliver Sherman Fund 1979.476

Thomas Birch

Born England, 1779–1851

*Engagement between the "Constitution" and the
"Guerrière,"* 1813

Birch was America's first marine painter and thus
the founder of a long and great tradition in this coun-
try. He studied under his father, William, a painter
and engraver, and in 1794 the two emigrated from
England to Philadelphia. The War of 1812 inspired the
younger Birch to produce a series of more than a
dozen naval pictures based on actual battles, each
executed within months of the event — exemplars of
the type of contemporary history painting inaugu-
rated by West. The unexpected American victories in
the war against Great Britain — the first test of the
nation's military force — were a source of great pride
to its citizens and provided a worthy subject for his-
tory painters wishing to promote the new republic.
Birch's compositions were as accurate as he could
make them. He carefully rendered the ships' portraits
and included details of the fighting gleaned from
interviews with participating crew members. His
paintings were acclaimed not
only for their sense of immedi-
acy but also for their appeal
to the patriotic fervor of the
young country.

This painting documents the
first great American naval vic-
tory of the War of 1812, the
defeat of the British frigate
Guerrière by the U.S.S. *Constitu-
tion* off the coast of Halifax,
Nova Scotia, on August 19, 1812.
At the right, the helpless *Guer-
rière*, her last mast broken off
and crashing into the ocean, is
driven up against the *Constitu-
tion*, whose cannon fire relent-
lessly pounds the British ship.
American flags proudly wave

above the conflict while the British banner sinks into
the waves. This was Birch's first subject from the War
of 1812, and it established his reputation.

The U.S.S. *Constitution* earned her nickname, "Old
Ironsides," during this very battle. A British sailor,
upon observing that their cannonballs appeared to
bounce off the ship (her hull is made of layers of oak
up to twenty-five inches thick), exclaimed, "Huzzah,
her sides are made of iron!" The *Constitution* went on
to win other engagements in the War of 1812. The
oldest active ship in the United States Navy, she is
permanently docked at the Charlestown Navy
Yard in Boston.

Oil on canvas
71.1 x 92.1 cm (28 x 36 ¼ in.)
Ernest Wadsworth Longfellow Fund and Emily L. Ainsley
Fund 1978.159

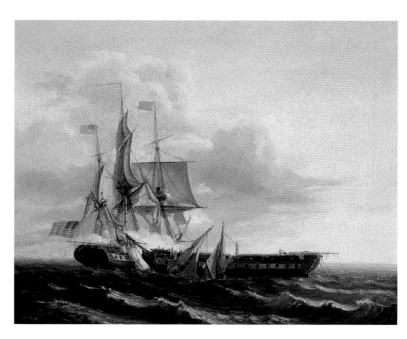

John Trumbull

1756–1843

The Death of General Warren at the Battle of Bunker's Hill, 17 June 1775, after 1815–before 1831

Called in his day the patriot-artist, Trumbull served in the Continental army from 1775 to 1777 and became known for his images of the Revolutionary War — another prime subject for contemporary history paintings. After resigning his commission, he went to London to study with West, returning to the United States with the plan to immortalize America's struggle for independence in a series of contemporary history paintings. These were to be based on the critical events of the conflict and would thus create a new iconography for the new nation. In 1817 Congress awarded him a commission to paint four such scenes as murals to decorate the U.S. Capitol.

The Death of General Warren at the Battle of Bunker's Hill, 17 June 1775 was the first Revolutionary War subject that Trumbull completed. (It was not chosen for the Capitol, however.) Joseph Warren, perhaps today less well known than Paul Revere, John Hancock, or Samuel Adams, was one of the key players in the events leading up to the outbreak of war.

A popular and innovative physician (he advocated inoculation and cleanliness in the treatment of patients), Warren plunged into politics in the late 1760s as an author of persuasive anti-Crown literature, an orator of eloquent speeches, and an underground leader of the growing Revolutionary movement. He accepted a commission as a major general on June 14, 1775, but it was as a volunteer that he was killed three days later at the Battle of Bunker Hill.

Warren's heroism immediately captured the imagination of the American public. He was so idolized that in the decade following his death more towns and streets were named after him than after Washington. Trumbull, who also was at Bunker Hill, immortalized the tragedy in dramatic fashion in a composition that, like West's iconic *Death of General Wolfe,* refers to Old Master images of the Lamentation of Christ. In the thick of the turbulent battle, Warren collapses in the arms of a comrade who holds off a further bayonet thrust. Actual participants, both American and British, in the surrounding fray are recognizable as portraits, including William Howe, Henry Clinton, and William Prescott (who allegedly gave the order to his American soldiers not to fire until "you see the whites of their

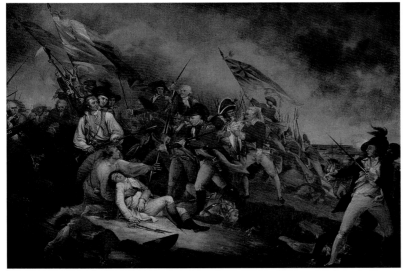

eyes"). When Abigail Adams viewed the original sketch for this composition, she claimed her "blood shivered" at the sight, so vivid was Trumbull's depiction of the tragedy. He painted several versions of the subject; the Museum's descended in the Warren family.

Oil on canvas
50.2 x 75.6 cm (19 ¾ x 29 ¾ in.)
Gift of Howland S. Warren
1977.853

Washington Allston

1779–1843

Elijah in the Desert, **1818**

A South Carolinian by birth, Washington Allston attended Harvard College. After graduating, he went to London in 1801, where he studied with West. He also traveled on the Continent, making extended visits to Paris for almost a year and to Rome, where he stayed for more than three years. After another trip abroad between 1811 and 1818, he returned to the United States and settled in Cambridgeport, near Boston.

Allston is considered America's first Romantic painter. He took the subject for *Elijah in the Desert* from the Old Testament. In 1 Kings 17.1–7, God orders the prophet into the desert, where he is miraculously kept alive by ravens, who bring him bread and meat. Allston conveyed Elijah's experience and appealed to the viewer's emotional rather than intellectual response to the bleakness of the vast, inhospitable landscape, which he painted in a sober palette of browns, steely blues, and grays. The mood of desolation and abandonment is underscored by the tiny figure. Allston's work reflects his study of the Old Masters during his time abroad. His subtle manipulation of expressive color is reminiscent of the Venetian Renaissance master Titian, and the drama of the composition recalls the Baroque painter Salvator Rosa.

Allston was held in the highest esteem in nineteenth-century Boston, where his work appealed especially to literary figures and intellectuals. After the Civil War, when plans to establish an art museum in the city were in the works, Alice Hooper (who with her mother was the donor of this painting) wrote to Martin Brimmer, one of the founders, "We thought we couldn't better testify our interest in this new art movement at home than by adding a really fine Allston to our public collection." She went on to suggest that the museum be named after Allston, "the one great artist of America," although in fact it became the Museum of Fine Arts. *Elijah in the Desert* was the very first object to enter the collection in 1870, even before the Museum had a building.

Oil on canvas
125.1 x 184.8 cm (49 ¼ x 72 ¾ in.)
Gift of Mrs. Samuel and Miss Alice Hooper 70.1

Thomas Sully
Born England, 1783–1872
The Passage of the Delaware, 1819

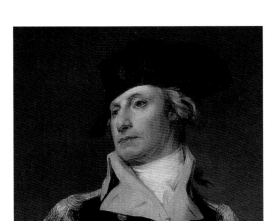

Admired for his lively brushwork, Thomas Sully was the leading portrait painter in Philadelphia in the first half of the nineteenth century. Historical subjects such as this one were rare in his oeuvre of well over two thousand portraits. Sully first studied with a succession of miniature painters, including his brother Lawrence. In 1807 he moved from Virginia to New York City, and later that year he traveled to Boston to meet the portraitist Gilbert Stuart. He settled permanently in Philadelphia in 1808 but soon afterward traveled to London to study with West. In England, Sully familiarized himself with paintings produced by other contemporary artists. He was especially influenced by the fluid style of Sir Thomas Lawrence's portraits.

The Passage of the Delaware was commissioned by the state of North Carolina for the Senate Hall of the State House in Raleigh — one of many contemporary history paintings sponsored by the young American government. According to the register of paintings that Sully kept, he began the painting on August 7, 1819, and finished it more than four months later, on December 15 (some three decades earlier than Emanuel Leutze's more famous version of the subject). Sully had suggested the subject, "the passage of the Delaware, preparatory to the battle of Princeton," to the governor of North Carolina. This event, a turning point for the American military during the Revolution, took place on Christmas night 1776. General George Washington and his troops unexpectedly crossed the dangerously ice-clogged Delaware River from Pennsylvania to New Jersey in a snowstorm to surprise the English forces. They engaged the next day in the Battle of Trenton, a crucial victory for the Americans. Paying close attention to accounts of the unfolding events that fateful December night, Sully depicted the moment before Washington dismounted his horse to join his lieutenants in crossing the river; the general sent an artillery

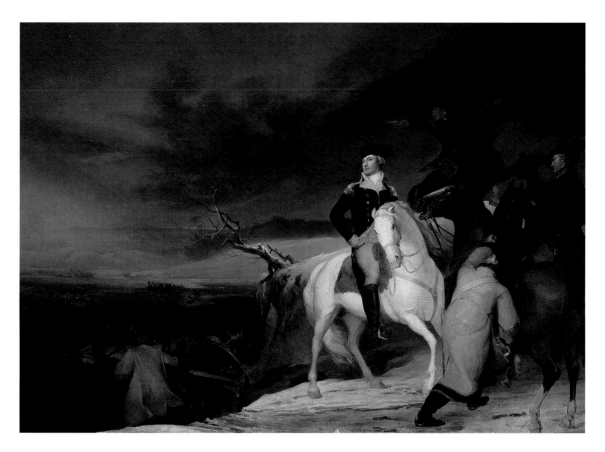

brigade first, as evidenced by the cannon visible over the crest of the hill. Sully's image of Washington is of a composed and decisive leader, dramatically highlighted and isolated from the surrounding flurry of activity.

Sully's painting was never hung in the North Carolina State House. Although Sully had corresponded with the governor regarding the dimensions of his canvas, by the time he received a reply he had already begun painting it. The final composition was too large to fit in any of the spaces of the Senate Hall. Shortly after its completion, the painting was sold by Sully to John Doggett, a Boston frame maker who also exhibited pictures. It was purchased from Doggett before 1841 by the Boston Museum — a theater with a picture gallery located on Tremont Street — where it remained until 1903, when the owners gave it to the MFA.

Oil on canvas
372.1 x 525.8 cm (146 ½ x 207 in.)
Gift of the Owners of the old Boston Museum 03.1079

From the Age of Jackson to the Civil War: Forging a National Style

Portraiture before the Civil War

Although history, landscape, genre, and still-life painting developed in the United States in the first half of the nineteenth century, portraiture was still the most common form of painting. Even after photography was introduced to the United States in 1839, Americans continued to seek out painters to portray them. Their ongoing interest in painted likenesses derived partly from their desire to participate in the larger international portrait tradition, as generations of Europeans had commemorated themselves and asserted their social status by commissioning such images.

American nationalism and individualism also helped to fuel this interest in portraiture. Immediately after the Revolution, in the Federal period, the country experienced a surge of patriotism as Americans celebrated their independence and sought to define themselves as citizens of a new nation. Particularly after the 1828 election of the populist Andrew Jackson, nationalistic Americans associated their country's greatness with its democratic ideals, grounded in its citizens' strong sense of individualism. As paintings that celebrated the individual, portraits were especially popular.

Whether trained at home or abroad, American portraitists tended to model their work on European styles, which lent status to their subjects. As the eighteenth century drew to a close, portraiture began to be dominated by Romanticism, a movement that influenced literature and music as well as art. Reacting to the rationalism of the Enlightenment, the Romantics emphasized feeling, subjectivity, and mood in their works. Romantic portraitists tended to dwell on the personality and inner character of their sitters. The leading American Romantic portraitist was Stuart, who had studied in London with West. Stuart's Romanticism is particularly evident in his portraits of women. In *Anna Powell Mason (Mrs. Patrick Grant)*, Stuart made his sitter ideally beautiful, with a gracefully rounded head, delicately pink face, and dreamy gaze (fig. 11). Her appearance reflects her mood. In her fashionable Empire dress, Mason is an

embodiment of feminine delicacy and charm. Stuart was especially admired for his great facility with paint, which he applied with a feathery touch that gives his portraits a lively immediacy. Many American artists of the early nineteenth century, including Allston and John Neagle, were profoundly influenced by Stuart's fluid style, and the portraits of this era look very different from the hard-edged, tightly finished colonial works of Copley and others.

However, portraiture often varied, depending on both the patron's wishes and the artist's level of training. Ralph Earl, for instance, the leading painter in Connecticut during the early nineteenth century, learned how to create grand, European-style portraits in London but deliberately changed his manner when he returned home. He realized that although his rural patrons, like their urban contemporaries, commissioned portraits to enhance their social status, they often had more modest ideas about pictures. So-called folk painters had no formal training but made their living by creating decorative likenesses of their fellow rural Americans.

In the early nineteenth century, miniatures in watercolor on ivory were another popular form of portrait. American painters had begun creating miniatures in the colonial period, filling the demand for portable keepsakes of

fig. 11. Gilbert Stuart, *Anna Powell Mason (Mrs. Patrick Grant)*, about 180[

loved ones. Women artists, such as Sarah Goodridge, enjoyed unusual success in this area, because the delicate technique required for miniatures was considered particularly suited to their supposedly natural refinement. With the advent of photography, however, miniaturists began to lose commissions; patrons preferred the new medium's realism and low cost. By the Civil War, the demand for miniatures had almost completely disappeared.

Although photography did not displace large-scale portraiture, it did influence stylistic developments in oil. Painters began to experiment with images that were more realistic than in the earlier Romantic age, emphasizing their subjects' physicality. This new direction in portraiture coincided with contemporary American society's interest in accumulating goods, as many items became cheaper with the rise of mass production during the

Industrial Revolution. Status in the middle class was determined by the sheer number of objects one had in one's home, and as a result, portraitists painted their sitters surrounded by furnishings and household items. Chester Harding, for instance, in *Mrs. Abbott Lawrence (Katherine Bigelow)* (fig. 12), carefully delineated his sitter's fashionable Gothic revival chair, decorative tablecloth, basket, and books, thus proclaiming her status as the widow of a prominent textile manufacturer in Boston.

Harding's depiction of Katherine Lawrence herself is just as uncompromising as his representation of the objects around her. He represented her faithfully, without seeking to improve her plain features. Harding began working in this straightforward manner because he did not know any other way to paint, and yet he did not change his technique, even after he saw high-style European art during several trips to England. Harding had already achieved great success with his strictly realistic approach and apparently did not want to risk changing it. Just as in the colonial period, mid-nineteenth-century Americans seemed to have a special fondness for such unadorned, unidealized images of themselves.

Although all of the artists included in this chapter worked within mainstream portrait painting, almost all the examples here stretch that tradition's conventions in some way, demonstrating the vitality of the genre of portraiture in the antebellum United States.

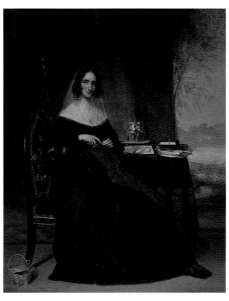

fig. 12. **Chester Harding,** *Mrs. Abbott Lawrence (Katherine Bigelow),* about 1855.

Washington Allston
1779–1843
Self-Portrait, 1805

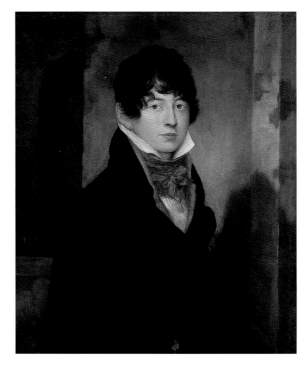

In this self-portrait, the young Allston presents himself as the new Romantic ideal of an artist. He painted the work when he was twenty-six, during his first trip to Rome. A Southerner by birth, Allston graduated from Harvard College in 1800 and left for Europe determined to become a painter. He studied for two years at the Royal Academy in London and then departed for the Continent to continue his artistic education in Europe's museums and galleries. After visiting Paris, Allston traveled to Rome, where he befriended other figures of the growing Romantic movement in Europe, including the English poet Samuel Taylor Coleridge, the German painter Joseph Anton Koch, and the Danish sculptor Bertel Thorvaldsen.

In his self-portrait, Allston's quiet gaze, open collar, loose cravat, and curly, dark locks tousled on his forehead establish his Romantic identity as a sensitive and poetic individual. Contemporary descriptions of Allston seem to match this likeness. His friend Washington Irving, the American writer, described him thus: "He is light and graceful of form, with large blue eyes, black silken hair, waving and curling around a pale expressive countenance, a man of intellect and refinement." Instead of including his brush and palette in an acknowledgment of the traditional view of the artist as a craftsman (see p. 31), Allston carefully delineated his Phi Beta Kappa key at his waist, stressing his identity as an intellectual and a gentleman. Indeed, set against the blackness of his coat and murkiness of the background, Allston's head becomes the focal point of the painting, emphasizing his mind and imagination as the origin of his art, whereas his hands, the tools of his trade, are not even included.

Allston's technique and the setting he chose enhance the portrait's sense of Romantic reverie. Emulating the sixteenth-century Venetian Renaissance painter Titian, he built up layers of oil paint with glazes, giving the painting a shimmering, atmospheric effect. The architecture in the background, with its rounded arch and simple forms, suggests a classical location. However, the mold and cracks in the masonry imply that this scene, like Rome, is of a civilization in decline. Rome fascinated Allston because of its many ruins which poignantly evoked its former glory. Interestingly, the painter placed his signature on the masonry behind his right arm, suggesting that it is inscribed into the architecture itself. This telling detail perhaps reveals the sort of artistic mark this ambitious young American hoped to leave on Rome.

Oil on canvas
80.3 x 67.3 cm (31⅝ x 26½ in.)
Bequest of Miss Alice Hooper 84.301

Thomas Sully
Born England, 1783–1872
The Torn Hat, 1820

Even in an era devoted to showing children as truly childlike, this portrait of Thomas Wilcocks Sully, the artist's nine-year-old son, is unusually informal. The older Sully was Philadelphia's leading portraitist in the early nineteenth century. This work displays his characteristically fluid use of paint, a skill he learned in London in emulation of his mentor, the British Romantic portraitist Sir Thomas Lawrence. The young Thomas is situated off center, creating a feeling of movement and immediacy. He wears an open shirt, rumpled jacket, and straw hat. Less restrictive clothing was becoming more common for children, since it was acknowledged that play was beneficial and healthful for young people.

The detail of the torn hat suggests real, human mischief on the part of the subject that is not apparent in the rosy sweetness of his face. The viewer wonders how the hat got torn, suggesting an element of narrative rare in a portrait and tying the picture to genre painting. The tear in the hat's brim also afforded Sully the opportunity to show off his ability to paint a face under a complex pattern of light and shadow. Like Copley before him (see p. 38), Sully felt free to experiment in a portrait that was not a commissioned work.

The artist's experimentation with such unusual effects may reflect the disappointing turn of events in Sully's career. By 1820 sales of his paintings had been down for several years, and he was uncertain whether he would be able to continue making his living as a portraitist. Sully may have thought that a more informal portrait might sell. Although the artist referred to the painting as a "study" and completed it in three days, he signed and dated it as he did his finished works. He also priced it at one hundred dollars, twice the amount he usually asked for a picture of this size.

Sully's gamble paid off. He sold the painting for the asking price just a year later, to Boston merchant and art collector John Hubbard. The artist went on to be much admired for his natural portrayals of children. Young Thomas Wilcocks Sully grew up to become a well-regarded portraitist in his own right.

Oil on panel
48.6 x 37.2 cm (19⅛ x 14⅝ in.)
Gift of Miss Belle Greene and Henry Copley Greene
in memory of their mother, Mary Abby Greene (Mrs. J. S.
Copley Greene) 16.104

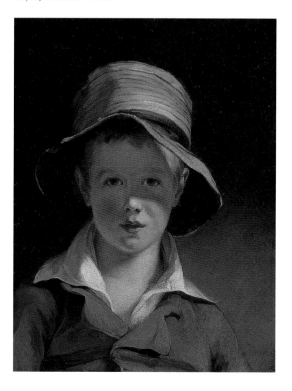

John Neagle

1796–1865

Pat Lyon at the Forge, 1826–27

This portrait of leading Philadelphia businessman and inventor Patrick Lyon is unusual for its era because it depicts a subject engaged in manual labor. Neagle was only twenty-nine when he received the commission for this work. He had begun his career by apprenticing to a coach decorator, and then he studied painting with a fellow Philadelphia portraitist, Bass Otis. He eventually began to work in the Romantic style under the combined influence of Stuart, whom he visited in Boston in 1825, and Sully (Neagle later married Sully's daughter). From them he learned to compose large-scale portraits in the European Old Master tradition. Neagle's indebtedness to Stuart in particular is evident in the painterly surface of *Pat Lyon* and in the atmospheric darkness of the blacksmith shop. However, the picture's ties to European styles end there.

Patrick Lyon was a wealthy, successful man when he commissioned Neagle to paint him. In the early nineteenth century, people who could afford large-scale, heroic images of themselves usually preferred to be depicted in formal dress and surrounded by expensive objects, implying their aristocratic status. But the sitter asked the artist to depict him as a blacksmith, which is how Lyon had begun his career. He explicitly told Neagle that he did "not wish to be represented as what I am not — a gentleman." His prejudice against gentlemen stemmed from the fact that early in his career he was wrongly accused of theft by a group of Philadelphia bankers and imprisoned. Consequently, he preferred to be shown as an honest workman rather than as a member of an upper class that he associated with injustice. Lyon also insisted that the jail in which he had been held appear in his portrait. Thus, Neagle included a view of its distinctive cupola in the upper left-hand corner. Despite the exceptional nature of this painting, it was widely admired in its time and garnered the young artist many commissions. It is still Neagle's most famous work.

Oil on canvas
238.1 x 172.7 cm (93¾ x 68 in.)
Henry H. and Zoë Oliver Sherman Fund
1975.806

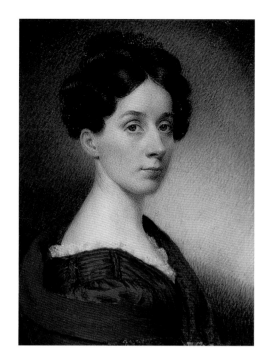

Sarah Goodridge
1788–1853
Self-Portrait, 1830

In this miniature self-portrait, Goodridge (sometimes spelled Goodrich) depicted herself staring out of the composition with a poised directness, implying confidence in herself and her artistic abilities. According to the artist's sister Eliza, who also became a miniature painter, Goodridge began studying art by reading a book on drawing and painting. In 1805 she moved to the Boston area, where she took drawing lessons, but it was only after she had worked with an unidentified miniature painter from Hartford, Connecticut, that she began experimenting with painting in this medium. In 1820 Goodridge opened a studio in Boston and perfected her artistic skills by studying with Stuart, the leading American portraitist of her time. Although Stuart specialized in large-scale works in oil, he purportedly painted one of his few miniatures (*General Henry Knox*, about 1820, Worcester Art Museum) as a demonstration piece for Goodridge.

This self-portrait displays Goodridge's characteristic realism, with every detail — down to the tiny wrinkles around her eyes — painstakingly delineated. The artist's evident self-assurance was well warranted. By 1830 she had become one of the leading miniaturists in Boston, executing as many as two paintings a week and supporting herself and her family through her art. She received commissions from such famous individuals as Daniel Webster, General Henry Lee, and her teacher, Stuart, and between 1827 and 1835 exhibited her miniatures at the annual exhibitions of the Boston Athenaeum. Such accomplishments were truly remarkable in the antebellum American art world, in which talented women were rarely given the opportunity to succeed.

Watercolor on ivory
9.5 x 6.7 cm (3¾ x 2⅝ in.)
Gift of Miss Harriet Sarah Walker 95.1424

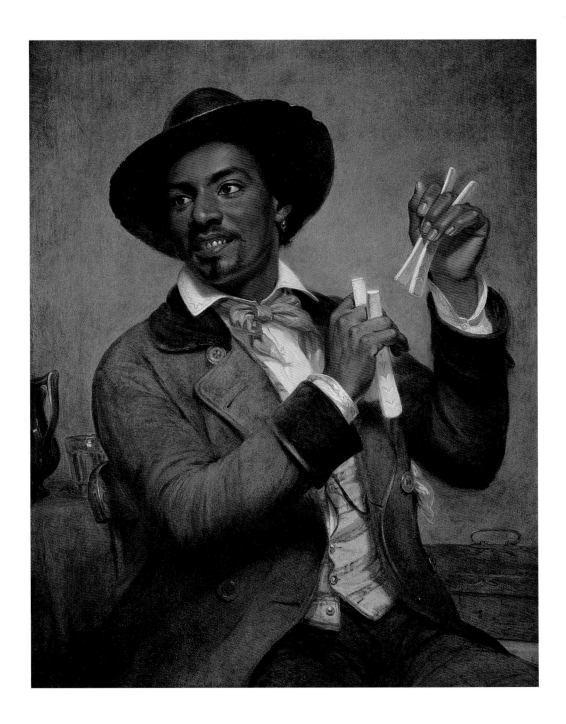

William Sidney Mount

1807–1868

The Bone Player, 1856

William Sidney Mount's *Bone Player* combines elements of portraiture and genre painting, two fields for which he was well known. Born on Long Island, he apprenticed with his brother, a portrait and sign painter, studied at the National Academy of Design, and by the 1830s was well established as one of America's leading artists. Mount painted *The Bone Player* after receiving a commission from the printers Goupil and Company for two pictures of African-American musicians, to be lithographed for the European market. These became the last in a series of five life-size likenesses of musicians that Mount executed between 1849 and 1856.

Scholars have differed over whether this image, painted just five years before the Civil War, when tensions over slavery were high, is a typical nineteenth-century stereotyped depiction of an African-American or a sensitive portrait of an individual. On the one hand, Mount titled the picture *The Bone Player*, indicating that his sitter's *activity*, rather than his *identity*, was the painting's subject. The bones — bars of ivory or bone clicked together — were an instrument associated with African-American minstrels, a type recognizable to American and European audiences. In popular theories of evolution, African-Americans were considered more intuitive than Caucasians and therefore more in touch with their natural musical talents. Mount knew that pictures of such African-American types would sell: they appealed to Europeans because of their exoticism and to Americans because they were distinctly American. Moreover, Mount was fervently

proslavery and so unlikely to challenge African-American stereotypes.

On the other hand, Mount carefully delineated his subject's distinctive physical characteristics, such as his high cheekbones, white teeth, and neat mustache, treating him as an individual and not a type. Unlike the depictions of African-Americans in contemporary genre painting, which often employed caricature, this sitter is life-size, allowing the viewer to relate to him as a fellow human being. Mount himself played the violin and loved music. His personal interest in the subject may explain his portraits of musicians, the first of which depicts a Caucasian subject and thus does not involve African-American stereotypes.

In the end, the most convincing conclusion about this painting is that both interpretations have merit. Mount was walking a fine line between stereotype and individualism, between genre painting and portraiture. His equivocation makes sense, for he executed the work when debates over slavery were intense. Whatever his political affiliations, Mount was primarily a painter trying to support himself through his art. In *The Bone Player*, he created a work that could be interpreted in different ways and could appeal to a buyer in the North or the South. Yet despite its ambiguity, the painting is still unprecedented in the humanity it accords to its subject.

Oil on canvas
91.8 x 74 cm (36 ⅛ x 29 ⅛ in.)
Bequest of Martha C. Karolik for the
M. and M. Karolik Collection of
American Paintings, 1815–1865
48.461

 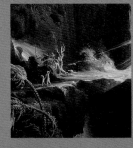

Landscape Painting

In 1825 the magnificent views of the Hudson River valley came to prominence with the opening of the Erie Canal, which linked the waterways of the Great Lakes through western New York to Albany and then south to New York City. Many Americans whose livelihoods depended on navigating the length of the Hudson became greatly appreciative of the beauties of their native surroundings. At just this time, the British-born artist Thomas Cole arrived in New York City and began to create an American style of landscape painting. Many of Cole's images depicted New York, and the movement came to be known as the Hudson River School.

Cole and the circle of artists he fostered sought to elevate landscape to the level of history painting, traditionally considered the noblest form of visual expression. Unlike European scenery, which was populated by temples, castles, or ancient ruins, America appeared to be a tabula rasa, a clean slate undefiled by civilization. Cole's portrayals of the Hudson Valley (see fig. 13) celebrated the sense of awe evoked in contemplating the wilderness. In a manner reminiscent of French philosopher Jean-Jacques Rousseau's concept of man existing in harmony with nature, Cole extolled the sublime appearance of the American landscape in his "Essay on American Scenery," published in 1835. In a moralizing tone, he praised the American primeval forests, mountains, lakes, and waterfalls (especially Niagara) and the moral rectitude their contemplation promised. Alexis de Tocqueville wrote in *Democracy in America*, "There is no country in the world in which the Christian religion retains a greater hold over the souls of men, than in America." De Tocqueville's observation held true for Cole and for many of the landscape painters who followed him. Ultimately, their works expressed a sense of ambivalence and loss in the face of the erosion of wilderness that made way for agrarian civilization, a transformation associated with the biblical fall from Paradise in a vain quest for knowledge and progress.

In addition to biblical themes, American landscape painters found inspira-

tion in contemporary literature. Cole's circle in New York City included poets like William Cullen Bryant and writers such as James Fenimore Cooper, whose popular tales, often inspired by Native American culture, suggested landscape settings for paintings. Cole's pupil Frederic Edwin Church also embraced the scenery of the Maine coast (see p. 75), producing imagery similar to that described by New Englander Henry David Thoreau in his series of essays *The Maine Woods*. Landscapes with literary associations appealed to highbrow patrons, yet their popularity was also bolstered by Jackson's presidential campaign for the era of the Common Man, a platform that promoted the agrarian roots and pioneering independence of American democracy.

Many of the foremost painters of the Hudson River School, including Cole, were largely self-taught and relied on a range of historical sources tempered by an intense study of nature. Asher B. Durand, one of the leading painters of the school, proclaimed the benefits of sketching directly from nature in a series of magazine articles entitled "Letters on Landscape Painting," published in 1855. American landscape painters, like their European counterparts, zealously adopted the practice of working outdoors and infused their compositions with a fresh and distinctive authenticity. Durand noted that their freedom from academic constraints enabled them to "boldly originate a high and independent style." As their devoted pursuit of nature spurred their travels to dramatic countryside well beyond the Hudson Valley, landscape painters traversed the Northeast through the Berkshires, the White Mountains, Vermont, the Adirondacks, and along the coasts of Connecticut, Massachusetts, and Maine.

One group of painters, including Martin Johnson Heade, Fitz Hugh Lane, and John Frederick Kensett, was devoted to a more contemplative style of landscape painting, first described as "luminist" in the late 1940s — at the same time that MFA benefactors Martha and Maxim Karolik donated their large collection of these works to the Museum of Fine Arts. These painters studied directly from nature and subtly altered topographical details to create an idealized image. The horizontal format of their compositions enhances the tranquillity they express in scenes of calm stretches of ocean and shorelines that draw the eye to the limitless horizon. The term *luminist* also reflects their carefully polished surfaces of burnished brushstrokes that suffuse the canvas with a range of light effects, from the

fig. 13. **Thomas Cole,** *View of the Round-Top in the Catskill Mountains,* 1827.

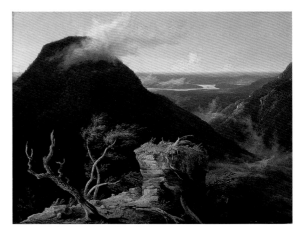

hazy atmosphere of Lane's *Boston Harbor* (p. 76) to the crisp autumn light in Sanford Robinson Gifford's *An October Afternoon* (p. 81).

Before the Civil War, American landscape painters such as Church also pursued subjects with international appeal. Inspired by contemporary naturalists including Baron Alexander von Humboldt and his book *Cosmos*, Church set his course for the uncharted jungles and rain forests of South America. Having learned to sketch outdoors from Cole, Church recorded

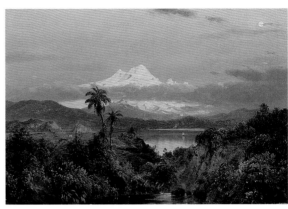

this exotic landscape in small oil sketches (see fig. 14), which he then used to produce oil paintings on a grand scale in his New York City studio. In 1859, when

fig. 14. **Frederic Edwin Church,**
Cayambe, **1858.**

Heart of the Andes (Metropolitan Museum of Art), Church's masterpiece based on his South American travels, made its debut in New York City, crowds of more than twelve thousand people flocked to see the canvas before it embarked on an international tour.

Also in 1859, Albert Bierstadt made his first trip to the Rocky Mountains and proceeded to capture the public fascination with the West that had been fueled by the gold rush and the popularity of travel accounts and geological surveys. The West offered the possibility of fulfilling America's sense of Manifest Destiny across the continent, which was linked by railroad in 1869. American landscape painters like Bierstadt found in the Rockies majestic mountains capable of rivaling the grandeur of the European Alps and the Andean peaks. Although Bierstadt often populated his Rocky Mountain scenes with Native American villages, his awe-inspiring images were idealized. Contemporary reviewers noted in *Harper's Weekly* that indigenous life as depicted by Bierstadt was "now rapidly disappearing from the earth, and may be called a historic landscape."

That sense of loss was also experienced when American artists increasingly traveled abroad after the Civil War. Following in the footsteps of Cole and artists of his generation, George Inness sought to drink deeply from the well of antiquity. The coasts and lakes of Italy, lauded by the ancient poets, inspired Inness to evoke the Arcadian past in his atmospheric landscapes. After the Civil War, American landscape painters also began to emulate works by the French Barbizon School. Inness, who greatly admired their rural and opalescent scenes, exemplifies the pivotal generation of artists who both looked back to the earlier style of the Hudson River School and anticipated the luminescent American Impressionist landscapes of the 1880s.

Thomas Cole

Born England, 1801–1848

Expulsion from the Garden of Eden, **1828**

Cole first exhibited *Expulsion from the Garden of Eden* along with his *Garden of Eden* (Amon Carter Museum) in 1828 at the National Academy of Design, of which he had been a founding member. Writing to his patron Robert Gilmor, Cole noted that his submissions aimed for a higher form of landscape painting. Although the works failed to sell, Gilmor supported Cole's travels abroad and set him on his way to receiving a major commission from New York art patron Luman Reed to paint a series of five monumental canvases entitled *The Course of Empire* (1836, New-York Historical Society).

Immigrating to the United States from England at the age of eighteen, Cole was largely self-taught and relied on British drawing books and prints for the rudiments of his artistic education. His scene of Adam and Eve dwarfed by promontories of terrifying proportions recalls contemporary British painter and printmaker John Martin's illustrations for John Milton's *Paradise Lost*, which was popular on both sides of the Atlantic. Cole's dramatic use of light streaming through the rocky portal to Paradise is clearly reminiscent of Martin's history paintings.

In his 1835 "Essay on American Scenery," Cole described the beauties of the American wilderness and its capacity to reveal God's creation as a metaphoric Eden. According to Cole, European scenery reflected the ravages of civilization, for which extensive forests had been felled, rugged mountains had been smoothed, and impetuous rivers had been turned from their courses. By contrast, the American wilderness embodied a state of divine grace. Cole lamented that signs of progress were rapidly encroaching on America. In his *Expulsion*, he vividly portrays both Paradise and a hostile world replete with the consequences of earthly knowledge. These opposing realms meet near the center of the canvas. The profusion of flora and fauna evokes the beauty and harmony of Eden. Outside Paradise, Adam and Eve are cast into an abyss marked by blasted trees, desolate rocks, and an ominous wolf.

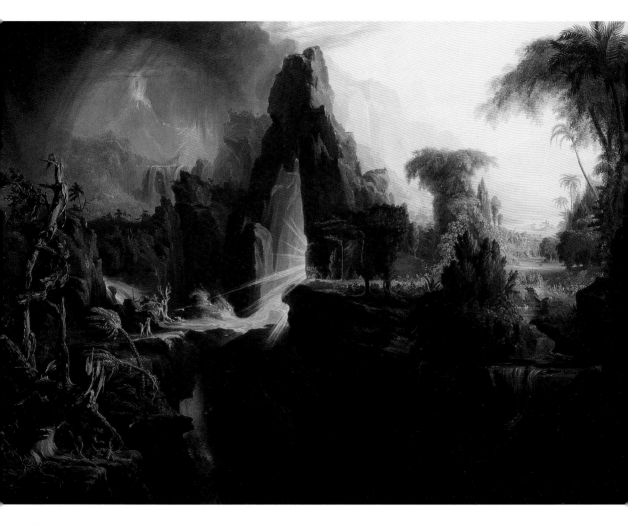

Oil on canvas
101 x 138.4 cm (39 ¼ x 54 ¼ in.)
Gift of Martha C. Karolik for the M. and M. Karolik Collection of
American Paintings, 1815–1865 47.1188

Samuel Finley Breese Morse

1791–1872

Niagara Falls from Table Rock, about 1809–10

The great falls at Niagara captivated many American landscape painters. Samuel Finley Breese Morse portrayed the now much eroded table rock on the Canadian side of the falls, describing the varied hues of the water, the spectacular spray, and the arcing rainbow that crowned one of the world's natural wonders. Morse even added diminutive Native American figures to emphasize the natural beauty and sheer immensity of the site and to locate it clearly in the New World.

Although the reverse side of the canvas bears Morse's signature and the date 1835, several scholars have debated the attribution. The composition resembles a painting of the falls by the American artist John Vanderlyn, and this canvas was initially thought to be one of his long-lost works. Vanderlyn sought to capitalize on the popularity of Niagara by becoming the first to paint the site in 1801, before any other American paintings of the location were known.

Overwhelmed by what he saw, Vanderlyn produced at least two paintings and numerous sketches of Niagara from the Canadian shore in 1802 and later had two compositions reproduced abroad in an edition of two hundred prints. At one time, this painting was also attributed to Benjamin Champney, Vanderlyn's assistant in Paris.

Current scholarship now favors the young Morse, a great admirer of Vanderlyn's work. Best known for his invention of the telegraph, Morse was an accomplished painter of historical subjects and portraits. Morse may have been inspired to paint the falls when he was studying with West in London between 1809 and 1810. He probably learned of Vanderlyn's Niagara engravings from the American expatriates West and Copley, who had been in charge of inspecting the printed proofs. Because the style of this painting is so unlike Morse's landscapes of the 1830s, scholars have suspected that the inscription and date on the reverse were added later. Despite all the questions surrounding the attribution of this composition, it stands as a testimony to the importance of Niagara for American landscape painters. This sublime wonder of the New World would later inspire many American artists including Church, Bierstadt, Inness, and William Morris Hunt.

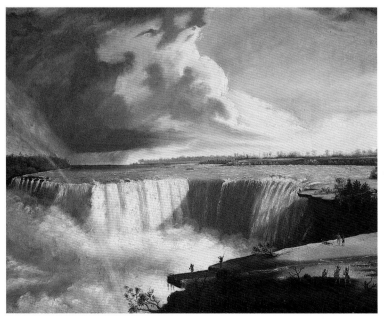

Oil on canvas
61 x 76.2 cm (24 x 30 in.)
Bequest of Martha C. Karolik for the M. and M. Karolik Collection of American Paintings, 1815–1865
48.456

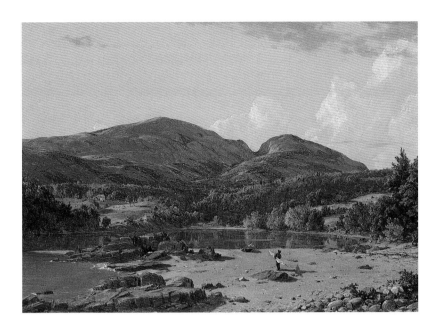

Frederic Edwin Church
1826–1900
Otter Creek, Mount Desert, 1850

When Church traveled to Maine in 1850 to paint the coast, he followed in the footsteps of several other American painters. Thomas Doughty had painted there in the 1830s and in 1836 had exhibited his view of the lighthouse of Mount Desert Island at the Boston Athenaeum. Church's esteemed teacher, Cole, had first visited Mount Desert during the summer of 1844. In 1849 Lane exhibited *Twilight on the Kennebec River* at the American Art-Union in New York City, where Church lived and retained a studio.

The clarity of light and atmosphere in Church's cabinet-size picture is reminiscent of works by German painter Andreas Achenbach and the Düsseldorf masters, whose polished and carefully delineated landscapes were highly acclaimed during the late 1840s and 1850s when they were shown at the American Art-Union. When Achenbach's *Clearing Up, Coast of Sicily* (1847, Walters Art Gallery) received commendation in the press, the *Bulletin of the American Art-Union* reported that Church, along with two other painters, had gone off to Maine with Achenbach's magnificent coastal painting in mind.

Like Cole, who had been greatly inspired by his circle of Knickerbocker writers, Church may have

been motivated to visit the Maine coast by the contemporary essays of Thoreau, whose own pursuit of the American wilderness took him to Maine. In 1848 Union Magazine published Thoreau's "Ktaadin and the Maine Woods," which described his travels deep into the interior of the state. When Church visited Otter Creek in 1850, Maine was still largely considered wilderness. The artist spent most of his time on the coast, although he would later visit many of the sites Thoreau described, including Katahdin, the tallest mountain in the state. Recalling Cole's depictions of the American wilderness and the encroachment of civilization, Church juxtaposes the majestic, craggy faces of Cadillac and Dorr Mountains and the settlers' cottage visible at their base.

Oil on canvas
42.5 x 61 cm (16 ½ x 24 in.)
Seth K. Sweetser Fund, Tompkins Collection, Henry H. and Zoë Oliver Sherman Fund and Gift of Mrs. R. Amory Thorndike 1982.419

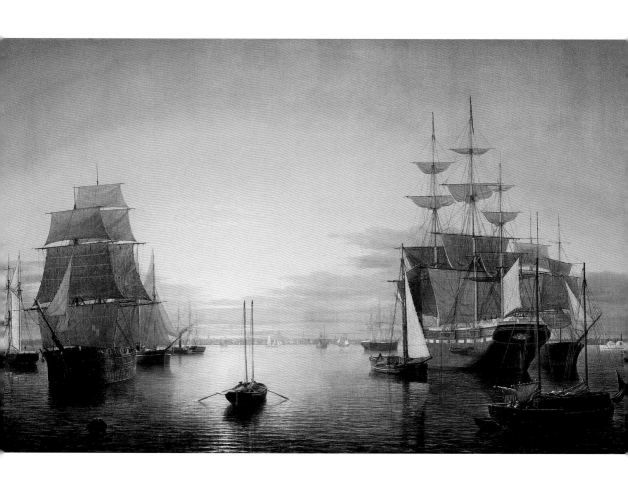

Fitz Hugh Lane
1804–1865
Boston Harbor, about 1850–55

Fitz Hugh Lane, a Gloucester native, was at the height of his career by 1850, when he executed this grand yet tranquil scene of the bustling port of Boston. From the vantage of a hill in East Boston, a perspective popularized in printed views of the city, Lane suggests topographical accuracy in his carefully constructed scene of vessels dispersed before the horizon. Prominent features of Boston such as the State House and the Old South Church are clearly visible, but Lane lowered the horizon line to convey a sense of the expansive harbor. Like Cole and Church, Lane achieves an extraordinary balance between the reality of the scene he depicted and an idealized seascape, with its sense of calm and quietude.

Lane was largely self-taught, being a quick study of those resources available to him. As an apprentice in the Boston lithography shop of William S. Pendleton, he was known for his careful draftsmanship and skill in rendering all the details of the sailing vessels. While he honed his skills producing popular prints, Lane also absorbed the lessons of British-born artist Robert Salmon, who settled in Boston in 1828 and flourished as a marine painter. Lane's *Boston Harbor* recalls both Salmon's

handling of topographical details and his use of familiar devices such as the small boat rowed toward the horizon that provides a sense of scale.

Lane portrays the calm waters with his characteristic luminosity. The elegiac quality of the scene is also typical of Lane; his paintings often depict the end of the day and evoke the end of an era. At the time that Lane was painting his ambitious scenes of Boston, Salem, and Gloucester, which were known to appeal to patrons engaged in the shipping industry, the Erie Canal had diverted much of the traffic that otherwise would have passed through these ports en route to New York Harbor. The encroaching world of steam power, which dominated the Hudson River corridor from Albany to New York City, is indeed indicated by the appearance of a white steamship entering the harbor at the far right.

Oil on canvas
66 x 106.7 cm (26 x 42 in.)
M. and M. Karolik Collection of American Paintings, 1815–1865, by exchange 66.339

John Frederick Kensett

1816–1872

Bash-Bish Falls, Massachusetts, 1855

Like Cole, who also painted Bash-Bish, Kensett was a great admirer of waterfalls. Kensett had trained as an engraver and traveled abroad before settling in New York City in 1847. By 1855, when he painted this version of the cataract, the artist had made two trips to Niagara and had depicted other well-known picturesque falls including Trenton, Rydal, and Kaaterskill. Scenes of Bash-Bish had special appeal for one of Kensett's important patrons, the New York collector of American and Dutch painting James Suydam, because of its association with the waterfalls portrayed by the seventeenth-century Dutch master Jacob van Ruisdael, whose works were greatly admired. Many of the American landscape painters, especially Kensett and his patron, also shared a deep interest in geology, and rocks feature prominently in Kensett's depiction of the falls.

Although Kensett was probably familiar with the Native American myth of a woman named Bash-bish who had been condemned to death at the site, he chose to focus on a realistic view, using carefully blended pigments that created a thickly scumbled surface. Having sketched from nature throughout the Northeast and Europe, Kensett displayed a remarkable facility for rendering textures, ranging from rushing and gently rippling water to moss-covered rocks and lacy foliage. The small scale of the bridge in relation to the height of the gorge, which Kensett enhanced by choosing a low vantage point from the lower pool, is reminiscent of J. M. W. Turner's far more dramatic views of the Saint Gothard pass in the Alps, scenes Kensett probably knew through popular engravings after the paintings. The vertical format of Kensett's composition is closely related to Cole's earlier images of Kaaterskill Falls and is similar to Hudson River artist Asher B. Durand's closely observed oil studies from nature, which also date from the mid-1850s.

Oil on canvas
75.9 x 61.3 cm (29 ⅞ x 24 ⅛ in.)
Bequest of Martha C. Karolik for the M. and M. Karolik
Collection of American Paintings, 1815–1865 48.437

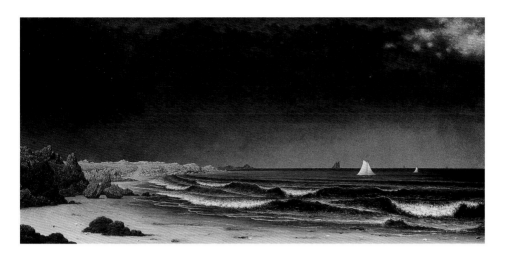

Martin Johnson Heade

1819–1904

Approaching Storm: Beach near Newport,
about **1861–63**

Like many of the Hudson River School landscape painters, Heade was highly attuned to meteorological phenomena. He produced this chilling scene of a thunderstorm at Point Judith near Newport as part of a series of compositions that depicted ominous weather at sea. Although Cole and the generation of artists who would follow him were intimately familiar with cloud formations and light effects, this scene of blackened water and an eerily illuminated shoreline suggests a more potent meaning. A thunderstorm accompanying a storm-tossed boat was a common metaphor for an imperiled or wrecked ship of state, which here is rendered with deadening calm. The three boats at full sail seem caught in imminent danger and unlikely to find a safe passage to shore. For a nation overshadowed by the upheaval of Civil War, the darkened appearance of the stormy sky also brought to mind the familiar black, sulphur-laden canopy that rose above the battlefields.

As the war approached, popular preachers, including Heade's lifelong friend Thomas March Clark, the fifth bishop of Rhode Island, incorporated images of the biblical deluge into their sermons, equating dark clouds lingering on the horizon with the infamy

that a civil war would bring. In contrast, sunlight symbolized the hope of God's redemption. In Heade's extraordinary scene, the blackened clouds give way to a small patch of blue sky at the upper right, and the roiling waves are juxtaposed with a supernatural glow that suffuses the promontory of Point Judith with an intense clarity.

Of all Heade's variations on the theme of thunderstorms, this composition is the most severe, lacking any narrative details. Heade's viewer is afforded little relief from the cloud cover and the relentless horizontality created by the ocean and the beach. Nature appears at her most terrifying and hostile, and the barrenness of the shore, which drops away from the viewer at the lower edge of the canvas, conveys the sense that there is no foothold on the edge of Heade's abyss.

Oil on canvas
71.1 x 148.3 cm (28 x 58⅜ in.)
Gift of Maxim Karolik for the M. and M. Karolik Collection of American Paintings, 1815–1865 45.889

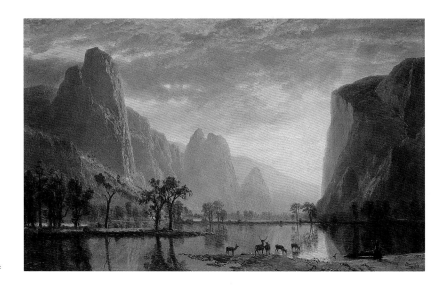

Albert Bierstadt
Born Germany, 1830–1902
Valley of the Yosemite, 1864

After his first trip to the Rocky Mountains in 1859, Bierstadt returned to the region in 1863 with his friend the author Fitz Hugh Ludlow. Both men had been tremendously impressed by the landscape. Ludlow published his assessment of the scenery in the June 1864 issue of the *Atlantic Monthly*, proclaiming that the Valley of the Yosemite surpassed the Alps in its waterfalls and the Himalayas in its precipices. To his friend John Hay, Bierstadt wrote that he had found the Garden of Eden.

Bierstadt effectively combined his training abroad with his facility for sketching outdoors, and he successfully cultivated a market for Western pictures back in the East. Small-scale oils like this one, which has the freshness of studies executed in the field, served as the inspiration for compositions the artist envisioned on a grand scale and painted in his New York studio. This work probably originated as a finished sketch for the much larger *Looking Down Yosemite Valley* (Birmingham Museum of Art, Alabama), painted the following year. Bierstadt became known for such panoramic canvases, particularly for his grandiose scene *Rocky Mountains, Lander's Peak* (1863, Metropolitan Museum of Art), which measured six by ten feet. By 1865, after another immense canvas of the Rockies toured the eastern

seaboard, Bierstadt sold it for twenty-five thousand dollars, a record price for an American painting.

The West symbolized the promise of further expansion into the wilderness and the possibility of recapturing Eden. Popular preacher Thomas Starr King extolled the virtues of Yosemite and considered those who depicted its scenery to be artist-priests. A sense of awe vis-à-vis nature clearly informs Bierstadt's composition, in which a seemingly divine light illuminates the Western landscape. The popular reception and acclaim of Bierstadt's views of the Yosemite Valley, along with the inspired photographs by his contemporary Carlton E. Watkins, strengthened the effort to preserve the inherent beauties of the region, and it was designated one of the first Western state parks in 1864.

Oil on paperboard
30.2 x 48.9 cm (11 ⅞ x 19 ¼ in.)
Gift of Martha Karolik for the M. and M. Karolik Collection
of American Paintings, 1815–1865 47.1236

Sanford Robinson Gifford
1823–1880
An October Afternoon, 1871

Gifford's *An October Afternoon*, which he painted after a remarkably productive period in his career, reflects the maturity of the American landscape tradition that began with Cole and his followers. Gifford's palpable orange glow of an Indian summer day creates a sense of time suspended in sublime light and is reminiscent of the atmosphere in Lane's *Boston Harbor* (p. 76). The horizontal composition — a stretch of shore curving around a glistening body of water — also recalls seascapes by Heade and Kensett. These qualities place Gifford's painting within the luminist aesthetic.

Gifford depicts the distinctive silhouette of Mount Chocorua in New Hampshire, where the artist sketched between 1863 and 1865. Like the site of Bash-Bish Falls, which was closely associated with Indian legend (see p. 78), Mount Chocorua takes its name from a Native American, in this case a historical figure: Chief Chocorua was shot on one of the high ledges by an earlier settler in the area. Along the shore at the right, Gifford depicts a cluster of figures, tepees, and canoes consistent with the folklore of the region. The warm illumination, calm reflections, and diminutive figures in relation to the majestic scenery all convey the artist's awe of the natural landscape in which Native Americans coexisted in an idyllic state.

Gifford's scene of Native Americans peacefully inhabiting a wilderness unspoiled by white colonization was clearly nostalgic. The notion that Native Americans embodied the traditions of the noble savage had culminated at mid-century. In 1855 Henry Wadsworth Longfellow's poem *The Song of Hiawatha* was at the height of its popularity, and in 1856 American sculptor Thomas Crawford designed the statue of a seated chief for the Progress of American Civilization group on the east pediment of the U.S. Capitol. By 1871, when Gifford painted his idyllic scene *An October Afternoon*, these Native American communities throughout the Northeast and even in the West had become a vision of the past.

Oil on canvas
34.3 x 61 cm (13 ½ x 24 in.)
Henry H. and Zoë Oliver Sherman Fund 1988.150

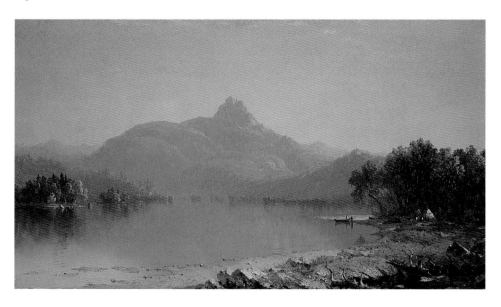

George Inness
1825–1894
Lake Nemi, 1872

The spectacular scenery of Lake Nemi, near Rome, enthralled the ancients. Virgil and Ovid wrote of it, and Roman emperors erected villas along its shores. Caligula even built floating barges from which to enjoy the three-mile circumference of the almost perfectly circular lake. One thousand feet above sea level, the body of water rests so deeply within the surrounding walls of a volcanic crater that hardly a breeze ripples its surface. Hence the lake was known in antiquity as Diana's mirror, an allusion to the temple for Diana that stood on Nemi's rim.

Many European artists traveled to Lake Nemi, including Gaspard Dughet, Claude Lorrain, and Turner. By the early nineteenth century, American painters also visited the lake, most notably Cole. Inness, who initially worked as a map engraver in New York City and first traveled to England and Italy in 1847, visited the region while living abroad between 1850 and 1852. He returned there in 1872, and soon thereafter this picture was acquired by Mr. and Mrs. A. D. Williams of Roxbury, Massachusetts, during their sojourn in Rome.

Inness probably painted the scene from the grounds of the Capuchin monastery in the near foreground (which was still extant in the nineteenth century). He created an ethereal view of the mythical world of Arcadia. Unlike earlier artists who depicted Diana's temple, Inness eschews architectural details in favor of a hazy atmosphere and panoramic vistas. Priests were known to walk the path around the lake, as suggested here by the garb of the man with his back to the viewer. By including the solitary figure, a common motif in earlier American landscape paintings (see, for example, p. 95), Inness invites the spectator to enter this seemingly oneiric world.

Inness alludes to the timeless splendor of the ancient world, yet in traditional descriptions of Arcadia, amid the beauty of life, the specter of death is omnipresent. Inness conveys a sense of longing for the past, but it is a past associated with a bizarre and ruthless ritual: historically, a murderous chase through the sacred grove surrounding Lake Nemi determined the next reigning priest of Diana's temple. Like Cole and Lane before him, Inness strikes a balance between the reality of the depicted scene and an idealized nature; in addition, he achieves both a convincing image of the well-known site and a vision that seems capable of vanishing like a dream.

Oil on canvas
75.6 x 114 cm (29 ¾ x 44⅞ in.)
Gift of the Misses Hersey 49.412

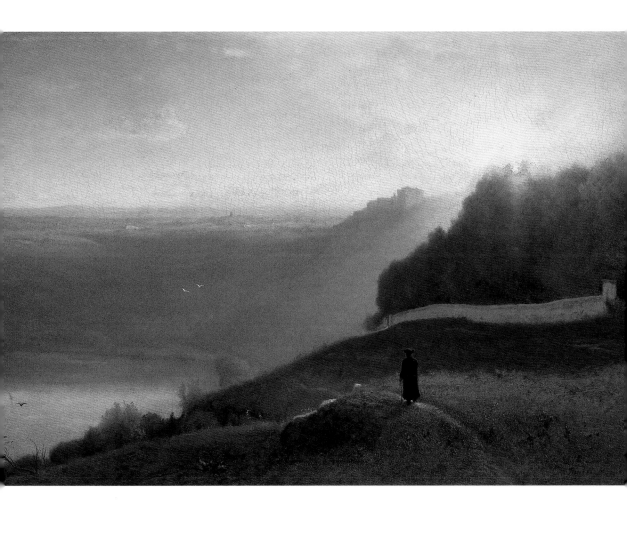

Folk Painting

In a 1798 newspaper advertisement, an itinerant portrait painter characterized himself as "a self-taught genius, deriving from nature and industry his knowledge of Art." This description provides the beginnings of a definition for what is generally called folk painting, though the term eludes easy explanation. Most of what is considered folk art was made by people who had little artistic training and whose work reflects both their observations of the world around them and their imaginative responses to these observations (what another folk artist called "the darling offspring of my brain"). Although some practitioners earned their living from their art, many others were amateurs, crafting wonderful objects to decorate their own homes or those of their families and neighbors. And although some folk objects are entirely original and idiosyncratic creations, others (such as the lively Pennsylvania German painted marriage chests, decorated redware plates, and ornamented birth and baptismal certificates) reflect cultural continuity — the perpetuation of long-standing traditions of form and decoration brought by immigrants from Europe and elsewhere beginning in the seventeenth century.

The bold and original paintings illustrated here belong to a larger group of works thought of as folk. Quilts, weather vanes, decoys, and painted furniture were functional objects, elevated beyond the merely practical by creative people eager to add visual richness to their lives. Whirligigs, carved birds, and carousel animals provided pleasure and amusement. Although these works have few equivalents in the realm of high-art, painted furniture often began as less expensive versions of the chairs, tables, and chests of drawers in mahogany and other costly woods produced for fashion-conscious city dwellers. Many of these kinds of objects continue to be created to the present day; however, much of what we think of as folk art was produced before the nation's centennial in 1876, that is, before the era of industrialization and America's prominence on the international stage.

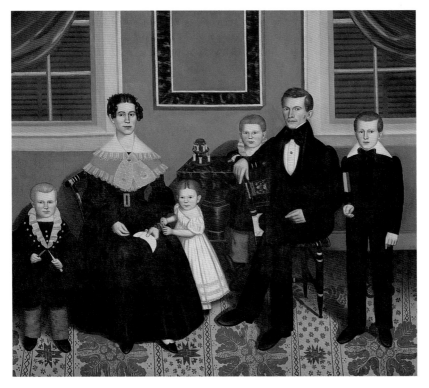

fig. 15. Erastus Salisbury Field, *Joseph Moore and His Family*, about 1839.

Like works by their academically trained counterparts, paintings created by folk artists had various functions and were considered highly desirable. Many Americans, whether wealthy or working class, had portraits painted to honor prominent members of the community, to assert their own economic and social success, and to perpetuate the memory of deceased family members. Throughout the nineteenth century, folk painters set up shop in small towns or traveled around the countryside, producing likenesses of men, women, families, and children (fig. 15). There was also a demand for images of prized farm animals and, occasionally, beloved pets. In addition, house portraits, a mainstay of eighteenth-century high-style art in England and to a lesser extent in America, were commissioned in the nineteenth century by proud owners of both country estates and modest cottages. These, too, were painted by itinerant artists (and sometimes by the homeowners themselves). National pride — beginning during the American Revolution and continuing through the early nineteenth century — led to the proliferation of images celebrating American victories (such as the Battle of Bunker Hill; fig. 16). In the more pious and sentimental Victorian era, people favored cheerful scenes of family life or renditions of memorable local incidents on the one hand (fig. 17), and of inspirational religious subjects on the other (p. 94).

fig. 16. Winthrop Chandler, *Battle of Bunker Hill*, about 1776–77.

Although folk painters addressed the kinds of subjects that their trained contemporaries did, their best work is far more than an unskilled imitation of the academic art of the time. Because painters such as Erastus Salisbury Field, William Matthew Prior, Susan Catherine Moore Waters, and Henry Darby had little or no formal training and little acquaintance with European art, their mastery of the techniques, practices, and conventions of high-style painting was limited. They nonetheless produced highly original and direct works, paintings that emphasize bright unmodeled color, pattern, and broadly outlined simplified forms. The idiosyncrasies of anatomy, pose, and perspective in folk paintings reflect a bold and creative spirit and an independent vision. And just as

fig. 17. Jesse D. Bunting, *View of Darby, Pennsylvania, After the Burning of Lord's Mill*, about 1862–67.

folk paintings belong to a vibrant artistic heritage that flourished outside the academic mainstream, they provide a window onto aspects of the American past that unfolded apart from the country's centers of wealth and power. Images such as *The Reverend John Atwood and His Family* (p. 90) and *Three Sisters of the Copeland Family* (p. 92) are rich in the kinds of details — dress, hair styles, household furnishings, and prized possessions — that present a vivid picture of the values and beliefs of the sitters and of the lives of ordinary people in America.

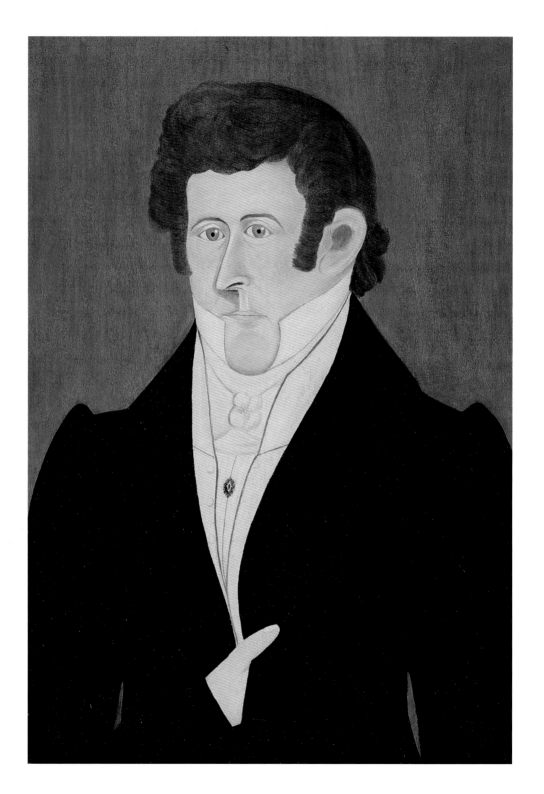

A. Ellis

Working 1820s–1830s

Mr. Tiffen of East Kingston, New Hampshire,
about 1820

Like Allston's self-portrait made a few years earlier (p. 62), this painting by A. Ellis clearly depicts a fashionably dressed gentleman of some wealth. But the similarities end there. Allston, an ambitious and cosmopolitan young painter, created a portrait of himself in order to advertise his artistic talents, his intellectual achievements, and his good taste. However, nothing is known about Mr. Tiffen — even his name and place of residence, which have been attached to this portrait for more than fifty years, may not be accurate, for no Tiffens were found in the census records of East Kingston, New Hampshire, or of any of the surrounding towns. Nor is it known why Mr. Tiffen hired Ellis to paint his portrait. Ellis, a shadowy figure, is associated with some fifteen pictures from the Waterville area of central Maine and southeastern New Hampshire. However, it is certain that, like other folk painters working in the rural United States at this time, he did not have access to the kind of rigorous art training that Allston had.

As a result, Ellis had difficulty creating a realistic depiction of a three-dimensional form. The portrait emulates high-style works like Allston's — for instance, Ellis depicted his sitter in a fashionable pose, with one hand tucked into his jacket — but since the artist used practically no shading, Mr. Tiffen looks like a collection of flat shapes rather than a real human being. Ellis also altered his vantage point from one section of the portrait to another in order to portray each of Tiffen's features in the clearest possible way. He depicted the eyes and mouth frontally but the nose and ear in profile, yielding an image of a sitter with an impossibly distorted body.

Despite this portrait's lack of realism, like many folk paintings, its expressive rhythm of line and decorative distribution of shape give it its own graphic strength. By the early nineteenth century, a tradition of such pictures had arisen in rural areas of the United States. Generations of self-taught artists created similar works for a local clientele, who associated these portraits with status in the community. Thus Mr. Tiffen would probably have appreciated Ellis's portrait of him on its own terms, as an elegant presentation of his style and character.

Oil on panel
66.36 x 47.94 cm (26 ⅛ x 18 ⅞ in.)
Gift of Edgar William and Bernice Chrysler Garbisch
69.1359

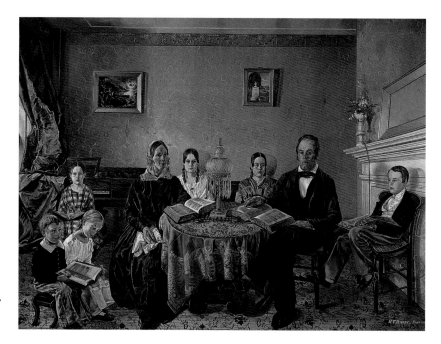

Henry Darby
1829–1897
*The Reverend John
Atwood and His Family,*
1845

Henry Darby was seventeen years old when he created this portrait of the Atwood family of New Boston, New Hampshire. Originally from Adams, Massachusetts, he boarded with the Atwoods in the summer of 1845 and may have painted this picture in exchange for food and lodging. He is not known to have had any artistic training, which makes this life-size painting all the more astonishing. The stern-faced parents and their six children are grouped naturally in the family parlor, as though the artist had come upon them during their daily prayers. The five open Bibles advertise the family's piety (Atwood was a Baptist minister, as well as state treasurer and chaplain of the state prison). The pictures on the wall — a memorial to a dead son, and a colored print by British artist James Lucas depicting Samson carrying off the gates of Gaza — further indicate their spirituality. The furnishings attest to the Atwoods' prosperity and provincial good taste, for the piano, table, and footstool are all in a version of the fashionable Empire style. At the center of the table, demon-

strating both the family's means and their interest in the latest technology, is a newly invented smokeless "solar" lamp, with its expensive cut-glass prisms.

Darby's style also reflects the latest technology, for the hyperrealism of his rendering (especially of the figures' chiseled features) probably indicates the new standards of verisimilitude inaugurated by the recent invention of photography. At the same time, although the painting's drawing and perspective are accurate, its hallucinatory quality connects it with other works of folk art. Unfortunately, Darby never again produced a work of this caliber. Between the early 1850s and his death in 1897, he worked as a portraitist, documenting the gentry of upstate New York in a competent but dull academic style.

Oil on canvas
183.2 x 244.5 cm (72⅛ x 96¼ in.)
Gift of Maxim Karolik for the M. and M. Karolik Collection
of American Paintings, 1815–1865 62.269

Susan Catherine Moore Waters
1823–1900
The Lincoln Children, 1845

Many folk artists of the eighteenth and nineteenth centuries were women (few of their names have come down to us) who created objects for domestic use — for instance, quilts, embroidered pictures, and watercolor memorials. Susan Waters, however, is unusual for having painted portraits for a living, and especially for traveling from town to town in search of commissions, a mode of working more often purchased by men.

Waters's only artistic training came during her years at a female seminary in Friendsville, Pennsylvania, which she first attended at the age of fifteen. She took up portraiture about 1843, when her husband became ill and was unable to support the family. Waters is known to have been active as an artist for only about three years, painting the local citizenry in southern New York State. In the 1840s she specialized in portraits of children, and this image of three of the twelve children of Otis Lincoln, an innkeeper from Newark Valley (near Binghamton), New York, is widely regarded as one of her finest achievements. The three little girls (Laura Eugenie, age nine; Sara, age three; and Augusta, age seven) are arranged in a pyramid. They are shown in fancy dresses, ornamented with eyelet and lace. The girls hold pieces of fruit and a book, common attributes in mid-nineteenth-century portraits of children and meant to advertise their sweetness and their attentiveness at school. The handsome furnishings (including an expensive ingrain carpet), the pretty plants on a stand, and even the charming puppy with its neatly aligned paws combine to create a pleasing image of domestic stability and comfort. The intense expressions of the children, however, give the painting a startling directness.

Shortly after finishing *The Lincoln Children,* Waters apparently retired from painting. She resurfaced about thirty years later as a painter of animals and achieved modest success with sentimental pictures of kittens and baby chicks. None of them, however, equaled the ambition and vividness of her early folk portraits, for which she is most admired today.

Oil on canvas
114.9 x 127.6 cm (45 ¼ x 50 ¼ in.)
Juliana Cheney Edwards Collection, by exchange 1981.438

William Matthew Prior

1806–1873

Three Sisters of the Copeland Family, **1854**

Prior was an exception to conventionally held notions about folk painters. He worked in a large city (Charlestown, part of Boston); he earned a handsome living as an artist, rather than making objects chiefly for his own enjoyment; and he adjusted his style according to his customer's ability to pay. His most elaborate portraits could cost as much as twenty-five dollars, but (as Prior advertised in 1831) "persons wishing for a flat picture can have a likeness without shade or shadow at one quarter the price." Such portraits — small, with plain backgrounds and little or no modeling, so that the figure appeared rather two-dimensional — were the mainstays of Prior's busy portrait practice.

It appears that Samuel Copeland, a second-hand-clothing dealer and real-estate investor from Chelsea, Massachusetts, was sufficiently affluent to pay full price for this complex and handsome portrait of his daughters. The girls — Eliza, about six years old; Nellie, about two; and Margaret, about four — wear the off-the-shoulder dresses that were fashionable in the 1850s; their necklaces and hair ribbons also indicate their father's prosperity. The book and flowers they hold indicate that they are educated, obedient, and have a pleasant demeanor. The book has a special poignancy, for despite Copeland's business acumen, he could neither read nor write.

In addition to being a skilled portrait painter, Prior was something of a political activist and prominent in abolitionist circles. He counted a number of African-Americans among his clients, including Samuel Copeland, and unlike many other images of blacks painted by artists of his day, Prior's were painted with seriousness and sympathy.

Oil on canvas

68.3 x 92.7 cm (26⅞ x 36½ in.)

Bequest of Martha C. Karolik for the M. and M. Karolik Collection of American Paintings, 1815–1865 48.467

Erastus Salisbury Field
1805–1900
The Garden of Eden,
about 1860

About 1860, after the death of his wife, Field set aside his busy portrait-painting practice in Ware, Massachusetts, and began creating religious and historical pictures. Although his brief training with Morse in New York no doubt exposed him to the conventions of high-style history painting, Field's own works in the genre were highly idiosyncratic and reflected his increasingly eccentric personality. Field's neighbors are reputed to have marveled at the extraordinary and often gargantuan pictures he created, but his work seldom found a market, and many of his canvases were found stacked against the walls of his studio — which was little more than a shack — when he died.

The Garden of Eden (which exists in two versions; the second is at the Shelburne Museum in Shelburne, Vermont) was among the first of Field's biblical subjects. Although based to some degree on paintings of the Creation story by such well-known artists as the British Romantic painter John Martin and the American Thomas Cole (see, for example, p. 73), which Field probably knew from illustrated Bibles and inexpensive engravings, Field's *Eden* also reflects his own fantasy world. His Paradise is a lush and pre-

cisely organized place. The cone-shaped mountains recede in orderly rows, New England fruit trees are matched with tropical palms, and — like a miniature Noah's ark — the animals are arrayed in pairs, with such exotic species as elephants, giraffes, and zebras coexisting amicably with their domestic brethren.

When the Museum acquired *The Garden of Eden* in 1948, it looked significantly different from the way it does now. It seemed less a depiction of the events leading to the expulsion from Paradise than an illustration of Adam naming the animals (as described in the Book of Genesis, 2.19–20), for neither Eve nor the serpent was present. Conservators discovered that they had been painted over (possibly, according to the artist's great-nephew, at the request of his prudish spinster aunt). Once the censorious overpaint was removed and the picture returned to the artist's original conception, the seeds of discord were again visible in Paradise.

Oil on canvas
88.3 x 116.5 cm (34 ¾ x 45 ⅞ in.)
Gift of Maxim Karolik for the M. and M. Karolik Collection
of American Paintings, 1815–1865 48.1027

Unidentified artist

Meditation by the Sea, early 1860s

Meditation by the Sea has fascinated scholars of folk art for its unique combination of naiveté and sophistication. As with many self-taught artists, the painting's creator derived inspiration from the popular press. The source for the composition has been identified as a wood engraving by an artist and illustrator using the pseudonym Porte-Crayon, published in *Harper's New Monthly Magazine* on September 21, 1860. The print was accompanied by "A Summer in New England," a written account of a recent visit to the "tumultuous spirit of the waters" at Gay Head on Martha's Vineyard, Massachusetts. The author of the article, David H. Strother, a Virginian and member of the Union army, was later identified as Porte-Crayon himself.

Similar to the carefully delineated curling waves in the print, the water in the painting is expressive. The artist emphasizes a sense of infinity by depicting the waves as though they are carved out of wood and gradually whittled down to a fine point toward the otherworldly rocks on the horizon. A familiarity with one-point perspective is evident in the rendering of the receding cliff, yet the artist skews the rest of the view to suggest the vastness of the space stretching into the distance. The single brooding figure in the foreground and the tiny silhouettes far in the distance endow the painting with a surreal sense of scale and mood.

Solitary figures contemplating the ocean occur frequently in works by the Hudson River landscape painters, especially those by Lane and Kensett. Such figures were a defining feature of their luminist paintings, as were pronounced horizon lines and a particular quality of light. This unknown artist probably had access to such works or may have consulted similar images in prints or drawing books. But the mood of this picture, enhanced by the expressive distortions of scale and by the idiosyncratic drawing, is unique. The immensity of the horizon, which dwarfs the figure, and the bare branch that seems to hang like the Sword of Damocles over the cliff create an impression of foreboding. *Meditation by the Sea* was probably painted near the outbreak of the Civil War (based on the date of the engraving that inspired it).

The figure's confrontation with the omnipotence of nature and of God underscores the sense of dread in contemplating the possible outcome of a devastating conflict.

Oil on canvas
34.6 x 49.9 cm
(13 ⅝ x 19 ⅝ in.)
Gift of Maxim Karolik for the M. and M. Karolik Collection of American Paintings, 1815–1865
45.892

Genre Painting

Scenes of daily life are rare in American art before 1828, when Andrew Jackson became president. Prior to this, art had served an honorific or commemorative function, preserving the likenesses of family members, celebrating the visages of heroes, and describing — usually in an idealized manner — events of historic importance. The few extant scenes of everyday life from the colonial and Federal periods tend to show events in the lives of the upper classes — for example, Henry Sargent's *Dinner Party* (p. 100), a depiction of a patrician social function.

Jackson was the first chief executive who was neither one of the nation's Founding Fathers nor from the eastern seaboard; his populist policies, his belief in a decentralized government, and the very presence in office of a Westerner from a relatively modest background signaled a shift in the centers of power in the United States. Jacksonian democracy ushered in a new respect for the rituals, practices, work, and play of the common man, whose life then became suitable for art. By the 1830s, oil paintings, illustrated books, and the brightly colored, affordable prints issued by Nathaniel Currier and other lithography firms began to feature ordinary scenes, familiar types, and charming or amusing incidents. These were more often set on a farm or in a small town than in the city and frequently presented a readily grasped moral lesson.

The first generation of genre painters — George Caleb Bingham, William Sidney Mount, Francis W. Edmonds, and James G. Clonney, among others — presented an idealized portrait of American life, rarely showing scenes of poverty or despair. These artists' presentations of rural manners were often comic (the country bumpkin besting the city slicker was a common theme), although sometimes they contained acerbic critiques of the characters depicted. Mount, Clonney, and Edmonds all worked along the eastern seaboard, and Missouri painter Bingham specialized in images of life on the frontier. Among Bingham's best-known works are a number of satirical election scenes, but most of his paintings are idyllic. A lazy day on the river was a subject he and his largely East

Coast audience preferred to any illustration of labor. His pictures seldom tell stories; rather, they present a gallery of pioneer types — sturdy and self-reliant.

Among the painters of this generation, only David Gilmour Blythe depicted the seamy side of American society. His scenes were often set in the city, and his characters were seldom appealing: his cigar-smoking, fire-setting urchins were the antithesis of the clean-cut lads who got into innocent scrapes in the work of Mount and others. Blythe's political satires were likewise searing indictments rather than amusing presentations of the foibles of political life, and his images of the Civil War — unlike the

fig. 18. **James Goodwyn Clonney,** *In the Woodshed,* 1838.

wistful scenes painted by Eastman Johnson (p. 104) and others of the next generation — were documents of inescapable misery and pain.

Although these painters' subject matter seems all-American, the origins of their themes were not. Seventeenth-century Dutch and Flemish painters had produced a wide range of genre scenes that were avidly collected by mid-century and included boisterous views of family life and comic images of the consequences of overindulgence. In the eighteenth century, French and English painters created pictures of daily life that were variously charming and sentimental, as well as sharply satirical. American painters were acquainted with these images through prints, and echoes of European prototypes are to be found in their work (see, for example, Blythe's *Libby Prison*, p. 103). Particularly popular in America were images of the confrontations between town and country dwellers, and between members of different social classes (fig. 18). As with the European paintings, the market for such images was to be found not among those depicted in them but among the socially and economically ambitious urban merchants, bankers, and lawyers, men like the prosperous New York grocer and patron of the arts Luman Reed and his partner Jonathan Sturges. For this new class of patrons, most of them self-made men, the idealized views of American life painted by Mount, Edmonds, and others provided assurance that a warm community feeling existed in the country despite the cultural and political shifts of the Jacksonian era; comic images centering on the "lower

orders" promised a stable social structure in the country despite clear signs of social change.

Genre painting flourished in America in the three decades before the Civil War. After the war, however, scenes of everyday life lost their swagger and became sentimental and nostalgic. Artists (who started going abroad in great numbers to study with French and German academic painters) began to favor the warm tones and prettified subjects of their European counterparts. Idealized re-creations of simpler times provided solace to a nation traumatized by the recent turmoil. Sweet images of children carried with them a promise for America's future — an antidote to the despair over the huge numbers of young men lost in the war. Artists such as Johnson and John George Brown (whose shoe-shine boys and other street children are always rosy cheeked and well nourished, however raggedy their clothes; fig. 19) found a ready market for genteel images of American life that neither satirized nor shocked but instead presented comfortable, reassuring subjects acceptable to the big businessmen who made up the patron class.

Contemporary with those Gilded Age artists were Winslow Homer and Thomas Eakins, arguably the greatest American painters of the late nineteenth century. Their views of daily life in America were neither consistently sunny nor small town. Homer, who in the 1870s painted charming scenes of children at play and the courting rituals of young adults, by the 1880s had moved on to images depicting the harsh lives of ordinary, yet heroic, fishermen, which he painted with epic solemnity. And Eakins, in a series of sporting pictures that focused on the recreation of the urban middle class, brought to genre painting a new sense of seriousness, specificity, and complexity.

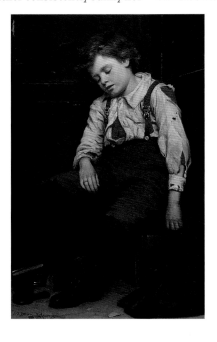

fig. 19. John George Brown, *Tuckered Out – The Shoeshine Boy*, about 1888.

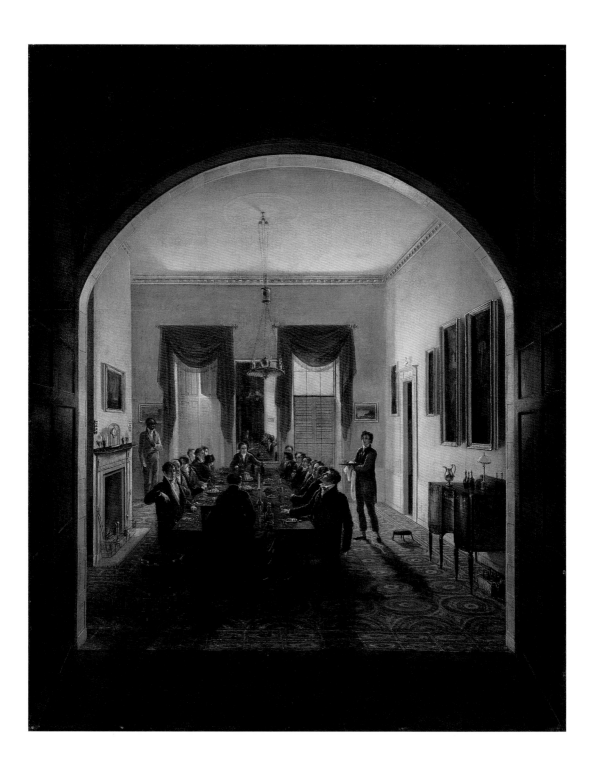

Henry Sargent
1770–1845
The Dinner Party, about 1821

Henry Sargent's painting gives us a glimpse of a fashionable dinner party in 1820s Boston. The dishes for the main course have been cleared, the tablecloth has been removed, and nuts, fruit, and wine are being offered for dessert. The single candle on the table is provided to enable the diners to light their tobacco. The shutters are drawn to keep out the sun, for during this period dinner parties were held in the middle of the afternoon. This gathering may represent a meeting of a specific group: the Wednesday Evening Club, which met weekly for dinner and discussion at members' houses. The club, which survives today, in Sargent's time consisted of four clergymen, four doctors, four lawyers, and, as is noted in a nineteenth-century history of the group, four "merchants, manufacturers or gentlemen of literature and leisure." Guests were sometimes included at the dinners, which would explain why there are more than sixteen in attendance here. Sargent, possibly the third figure on the right side of the table, was a successful politician and inventor as well as a talented painter, and he may well have belonged to the club; however, no membership records were kept at this time, so it is not certain what convivial gathering is represented here.

In addition to serving as an invaluable document of Federal Boston's social customs among the elite, the painting preserves the appearance of an upper-class interior. This elegant room was probably Sargent's own dining room at 10 Franklin Place on Tontine Crescent, the handsome row of townhouses built by the celebrated architect Charles Bulfinch. The contents of the room — the sideboard (a new form, whose curvilinear front allowed one to reach across it with ease), the expensive Wilton carpet (here protected by a green baize "crumb cloth"), paintings, a large looking glass, and a dining table large enough to accommodate many guests comfortably — conform to those recommended by Thomas Sheraton, an English designer and champion of good taste. The cellarette in the foreground, used to cool bottles of wine, was also a new form; it remained in Sargent's family and was given to the MFA by one of the artist's descendants.

Although the painting records a private event, it was created for exhibition. In the 1820s visitors willing to pay twenty-five cents could see it in a gallery operated by the drawing master David Brown at 2 Cornhill Square, Boston. Business was brisk; presumably the picture was appreciated not only by Sargent's social circle but also by those who could not afford such luxurious surroundings yet enjoyed a peek into an elite and opulent world.

Oil on canvas
156.5 x 126.4 cm (61⅝ x 49¾ in.)
Gift of Mrs. Horatio A. Lamb in memory of Mr. and Mrs. Winthrop Sargent 19.13

George Caleb Bingham

1811–1879

The Squatters, 1850

Missouri painter Bingham specialized in images of life on the Western frontier. He was self-taught, acquiring information about technique, composition, anatomy, and pose from engravings, drawings, and casts of antique sculpture he purchased on a trip east in the late 1830s. He painted many portraits, primarily of his middle-class Missouri neighbors, but his most admired works, both in his lifetime and now, are his idyllic views of boatmen on the placid Missouri River and his sharply satiric scenes of elections in small towns.

When Bingham sent *The Squatters* to the American Art-Union, an exhibition and auction house in New York City, he provided his East Coast audience with the following explanation of the picture's cast of characters:

The Squatters as a class, are not fond of the toil of agriculture, but erect their rude cabins upon those remote portions of the national domain, when the abundant game supplies their phisical [*sic*] wants. When this source of subsistence becomes diminished in consequence of increasing settlements around they usually sell out their slight improvement, with their 'preemption title' to the land, and again follow the receding footsteps of the Savage.

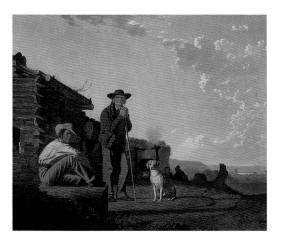

Although Bingham's description might make the squatters seem predatory, they were in fact an important part of the process of settling the West. At mid-century, these pioneers claimed new territory by "squatting" on, or occupying, it for a year or two. They would then abandon the land to a second group of settlers, who would farm it and establish communities. The squatters were admired for their independence, and to small farmers and businessmen back East they represented the allure of the frontier. In 1843 the *New York Tribune* noted that "[f]earlessness, hospitality and independent frankness, united with restless enterprise and unquenchable thirst for novelty and change are the peculiar characteristics of the Western pioneers."

Bingham's own admiration for the squatters was tempered by his political ambitions. A staunch Whig, he ran unsuccessfully for state legislature in 1846 and blamed his defeat, in part, on the squatters in his district, who consistently voted Democratic. Nonetheless, he painted them with understanding, if not sympathy. A young man, an old man, and their dog form a pyramid in the foreground — theirs is a strong and stable family unit, however footloose their lifestyle. The patriarch looks out at the viewer somewhat suspiciously, but the young man's expression is mild and open. In the background, in shadow, a woman washes clothes, and boys play near her boiling kettle. And just beyond the little rise on which the squatters have built their rude cabin is a handsome river valley, bathed in a golden light that conveys the attraction of the open spaces farther west.

Oil on canvas

58.8 x 71.8 cm (23 ⅛ x 28 ¼ in.)

Bequest of Henry Lee Shattuck in memory of the late Ralph W. Gray 1971.154

David Gilmour Blythe
1815–1865
Libby Prison, 1863

Located in Richmond, Virginia, Libby Prison was one of the most notorious Confederate prisons in operation during the Civil War. The building was originally a tobacco warehouse, constructed by local merchant Fulton Libby in 1845; by 1862, it was a filthy, vermin-infested, dank prison, housing as many as twelve hundred Union soldiers in six rooms, each no more than forty by one hundred feet. Many prisoners died there; those who survived suffered from poor health for the rest of their lives.

Blythe, a self-trained artist with a satirist's eye and a keen dramatic sense, never saw Libby Prison. He spent the war years in Pittsburgh and relied on newspaper accounts and prints of the prison for information about the setting and the prisoners' wretched lives. Some of his details are true to life — men play cards and checkers to pass the time, others wash themselves at a water trough; a soldier at center comforts a feverish friend. Other elements are broadly satirical — a man at center writes "Time" on a post, and another reads *Rip Van Winkle* (as though relief could be found in a story about a twenty-year slumber); the chaplain at center right offers sham solace to the despondent men.

Although many of his figures are crudely drawn, Blythe's use of lighting is deftly theatrical, and his rich red-and-brown color scheme intensifies the emotion of the scene. Beneath the propagandistic accu-

mulation of horrifying detail are echoes of several famous European paintings depicting related themes, which Blythe probably would have known through prints. The similarities with William Hogarth's *Bedlam* (the final scene in his epic series of paintings "The Rake's Progress," which were widely distributed in prints) and Baron Gros's *General Bonaparte Visiting the Plague-Stricken at Jaffa* (1804, Musée du Louvre; a copy of Gros's painting is in the MFA) suggest that the inhumanity of Libby Prison was not limited to the Civil War or America but was part of the larger, age-old story of man's inhumanity to man.

Oil on canvas
61.3 x 91.8 cm (24⅛ x 36⅛ in.)
Bequest of Martha C. Karolik for the M. and M. Karolik
Collection of American Paintings, 1815–1865 48.414

Eastman Johnson

1824–1906

Writing to Father, **1863**

Johnson's early career parallels that of the slightly younger Winslow Homer, with whom he was compared for much of his life. Both were initially trained as lithographers in Boston and produced their first significant works in black and white. Both went to Europe at critical points in their artistic development (Johnson studied in Düsseldorf and The Hague as well as visiting Paris). And both came to national attention with images depicting aspects of American life affected by the Civil War. Unlike Homer, however, who spent several years following the Union troops

and produced many scenes of camp life, Johnson made only two or three brief trips to the battlefield. Most of his Civil War pictures depicted slaves or centered on the home front. In the latter, the tragedy of the war was measured by the cost to the children who were left behind.

In this tiny, cozy picture, a little boy is writing laboriously. He has obviously just mastered his letters and is concentrating intently. The Union army cap placed prominently on the chair at left signals a father away at the war. The pathos of the scene is underscored by the gray cadet's uniform that the child wears, in homage to his absent father, and by the chair in which he sits, a painted fancy chair with a writing arm whose bulky proportions emphasize his smallness.

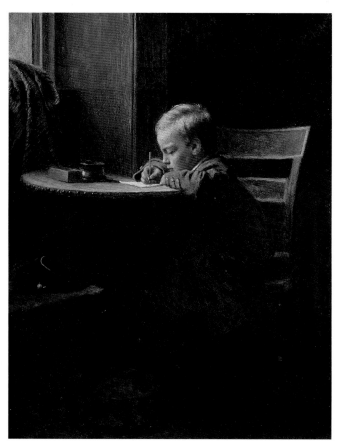

In the charcoal study for this picture (also in the Museum's collection), the child appears even younger than he does here. The image focuses more tightly on him; both the room's middle-class furnishings and the references to the conflict — the cadet's uniform and the poignantly solitary cap — were added as Johnson expanded his design. Paintings like this one, with its narrative sentimentality, found an appreciative audience in New York; on April 27, 1862, the *New York Times* described a similar picture by Johnson as "singularly beautiful."

Oil on composition board
30.5 x 23.5 cm (19 x 9¾ in.)
Bequest of Maxim Karolik 64.435

Thomas Eakins
1844–1916
Starting Out After Rail, 1874

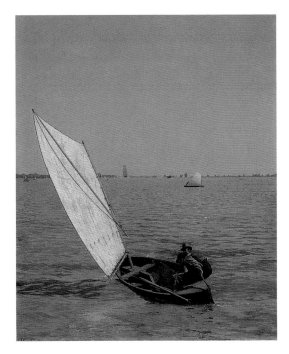

Philadelphia painter Eakins had many and varied interests, and they all found their way into his pictures. He was an eager student of anatomy, attending lectures at local medical schools even while completing his artistic training at the Pennsylvania Academy of the Fine Arts; thus Philadelphia's doctors and professors of medicine figure prominently among the subjects of his portraits. He was fascinated by perspective, optics, and stop-motion photography, and he used perspective studies and photography in planning his oils and watercolors. He enjoyed music and often painted rehearsals, home musicales, and professionals in concert. He was an avid outdoorsman, and especially in the 1870s, when his career was just beginning, he painted a number of pictures of friends and family members hunting, rowing, racing sailboats, or, as here, setting out in pursuit of rail, small game birds that were plentiful in the marshes along the Delaware River.

The sailors in this picture, Sam Helhower and Harry Young, were friends of Eakins's; their names are inscribed on the watercolor version of this painting at the Wichita Art Museum. Eakins was a highly disciplined artist and often made carefully crafted studies in one medium as preparation for a work in another. In the case of *Starting Out After Rail*, he made a perspective drawing and this oil in advance of the watercolor. The composition reflects his love of boats and his fascination with perspective. As Eakins himself said, "I know of no prettier problem in perspective than to draw a yacht sailing . . . tilted over sideways by the force of the wind." Here, the "yacht" is a Delaware ducker, a small skiff that came into widespread use in the 1870s. His perspective study enabled him to place the boat so that the viewer — presumably positioned on a wharf, for the men have just begun their expedition — can see into the boat and understand its simple construction. In his pre-

cisely realistic style, honed during years of study in France with Jean-Léon Gérôme, Eakins depicts the expressions of the sailors and their telling poses — one intent on manning the rudder, the other leaning more casually against the side of the boat — as vividly as in a close-up photograph. The bright sky and shimmering blue-brown water render the scene even more immediate.

Eakins clearly thought highly of this image, for he sent the oil to Gérôme in Paris so that the French artist could gauge his progress. The watercolor was the first picture he submitted to the American Water Color Society's annual shows. Although praised for its originality, the watercolor did not sell; later, Eakins reportedly traded it for a boat.

Oil on canvas mounted on Masonite
61.6 x 50.5 cm (24¾ x 19⅞ in.)
The Hayden Collection. Charles Henry Hayden Fund
35.1953

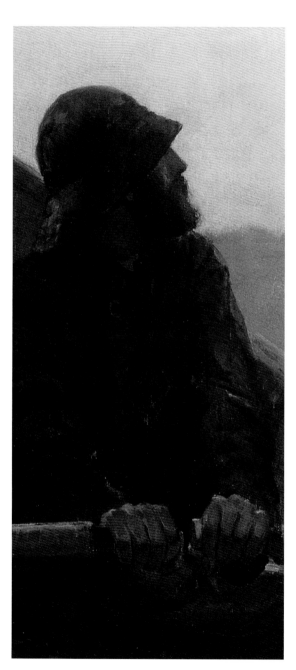

Winslow Homer
1836–1910
The Fog Warning, 1885

Homer made his reputation in the 1860s with
images of the Union troops during the Civil War
and of the returning veterans afterward. In the
late 1860s and 1870s, he turned to lighter subjects
and found an equally enthusiastic audience for
his paintings of healthy, handsome children play-
ing in the country (see fig. 2, p. 12) or at the
seashore and of adults enjoying leisure-time pur-
suits. However, perhaps feeling the need for
greater seriousness in his art, Homer spent a year
during 1881 and 1882 in Cullercoats, England.
Both a fishing village and an artists' colony,
Cullercoats provided Homer with new, more pro-
found themes: the arduous lives of fishermen and
their families. Shortly after returning to the
United States in late 1882, he settled in Prout's
Neck, Maine — similarly both a fishing community
and a pleasant summer resort — where he painted
the local population and their work. *The Fog
Warning* is one of three paintings he produced at
Prout's Neck in 1885 describing the lives of the
North Atlantic fishermen.

Like many of Homer's 1870s images featuring
farm children, *The Fog Warning* is a narrative pic-
ture. However, its story is disturbing rather than
charming. As the halibut in his dory indicates, the
fisherman in this picture has been successful. But
the hardest task of the day, the return to the main
ship, is still ahead of him. He turns to look at the
horizon, measuring the distance to the mother
ship — and to safety. The seas are choppy, and the
dory rocks high on the waves, making it clear that
the journey home will require considerable physi-
cal effort. But more threatening is the approach-
ing fog bank, whose streamers echo — even mock —
the fisherman's profile. Contemporary descrip-
tions of the fishing industry in New England make

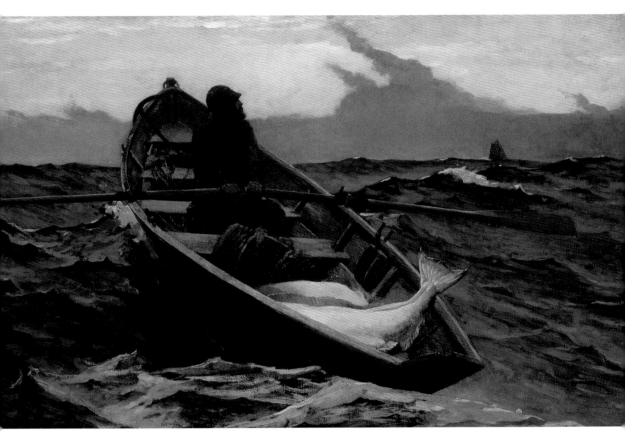

clear that the protagonist's plight — the danger of losing sight of his vessel — was all too familiar. The dramatic tension of *Fog Warning* is all the greater because Homer does not specify the fisherman's fate. However, Homer's *Lost on the Grand Banks*, another painting in the series, shows that fishermen's peril was deadly. An account from the 1876 history *The Fisheries of Gloucester*, about the insidious horrors to which fishermen were prey, could well have served as a description of *Fog Warning*: "His frail boat rides like a shell upon the surface of the sea . . . a moment of carelessness or inattention, or a slight miscalculation, may cost him his life. And a greater foe than carelessness lies in wait for its prey. The stealthy fog enwraps him in its folds, blinds his vision, cuts off all marks to guide his course, and leaves him afloat in a measureless void."

Oil on canvas
76.8 x 123.2 cm (30 ¼ x 42 ½ in.)
Otis Norcross Fund 94.72

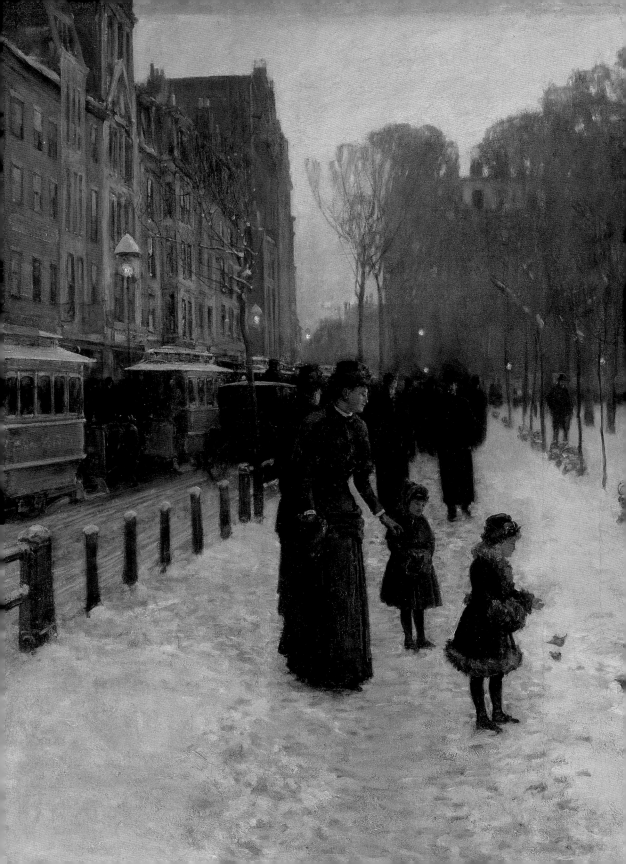

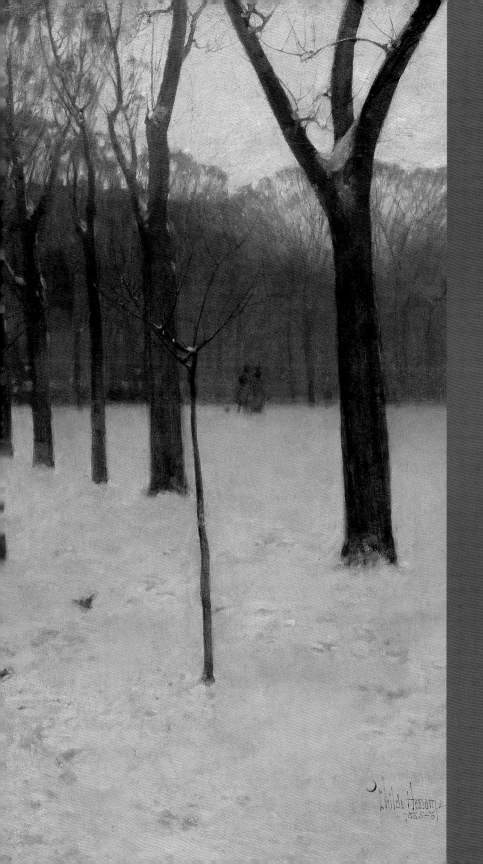

From the Civil War to the Turn of the Century:
Americans at Home and Abroad

Nineteenth-Century Still-Life Painting

Still-life painting had a slow start in the United States. Beginning in the colonial era, small still lifes were often included in portraits (see p. 38), but there are almost no examples of still lifes as independent works of art until after 1800. In Philadelphia Charles Willson Peale, who was particularly interested in science, optics, and illusion, painted an unusual life-size portrait of two of his sons climbing a staircase (1795, Philadelphia Museum of Art). He extended his canvas by setting it into a real doorway above an actual wooden staircase, and he painted a ticket to his own museum on one of the steps in the image. This inventive painting, meant to deceive the viewer, marks the beginning of the trompe l'oeil (fool the eye) tradition in the United States — a style that would become popular for still lifes. Raphaelle Peale, one of the boys represented in that portrait, became one of the few American artists to specialize in still life during the first half of the nineteenth century. However, there was yet little demand for still life from American collectors, who were more interested in portraits and landscapes.

American still-life painting drew on European prototypes. As had their predecessors, American artists painted still lifes of fruit and other comestibles, flowers, fish and game, arrangements of manmade objects, and, rarely, *vanitas* pictures (paintings meant to convey the fragility of life and the inevitability of death). Trompe l'oeil paintings were particularly well liked, for a wide audience appreciated an artist's skill at so faithful a reproduction of the material world that the viewer was deceived by the illusion. In the standard European hierarchy of painting genres, still life was the least respected because it entailed the transcription of humble objects that did not move. However, by the mid-nineteenth century, such attitudes began to change.

The celebration of popular culture during the Jacksonian era affected the status of still-life painting. An expansion in public education, the publishing of periodicals, exhibitions of art, and the development of art organizations

followed the election of Jackson in 1828. The displays and lotteries of the American Art-Union from 1839 to 1851, for instance, served to educate the public and to distribute art throughout the United States. Artists welcomed the increased sponsorship, and Americans saw more kinds of painting, including still life.

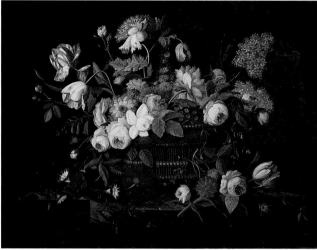

Among the artists who benefited from the American Art-Union was Severin Roesen, an accomplished German flower and fruit painter who arrived in the United States in 1848. Roesen's large, lush pictures of abundant fruits and flowers appealed to patrons celebrating the richness and agricultural prosperity of the New World (see fig. 20). Roesen's success influenced several artists to specialize in still life, and, like Roesen, they began to choose bigger canvases, giving still-life painting a more commanding presence.

fig. 20. **Severin Roesen,** *Still Life— Flowers in a Basket,* 1850s.

Two Englishmen — art critic John Ruskin and scientist Charles Darwin — also influenced American still life. Inspired by Ruskin's writings and theories, many painters began to study directly from nature instead of fabricating scenes in their studios. Still lifes became more natural, and floral elements or fruit were often depicted in an outdoor setting rather than on tabletops (see fig. 21). Darwin, whose 1859 *On the Origin of Species* and subsequent publications focused attention on evolution and on the interactions between flora and fauna, led some artists to examine and record nature more scientifically.

In the 1860s middle-class citizens were urged by Catharine Beecher, Harriet Beecher Stowe, and other advocates of domestic science to decorate their homes with paintings and prints. Firms such as Currier and Ives produced inexpensive lithographs, which allowed even citizens of modest income to adorn their rooms. Louis Prang, a leading producer of chromolithographs, actually called still lifes of food "dining-room pictures." In Europe interest in the great French eighteenth-century still-life master Jean-Siméon Chardin was revived, and American artists who were studying in Paris after the Civil War became aware of Chardin's work and his influence on French artists, critics, and patrons. An increased respect for still-life painting in general crossed the Atlantic with returning American artists and collectors, and by the 1870s art schools in Philadelphia and New York had begun to offer instruction in still life.

Under the influence of the international Aesthetic Movement, which stressed the moral power of beauty and emphasized harmonious arrangements of paintings, furnishings, and objects in carefully designed interiors, still life became part of an integrated decorative scheme for very wealthy patrons. These interiors and the handcrafted objects within them provided a respite from the unpleasant aspects of an increasingly industrial age. Even if a collector could not afford an entire room designed by an artist, a single painting could represent symbolic values. Flower painting became one of the most widespread forms of still life, perhaps because of the profusion of books on flower symbolism that were published in the United States as early as 1829. Specific meanings were assigned to individual species, and lovers could express their sentiments using the language of flowers. These fashionable volumes, together with the growth in the number of florists, may account for the popularity of painted floral bouquets. Flower painting also derived from the tradition of botanical books, whose detailed illustrations were often used as decoration.

Although such compositions attracted many women collectors and artists, there was also a masculine interest in still life. By the last quarter of the nineteenth century, the Industrial Revolution and the material needs of the Civil War had produced a class of successful businessmen who had both the means to buy paintings and the offices in which to display them. Trompe l'oeil painters such as William Michael Harnett, John Frederick Peto, and John Haberle appealed to these merchants. Although trompe l'oeil painting had roots in seventeenth-century Holland — another Protestant republic where commerce and mercantilism were paramount and technical ingenuity was admired — it had become far more prevalent in the United States than in Europe. In addition to dead game, Harnett and others depicted manmade objects — books, pipes, musical instruments, writing paraphernalia, and money — with convincing realism. Many of these works were considered amusements and were seen more often in barrooms and shop windows than in fine art exhibitions.

fig. 21. **Worthington Whittredge,** *Apples,* 1867.

John La Farge
1835–1910
Vase of Flowers, 1864

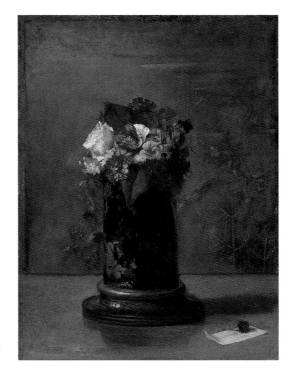

Best known for his major projects in mural painting and stained glass, particularly the interior design of Trinity Church in Boston, John La Farge also painted an important series of floral still lifes in oil in the 1860s. La Farge grew up in a cosmopolitan, French-speaking household and in 1856 toured the museums of Europe, spending a few weeks working in Thomas Couture's studio. He decided to become an artist in 1859 and studied with William Morris Hunt in Newport, Rhode Island. Over the next decade La Farge painted lyrical still lifes of flowers in vases, hanging wreaths, and water lilies and other flowers in their natural settings. His still lifes are poetic and generalized rather than botanically accurate, evoking a mood and expressing emotion. Through his own success and that of his pupils, as well as other artists who were influenced by his work, La Farge was largely responsible for the development of the poetic flower composition in American still-life painting.

Vase of Flowers is one of the most ambiguous and mysterious of La Farge's floral paintings. A vase of roses, geraniums, and other pink and red flowers is set off center on a tabletop in a shallow space. The background may be a Japanese screen or an open window, as in many of the artist's early still lifes. It has been suggested that the vase may be a *pi t'ung*, a Chinese porcelain vessel that held the brushes of artists and calligraphers, thus accounting for its distinctive shape. An early collector of Japanese prints, La Farge also had a large collection of Chinese and Japanese ceramics. In addition, his wife was the great-niece of Commodore Matthew Perry, who had opened Japan to Western trade in 1854.

La Farge's use of a gilded panel for this painting, as well as his atypical inclusion of a calling card with the date and his signature in the lower right corner, may indicate that *Vase of Flowers* was painted as a demonstration piece in the hope of obtaining a com-

mission from architect Henry Van Brunt for decorative panels. La Farge did, in fact, receive the commission and completed three of six panels intended for the dining room of a townhouse that Van Brunt was designing. However, La Farge fell ill and was forced to give up the project.

Later La Farge painted glowing still lifes of flowers in watercolor and created floral stained glass windows. These jewel-like panels of opalescent glass, for which he received a patent in 1880, graced the mansions of such wealthy patrons as Cornelius Vanderbilt.

Oil on gilded panel
47 x 35.6 cm (18 ½ x 14 in.)
Gift of Misses Louisa W. and Marian R. Case 20.1873

Charles Caryl Coleman

1840–1928

Still Life with Azaleas and Apple Blossoms, 1878

Still Life with Azaleas and Apple Blossoms demonstrates the influence of the Aesthetic Movement on American painting and decorative arts. The movement originated in Britain in the 1870s and 1880s as a reaction against the Industrial Revolution and mass production. It was characterized by a belief in the spiritual and moral power of beauty and by a desire to improve the quality of everyday life through handsome and well-made furnishings and decorations. Like John La Farge, Thomas Dewing, James Abbott McNeill Whistler, and other exponents of the Aesthetic Movement, Charles Caryl Coleman strove for beauty in the line, color, and arrangement of the objects in his painting. The overall patterning of his composition, his incorporation of exotic traditions, and the manner in which Coleman planned his painting to harmonize with its frame and the room around it demonstrate his sympathy with the movement.

An expatriate who lived in Italy for more than fifty years, Coleman was renowned for his beautiful studio in Rome, where he lived until the mid-1880s, and his Villa Narcissus in Capri, where he stayed for the remainder of his life. Both were sumptuously decorated with tapestries, classical antiquities, and ornamental objects from various cultures. The English painter Walter Crane described Coleman's Roman studio as "the most gorgeous studio of bric-a-brac of any." Coleman's interest in the decorative is nowhere more apparent than in the series of large-scale still-life panels he painted in the late 1870s and 1880s.

In his still-life paintings, Coleman often mixed objects from many cultures — Persian fabrics, Turkish carpets, Venetian vases, and Japanese fans, many from his own collection. In the Museum's painting, however, he was inspired both in his composition and his choice of objects by the contemporary fashion for Japanese art. Coleman chose a tall, narrow canvas to suggest a Japanese hanging scroll or the panel of a screen. He painted apple blossoms in a yellow vase intertwined with azaleas in a lustrous Japanese bronze repoussé pot, against a background of kimono fabric. Even Coleman's initials in monogram in the lower right and the inscriptions "1878" and "Roma" in the gold-leaf rectangular cartouches on the lower left recall the seals often found on Japanese scrolls.

Like Whistler, whose famous Peacock Room (Freer Gallery, Washington, D.C.) of 1876–77 epitomized Aestheticism, Coleman thought of his panel as an integral part of the decorative scheme for an entire room. This intention is clear from a sketch on the stretcher (the wooden framework supporting the canvas) indicating the position of this painting on a wall and an accompanying penciled note that reads "From Drawing Room facing fire, right of glass." He was evidently pleased with *Still Life with Azaleas and Apple Blossoms,* for in 1879 he made a near copy that is in a private collection.

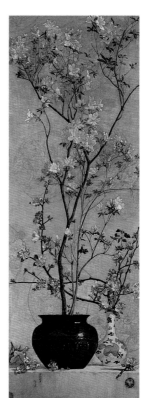

Oil on canvas
180.3 x 62.9 cm
(71 x 24¾ in.)
Charles H. Bayley Picture and Painting Fund, Paintings Department Special Fund, American Paintings Deaccession Fund, and Museum purchase with funds donated by William R. Elfers Fund, an anonymous donor, Mr. and Mrs. E. Lee Perry, Jeanne G. and Stokley P. Towles, Mr. Robert M. Rosenberg and Ms. Victoria DiStefano, Mr. and Mrs. John Lastavica, and Gift of Dr. Fritz B. Talbot and Gift of Mrs. Charles Gaston Smith's Group, by exchange 2001.255

Martin Johnson Heade

1819–1904

Passion Flowers and Hummingbirds, about 1870–83

Whereas La Farge's flowers are often generalized, Heade's are clearly identifiable. During a career that spanned almost seventy years, Heade, an ardent naturalist and traveler, painted a great variety of subjects: portraits, luminous salt marsh scenes, seascapes (often with thunderstorms, for example, p. 79), tropical landscapes, hummingbird and orchid pictures, and floral still lifes. Heade had been fascinated by hummingbirds since his childhood, and starting in 1863 he spent six months in Brazil with the intention of publishing a book illustrating hummingbirds — known as the gems of Brazil — in their natural habitat. Although the book was never published, the artist did complete some forty-five small paintings of hummingbirds. After two trips to Central America, in 1866 and 1870, Heade began a distinctive group of works combining hummingbirds and tropical flowers. These paintings were informed by a worldview recently revolutionized by Darwin. While supporting his theories about evolution in *The Effects of Cross and Self Fertilisation in the Vegetable Kingdom* (1876), Darwin specifically mentioned the adaptation of hummingbird beaks to fertilize passionflowers.

In *Passion Flowers and Hummingbirds,* Heade depicted two snowcap hummingbirds, small black-and-white birds found in Panama, and the most brilliantly colored species of passionflower, *Passiflora*

racemosa, in a steamy, lush jungle setting. The passionflower is so named because missionaries saw correspondences between the parts of the flower and the Passion (or sufferings) of Christ. For example, the ten petals represent the ten apostles present at the Crucifixion, the corona filaments resemble the crown of thorns, and the three stigmas relate to the nails. In this work, Heade successfully combined his scientific interests and his aesthetic sensitivity. He rendered the birds and the passionflowers accurately in a close-up view but also gracefully composed the winding stems across the surface of the picture and contrasted the cool greens and grays with the dazzling red of the flowers.

Heade painted more than 150 still lifes of Victorian vases with flowers, magnolia blossoms on velvet-covered tabletops, and exotic orchids and passionflowers growing in the jungle. One of his tabletop still lifes, *Flowers of Hope* (1870, location unknown), was the source of a chromolithograph by Louis Prang and was distributed widely through this medium. His still lifes of flowers in vases were also extensively exhibited during the late 1860s and 1870s. Although Heade was one of the first to reflect Darwin's theories in his paintings of flowers in their natural habitats, other artists were also affected by Darwin's view of the vitality of plants and the interaction of plants with their environment.

Oil on canvas
39 x 54.9 cm (15 ½ x 21⅝ in.)
Gift of Maxim Karolik for the M. and M. Karolik Collection of American Paintings, 1815–1865 47.1138

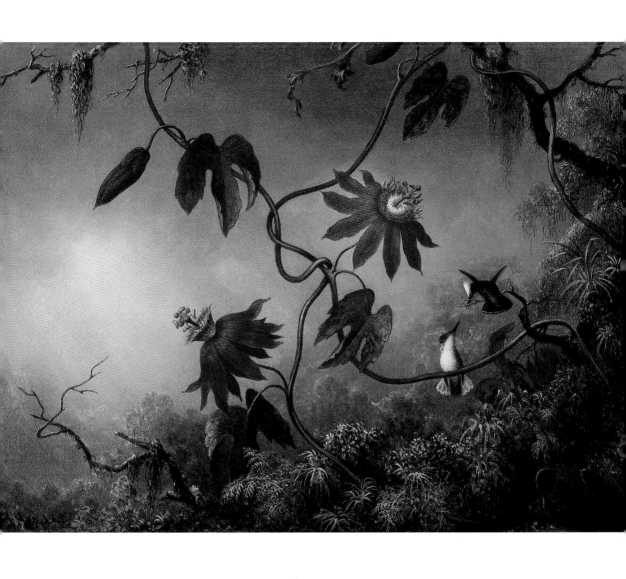

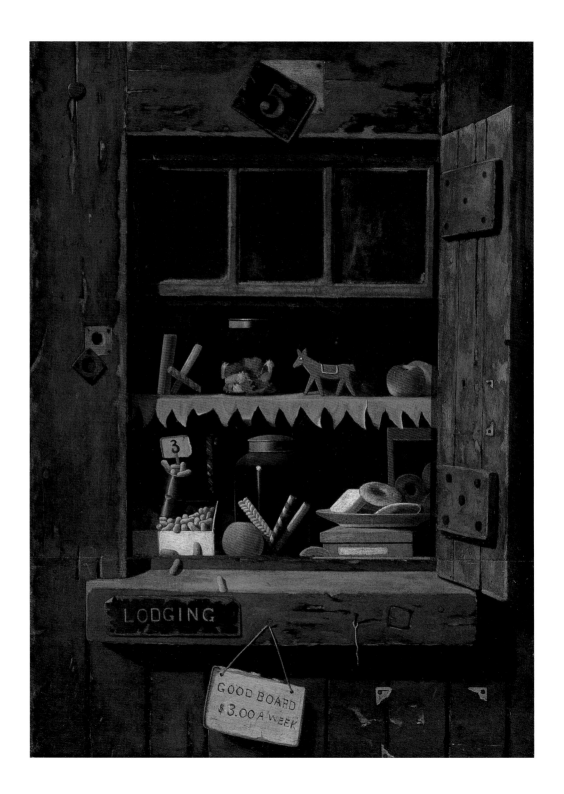

John Frederick Peto
1854–1907
The Poor Man's Store, 1885

Peto's painting of a shabby but colorful storefront window belongs to the school of trompe l'oeil paintings associated with William Michael Harnett. It is an early masterpiece in a career that stretched from 1877, when Peto enrolled for a year at the Pennsylvania Academy of the Fine Arts, until his death thirty years later. While living in Philadelphia, Peto became friendly with Harnett and borrowed many of his subjects and compositional devices, although he worked in his own distinct, more painterly style. The canvas of *The Poor Man's Store* depicts brightly colored candies, peanuts, gingerbread, and fruit for sale. It is surrounded by a wooden frame illusionistically painted to simulate a door, shelf, and wall.

Such shop windows were characteristic of Philadelphia during the nineteenth century. In 1880 a contemporary reviewer described one of Peto's earlier paintings of the same subject in the *Philadelphia Record*:

[It] cleverly illustrates a familiar phase of our street life, and presents upon canvas one of the most prominent of Philadelphia's distinctive features. A rough, ill-constructed board shelf holds the "Poor Man's Store" — a half dozen rosy-cheeked apples, some antique gingerbread, a few jars of cheap confectionery "Gibraltars" and the like, and, to give all a proper finish and lend naturalness to the decorative surroundings of the goods, a copy of *The Record* has been spread beneath.

It was not unusual for Peto to paint several versions of a theme, and this description suggests that the Museum's picture is similar to the painting described except for the presence of the newspaper in the earlier work. Here the newspaper has been replaced by signs advertising "lodging" and "good board $3.00 a week." The hanging metal number plate above the window, the piece of string, and the torn remains of notices were some of Peto's favorite devices, each one painted to add to the illusionistic effect.

Peto's penchant for portraying humble, derelict objects in disordered arrangements may account for his lack of wealthy patrons during his lifetime. In 1891 he moved to Island Heights, New Jersey, where he was largely forgotten by the Philadelphia art world. In the early twentieth century an unscrupulous art dealer forged Harnett's name on many of Peto's works in order to sell them more readily. It was not until the mid-twentieth century that the paintings were reattributed and that Peto began to be appreciated as one of the preeminent still-life painters of the late nineteenth century. His work is generally darker and more melancholy than Harnett's and often reflects both his own unhappy family life and the nation's grief following the Civil War and the assassination of Abraham Lincoln, whose image he frequently included in his paintings.

Oil on canvas and panel
90.2 x 65.1 cm (35 ½ x 25 ⅝ in.)
Gift of Maxim Karolik for the M. and M. Karolik Collection of American Paintings, 1815–1865 62.278

Levi Wells Prentice

1851–1935

Apples in a Tin Pail, 1892

Fruit continued to be a frequent theme of still-life paintings throughout the nineteenth century, despite the growing popularity of floral paintings. De Scott Evans, Joseph Decker, William John McCloskey, and Levi Wells Prentice all painted fruit in a hard-edged or trompe l'oeil style during the last decades of the nineteenth century. Almost entirely self-taught, Prentice began his career in 1871 as a landscape painter in the Adirondack Mountains of New York State. It was not until he moved to Brooklyn in 1883 that he began to paint still lifes, usually of fruit, although occasionally of flowers and fish too. Prentice supplemented his income by designing furniture, building houses, making frames, and creating stained-glass windows.

He also made his own palettes, brushes, easels, frames, and shadow boxes.

Prentice made painting apples something of a specialty, depicting the fruit in no fewer than forty pictures. In the 1840s the Boston writer-philosopher Ralph Waldo Emerson declared the apple America's "national fruit." An integral part of the American diet for four centuries, apples have traditionally been used in pies, jellies, sauces, and cakes, eaten plain or baked, and made into cider — especially hard cider, a staple in the nineteenth century. Prentice's paintings of apples depict the fruit variously spilling out of baskets, bags, and hats placed on the ground or on a tabletop, growing on boughs, or loosely resting on the ground. The Museum's picture, his best-known still life, shows apples in a tin pail, on a rough table, and in a bowl. Bruised and blemished, the apples are undoubtedly to be used for cooking or for cider. Although the subject matter of the painting is humble, Prentice's technique is meticulous. He portrayed each apple with hard-edged realism and painstakingly conveyed the reflections of the apples and the bowl in the curved, gleaming surface of the tin pail. A striking composition of rounded forms in vibrant colors, Prentice's painting celebrates a rich harvest in rural America.

Oil on canvas
41.3 x 33.7 cm (16 ¼ x 13 ¼ in.)
The Hayden Collection. Charles Henry Hayden Fund
1978.468

William Michael Harnett
Born Ireland, 1848–1892
Old Models, 1892

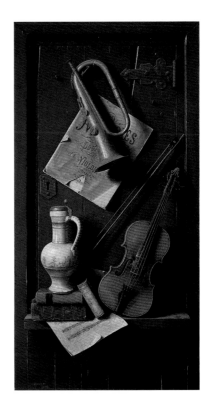

To late-nineteenth-century viewers in an age of industrialization and progress, Harnett's *Old Models* was a nostalgic tribute to the unhurried cultural pursuits of a bygone era. Harnett, the talented leader of the group of illusionistic still-life painters that included Peto and John Haberle, trained initially as a silverware engraver, which undoubtedly shaped his later, precise style of painting. He then studied at the Pennsylvania Academy and the Cooper Union before spending six years working in Munich and, for a short time, Paris. In Europe, Harnett examined the work of seventeenth-century Dutch painters.

Old Models is one of Harnett's best compositions, representative of his trompe l'oeil style and his subject matter. Harnett created the painting for display in the 1893 World's Columbian Exposition, a great world's fair that was held in Chicago. To draw attention to his painting, he selected a large, vertical canvas and composed a monumental still life painted with brilliant technical virtuosity. Instruments, sheet music, and books — emblems of civilized leisure activities — are bathed in a golden light evoking such Old Masters as Rembrandt.

An amateur flute player, Harnett owned a collection of musical instruments that he frequently used as props. The violin, realistically covered with rosin dust, was described in his estate sale as "Cremona Violin . . . 'Joseph Guarnerius, fecit. Cremona, anno 1724' . . . procured by Mr. Harnett at a great cost from a celebrated collection in Paris." Although it was probably not a genuine Guarneri, the violin, as well as the other objects, appealed to nineteenth-century patrons fond of collecting antiques and bric-a-brac. The keyed bugle, dented and tarnished, was a simplified version of the instrument portrayed in several earlier works. Behind the bugle, Harnett included a tattered copy of *50 Mélodies pour violon*; the sheet music hanging over the shelf is Thomas Moore's

"'Tis the Last Rose of Summer," a sentimental Irish ballad that evokes Harnett's country of birth and perhaps alludes to the ill health that had dogged him in the preceding three years. Harnett also included Shakespeare's *Tragedies*, Homer's *Odyssey*, and a seventeenth-century medical reference book, all of which may also allude to the trials of his illness. The dusty, worn, and dilapidated objects are "old" in two senses: they bear signs of the passage of time, and they were used as props in Harnett's previous paintings. Likewise, they are "models" in that they are both subjects for artistic representation and exemplars of a contemplative and musical life. *Old Models* turned out to be Harnett's valedictory painting; he died of kidney disease in 1892 at the age of forty-four. Although it was never exhibited in Chicago, *Old Models* was shown posthumously at the Saint Louis Exposition of 1896.

Oil on canvas
138.1 x 71.8 cm (54 3/8 x 28 1/4 in.)
The Hayden Collection. Charles Henry Hayden Fund 39.761

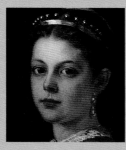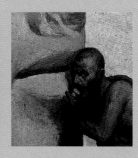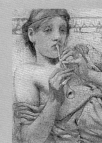

Painting after the Civil War

The story of American art after the Civil War is a complex tale of satisfaction and desire. Citizens of the United States were proud of their native vitality, freedom, and confidence and attempted to define American culture based on qualities they felt were distinct to the New World. At the same time, many longed for a cosmopolitan sophistication, hoping to overcome a provincial reputation and to compete as equals on the international stage. Some painters sought to renounce "foreign" influences, and others preferred to embrace them. Whether accepted, rejected, or some combination of both, the traditions and innovations of European art haunted American painters.

In 1867 a large international exposition was held in Paris. The U.S. delegation sought to prove to the world that the country had recovered from the Civil War and that its government and industry were stable and productive. Along with great mechanical inventions like the Corliss engine and the McCormick reaper, about seventy-five paintings were shipped to Paris to represent America's artistic achievement. Many were landscapes by such artists as Church and Bierstadt, painters who had dominated American art during the mid-nineteenth century. Although the American industrial and scientific exhibits were lavishly praised, the art display was a failure, "proving," as the New York critic James Jackson Jarves remarked, "our actual mediocrity" in comparison with Europe. For the rest of the century, American painters sought to renew their national pride and to redefine American art.

Part of this process involved familiarity with what Europe had to offer, a task made easier and less expensive by recent advancements in transportation and communications. Record numbers of aspiring American painters traveled to Paris, capital of the Western art world, to enhance their artistic education. They enrolled in art schools, studied examples of the great art of the past at the Louvre (fig. 22), and visited other prominent collections throughout Europe. They also attended exhibitions of contemporary art, most often the annual Salon

exhibitions sponsored by the French Academy, where they could measure their own achievements against artists from around the world. Some, including John White Alexander, Mary Stevenson Cassatt, Charles Caryl Coleman, Frederick Carl Frieseke, John Singer Sargent, Elihu Vedder, and James Abbott McNeill Whistler, spent significant portions of their careers abroad. In 1887 the novelist Henry James remarked that "it sounds like a paradox, but it is a very simple truth, that when to-day we look for 'American art' we find it mainly in Paris. When we find it out of Paris, we at least find a great deal of Paris in it."

American artists often put their lessons to work at home, helping to bring aspects of European culture to the United States. "I hardly know what will take [the] place of my weekly visit to the Louvre," wrote one painter in 1885, "perhaps patriotism." Certainly pride in their country's artistic potential helped to motivate some of America's prominent painters to become teachers, thereby sharing their sophisticated European training with their compatriots at the many new American art schools across the country. Other artists advised collectors on their purchases, bringing great examples of art of all kinds to the United States. A number also helped to found encyclopedic museums (including the Museum of Fine Arts in Boston [fig. 23] and the Metropolitan Museum of Art in New York) that would make such cultural treasures widely available to America's residents. They also decorated libraries, courthouses, and state capitols with ornamental paintings that created artistic palaces for the people.

These enterprises were also motivated by a hunger to make art more integral to life in the United States. Influenced by English efforts to enhance the quality of industry through training in the fine arts, Americans began to accept an increasingly public and educational role for paintings and sculpture. Art, once viewed with suspicion as a sensuous and superfluous trifle, became fashionable and gained status as a power for moral and spiritual good. It was regarded as a civilizing force, which through nostalgia and elevated subject matter, or simply by its beauty, could help heal the wounds of both the recent war and the more offensive aspects of the industrial age. Many thought the arts could also serve to unite immigrants from an increasing variety of countries behind common truths.

fig. 22. Winslow Homer, *Art Students and Copyists in the Louvre Gallery, Paris*, 1868, wood engraving.

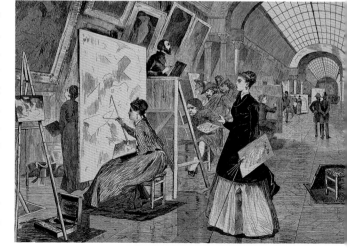

fig. 23. **Museum of Fine Arts, Boston, Copley Square, about 1895.**

Despite a desire to create some sort of national style, there was continuous debate about what was appropriate and what was American about American art. Some artists, including Eakins and Harnett, preferred tightly finished, realistic techniques, whereas others, from Homer to William Merritt Chase, devoted themselves to more freely brushed studies of light and atmosphere. Artists during this period not only differed from one another stylistically but also selected a wide range of subjects. Portraits, genre scenes, still lifes, and landscapes remained popular. Allegories intended to represent abstract concepts of virtue, like Abbott Henderson Thayer's *Caritas* (p. 133), appealed to many artists and patrons. In Boston, where the American publishing industry had been headquartered, the interest in literary and imaginative compositions that had begun with Allston continued in collectors' enthusiasm for work by such artists as Vedder and William Rimmer.

The paintings produced during this period are distinguished chiefly by their variety, a quality that also characterizes them as American. Artists of the late nineteenth century found their sources in many countries, from Japan to Italy to France to the Near East. Americans "can deal freely with forms of civilization not our own, [we] can pick and choose and assimilate and . . . claim our property wherever we find it," wrote Henry James. This "vast intellectual fusion and synthesis of various National tendencies of the world," he added, "is the condition of more important achievements than any we have seen."

Elihu Vedder

1836–1923

The Questioner of the Sphinx, **1863**

Vedder first studied art in his native New York but traveled to Europe in 1856, enhancing his education in both Italy and France and beginning a lifelong engagement with European art and literature. He eventually established his studio in Rome and lived as an expatriate in Italy for more than sixty years. A poet and writer as well as a painter, Vedder had been fascinated from the beginning of his career with ancient myths and fantastic tales. He developed a particularly strong following in Boston, which had cultivated a taste for Romantic, literary paintings. *The Questioner of the Sphinx* was exhibited in New York in 1863 and was purchased immediately by Martin Brimmer, a Boston collector, for five hundred dollars.

Vedder, then in his twenties, had not yet visited Egypt when he painted his mysterious *Questioner of the Sphinx.* Depictions of the Great Sphinx at Giza, however, had appeared in a number of travel books by the mid-nineteenth century, when the popular taste for imagery of the Near East was increasing. Vedder seems to have used such an illustration as a source. However, the subject of an Arab wayfarer questioning the mysterious monument came from Vedder's fertile imagination, although it does recall the ancient Greek myth of the sphinx that guarded the road to Thebes by posing riddles to passing travelers. Vedder's pilgrim, dressed in ragged robes, appears to have made a long and difficult journey through an inhospitable wilderness in the hope of hearing a great truth from the implacable statue. His success is uncertain, for the skull of another questioner lies in the foreground, a mute witness to the occasion. Broken columns, remnants of human activity, lie strewn in ruins, almost buried by the shifting sands. Vedder wrote that in this painting, he sought to portray the hopelessness of man before the laws of nature; to the modern viewer, it also resonates with the uncertainty that accompanied the Civil War. Vedder continued to be haunted by this subject, and he produced a number of other images of the sphinx over the course of his long career.

Oil on canvas
92.1 x 107.3 cm (36 ¼ x 42 ¼ in.)
Bequest of Mrs. Martin Brimmer 06.2430

William Morris Hunt

1824–1879

Olivia Buckminster Lothrop (Mrs. Lewis William Tappan, Jr.), mid-1860s

Hunt was mid-nineteenth-century Boston's leading painter. He was highly admired for his work, his teaching, and the astute advice about purchases he gave to the city's collectors. Born in Vermont, he attended Harvard University and in 1843 joined his family on an extended trip to Europe. Cosmopolitan by nature, Hunt traveled for a number of years, studying art in Italy, Germany, and France. He worked with the French Realist painter Thomas Couture, whom he especially admired for his method of painting directly on the canvas, without careful preparations in pencil. Hunt brought the same spontaneity to his own art, preferring to capture nuances of light and atmosphere without finicky detail. He exhibited at the Paris Salon in the 1850s and became a close friend of Jean-François Millet, the leading painter of the French Barbizon School, who made heroic images of peasant life. The two artists worked together, and when Hunt returned to the United States in 1855, he encouraged Bostonians to buy Millet's work. He also reinterpreted Millet's rural subjects with an American vocabulary, using the rustic landscapes of Newport, Rhode Island, and Gloucester, Massachusetts, as Millet had employed the fields of Barbizon.

Hunt also brought French sophistication to his many images of well-to-do Bostonians. Portraiture remained an important source of income for most American painters after the Civil War, and portraits by well-known artists continued to serve as status symbols in American society. Olivia Lothrop was in her twenties when she sat for this painting. The daughter of Samuel Kirkland Lothrop, Unitarian minister of the Brattle Street Church in Cambridge, Massachusetts, and his first wife, Mary Lyman Buckminster Lothrop, Olivia was raised in an intellectual and spiritual household. In 1870 she married Lewis W. Tappan, a Harvard graduate and grandson of the famous abolitionist Lewis Tappan. Tappan, who had served as U.S. consul to Java during the 1860s, was a businessman and philanthropist with an estate in Milton, Massachusetts; the couple had three children but lost two before Olivia herself died in 1878 at the age of thirty-seven.

For her portrait, Lothrop stood demurely before a neutral background in a stylish copper silk dress. The dark setting and subtle colors help to focus attention on the sitter and are typical of Hunt's sophisticated approach to portraiture. He selected an elegant stance for his model, turning her to the side to feature the fashionable contour of her corseted waist and full skirt. Such poses were popular with aristocratic sitters in European capitals and followed the example of Franz Xavier Winterhalter, court painter of the French Second Empire. In Hunt's portrait, Lothrop turns her head to face the viewer, and her serious expression, combined with her golden tiara, gives the effect of royalty.

Oil on canvas
158.8 x 84.5 cm
(62 ½ x 33 ¼ in.)
Gift of Mrs.
Ellerton James
27.457

William Rimmer

Born England, 1816–1879

Flight and Pursuit, 1872

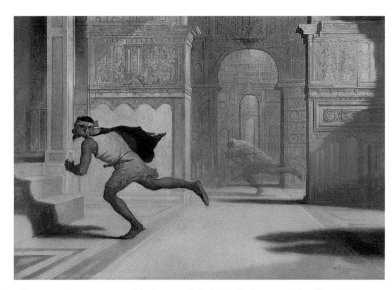

Rimmer, like his contemporary Vedder, was interested in literary and mystical themes and found many patrons in his native Boston, where such subjects had always been favored. An accomplished sculptor, teacher, painter, businessman, anatomist, and physician, Rimmer was one of Boston's most noted artists in the 1860s and 1870s. Contradiction and controversy marked his professional career. He was learned and ambitious but worked quickly with unstable techniques. He aspired to the highest social circles yet often undermined his position with his quick temper and irascible disposition. Rimmer inspired his students in both Boston and New York, particularly the women to whom he offered equal educational opportunities, but he was overshadowed in many ways by his younger and more sophisticated colleague Hunt. Nevertheless, his contemporaries admired Rimmer for his artistic passion and skill, comparing him to the multitalented artists of the Italian Renaissance.

Rimmer's best-known and most enigmatic painting is *Flight and Pursuit.* The picture is set in the shadowy and mysterious labyrinth of a chimerical Near Eastern temple or palace. One man races toward a stair, following his shadow. The irregular patch of shade at right suggests another runner following behind the first. In a parallel hallway, a ghostly third man, real or imaginary, swathed in white and holding a sword, runs alongside and glances toward the other figures. Which man flees and which one speeds in pursuit is left to the viewer's imagination. A drawing of the main figure, now in a medical library at Yale University, is inscribed with the words "oh for the horns of the Altar." That phrase appears several times in the Old Testament, and it implies that one of Rimmer's figures is rushing toward sanctuary, for a criminal was untouchable as long as he remained within the sacred space of the altar.

Rimmer drew many of his subjects from the Bible and ancient history, and he doubtless knew a variety of artistic interpretations of such themes, including the work of the visionary English poet and painter William Blake, whose books and watercolors were avidly collected in Boston during this period. Although several scholars have sought to place *Flight and Pursuit* in the context of Rimmer's complex psychological state, his interest in arcane literary and imaginative compositions was well within the parameters of Bostonians' taste.

Oil on canvas
46.1 x 66.7 cm (18 ⅛ x 26 ¼ in.)
Bequest of Miss Edith Nichols 56.119

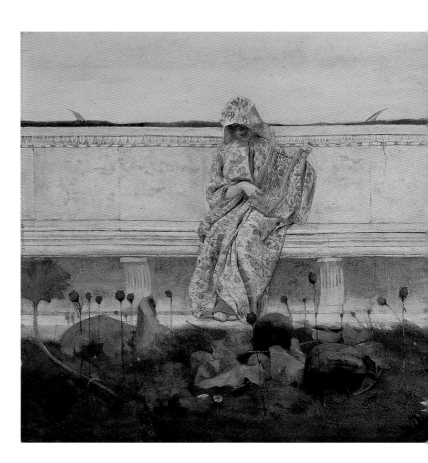

Thomas Wilmer Dewing
1851–1938
A Garden, 1883

A native of Boston, Thomas Wilmer Dewing began his career as a lithographer. In city directories, he first listed himself as a taxidermist and then as a clerk, but by the early 1870s he had started to think of himself as a painter. He traveled to Paris for two years of study, like many American artists in the decades after the Civil War, and returned to Boston to teach at the newly founded School of the Museum of Fine Arts. In 1880 he moved to New York, where he taught at the Art Students League, later explaining that living anywhere other than Manhattan was "camping out." He and his wife, Maria, also a painter, did leave the city to spend each summer in Cornish, New Hampshire, where they became integral members of the art colony that was established there.

Dewing was interested in contemporary European art, and, especially during the early part of his career, he drew inspiration from a variety of sources — Italian, French, and English. *A Garden* was one of the first paintings he made in the manner of the Aesthetic Movement. English painters like Lawrence Alma-Tadema, whom Dewing especially admired, crafted flawless genre scenes with themes from classical antiquity. In *A Garden,* Dewing worked in a delicate, realistic style, employing a number of motifs common to these consciously artistic paintings — lovely women in classical robes, a marble bench imagined from Greek and Roman sources, swaying poppies, and elegant peacocks. Dewing's garden, however, is hidden, detached from the world beyond the wall

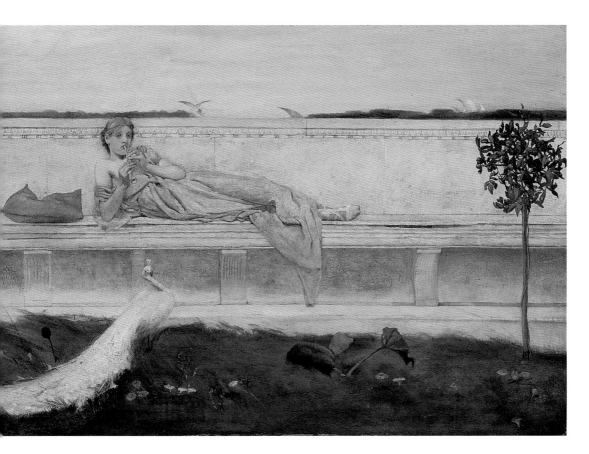

where bright sails can be glimpsed plying an unknown sea. The lyre-playing figure is hooded and sits before a patch of ripe melons, symbols of fertility, and poppies, emblems of sleep, dreams, and decadence. The flute player reclines gracefully near a white peacock, a token of marriage, immortality, and vanity. Yet this combination illustrates no obvious myth or legend, intriguing viewers with its mystery and exquisite grace. Instead of telling a story, each carefully chosen color, pattern, and shape in *A Garden* is arranged to create a poem in paint.

Oil on canvas
40.3 x 101.6 cm (15 ⅞ x 40 in.)
Bequest of George H. Webster 34.131

John White Alexander
1865–1915
Isabella and the Pot of Basil, 1897

The enigmatic literary subjects of artists like Vedder, Rimmer, and Dewing take on a gruesome flavor in this work by Alexander. A native of Pittsburgh who trained as an artist in Munich, Alexander first established himself in New York as an illustrator and cartoonist. He also earned praise for his fashionable portraits, many of them of writers and actors. In 1890 Alexander moved to Paris. There he met Whistler, who introduced him to many of the leading figures of the European Symbolist movement. These painters and writers were interested in dreams and the imagination, and elements of macabre fantasy often appear in their work. During the ten years he spent in Paris, Alexander experimented with decorative and decadent themes, often employing the slender, sinuous lines of the Art Nouveau style.

Alexander's subject in this painting was popular among painters and writers interested in the unusual and bizarre. "Isabella; or, The Pot of Basil" was a poem written in 1820 by the English poet John Keats, who borrowed his narrative from the Italian Renaissance poet Giovanni Boccaccio. Isabella was a Florentine merchant's beautiful daughter whose ambitious brothers disapproved of her romance with the handsome but humbly born Lorenzo, their father's business manager. The brothers murdered Lorenzo and told their sister that he had traveled abroad. The distraught Isabella began to decline, wasting away from her grief and sadness. She saw the crime in a dream and then went to find her lover's body in the forest. Taking Lorenzo's head, she bathed it with her tears and finally hid it in a pot in which she planted sweet basil, an herb associated with lovers.

Alexander used a theatrical scheme to render this grim scene, isolating Isabella in a shallow niche and lighting her from below, as if she were an actor on a stage illuminated only with footlights. This eerie

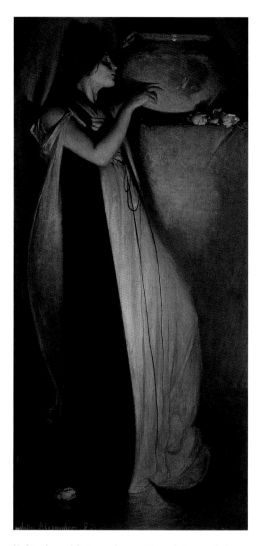

light, the cold monochromatic palette, and the sensuous curves of Isabella's gown draw attention to the loving gesture Isabella bestows on the pot, which she gently caresses. Isabella seems lost in an erotic spectral trance, oblivious to the world and to observers. With his strange subject, Alexander created an extraordinary and mysterious image of love gone awry.

Oil on canvas
192.1 x 91.8 cm (75 ⅝ x 36 ⅛ in.)
Gift of Ernest Wadsworth Longfellow 98.181

Abbott Handerson Thayer
1849–1921
Caritas, 1894–95

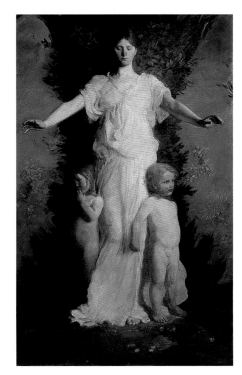

Thayer was one of the best-known artists in the United States during the 1890s. His art, often inspired by the Italian Renaissance and classical antiquity, fulfilled the aspirations of a country seeking to establish itself on an international stage as the new Rome. With large public buildings in classical styles, with murals (see p. 135), and with allegorical representations like *Caritas*, American artists created an image of strength and confidence which came to be called the American Renaissance.

Thayer first studied painting in Boston and Brooklyn, then traveled to Paris in 1875 to train at the prestigious Ecole des Beaux-Arts. He based his career in New York but produced much of his work in the summer studios he kept, first in South Woodstock, Connecticut, and then in Dublin, New Hampshire. The model for the main figure in *Caritas* was Elise Pumpelly, daughter of a well-known Harvard geologist, who also summered in Dublin and posed frequently for Thayer. The artist idealized Pumpelly by dressing her in a classical Greek chiton, using its long columnar folds to give the impression of stability and strength. The two children, innocent and trustful, seem embodiments of natural purity. The setting is enlivened by Thayer's opalescent strokes of paint, flickers of light green and blue that seem to vibrate with the freshness of spring.

An intensely spiritual man, Thayer sought to imbue his paintings with the moral principles of his age, hoping to communicate such abstract ideals as virtue, beauty, and truth. In 1893 (along with Vedder and La Farge) Thayer had been commissioned to paint a mural for the art museum at Bowdoin College, an allegorical composition symbolizing the city of Florence. That mural, depicting a winged woman with outstretched arms that protect two children, may have inspired *Caritas*. The image was a traditional representation of the virtue Charity (*caritas* in Latin),

and the title became associated with this painting when it was first exhibited in Philadelphia in 1895. Thayer later wrote to the MFA asking to change it, explaining that he felt *Spring* or *Morning* would be more appropriate; in 1899 he wrote again, informing the Museum's president that he detested the picture and asking to trade it for another.

Despite the artist's continued protestations, *Caritas* was highly admired from the time of its first exhibition and won a large prize in Philadelphia. When it was first shown in Boston in 1897, a group of local painters and collectors admired it intensely. They explained that it was of the utmost importance that the finest works by America's leading contemporary artists be represented in the Museum's collections, and they raised the funds to buy *Caritas* for the MFA.

Oil on canvas
216.5 x 140.3 cm (85 ¼ x 55 ¼ in.)
Warren Collection and contributions through the Paint and Clay Club 97.199

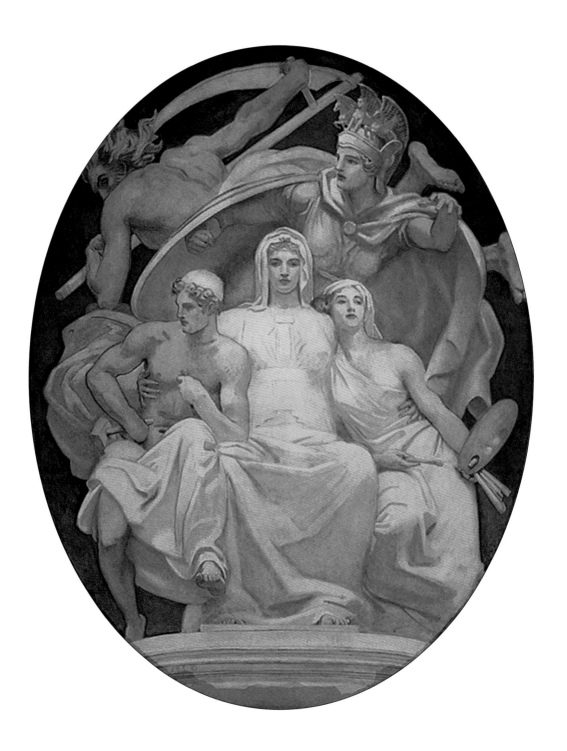

John Singer Sargent

Born Italy, 1856–1925

Architecture, Painting, and Sculpture Protected by
Athena from the Ravages of Time, **1921**

In emulation of the elaborate public buildings they admired in Europe, Americans had begun to decorate their libraries, capitols, churches, and museums with large-scale paintings and sculpture intended to evoke the viewers' civic pride. Because few of the country's artists had any training as muralists, building committees turned to men (and occasionally women) who had earned acclaim as easel painters. With his incredible facility with the brush and his keen understanding of the psychology of his sitters, Sargent had become one of the most successful por-traitists of the late nineteenth century (see p. 145). In 1890, in search of new artistic challenges, Sargent accepted an invitation to decorate one of the large halls of the Boston Public Library with murals. He was delighted to undertake such an important com-mission, for murals were at the top of the traditional hierarchy of painting. Sargent, trained in the acade-mies of Europe and well educated in the history of art, had always drawn inspiration from Old Master paintings. The greatest artists of the Renaissance and Baroque periods had been masters of public art, and Sargent welcomed the opportunity to work in that illustrious context (mural painting would fasci-nate him for the rest of his life).

In 1916, when the trustees of the Museum of Fine Arts decided to embellish their Huntington Avenue building with permanent decorations, they naturally turned to Sargent, the city's favorite artist. Originally invited to contribute three lunettes over each doorway to the Museum's main galleries, Sargent persuaded the board to allow him to redesign and redecorate the entire rotunda, devising an imaginative scheme that used images from classical mythology to pay homage to the arts. This project resulted in a sophisticated blend of architecture, sculpture, and painting.

Architecture, Painting, and Sculpture Protected by Athena from the Ravages of Time would be the first painting visitors would see after climbing to the top of the Museum's grand staircase. Sargent devised a new painting technique for these murals, using strong outlines, a soft color scheme, and flat unvar-nished surfaces that from a distance evoke the famous fresco cycles of Italy. He selected three fig-ures — one on a plinth, one with a mallet, and one with brush and palette — to represent the fine arts. Athena, goddess of wisdom, shields them from the destructive scythe of Father Time. Sargent intended this allegory to illustrate and to validate the Museum's mission of collecting and preserving the greatest examples of art. He based his figures on a variety of ancient and Renaissance sources, appro-priating their prestige to add luster to his composi-tion. When these murals were unveiled in 1921, Sargent was praised as a modern Michelangelo.

Oil on canvas, installed in rotunda
320.4 x 261.3 cm (126 ⅛ x 102 ⅞ in.)
Francis Bartlett Donation of 1912 21.10513

American Impressionism

In 1874 a group of young French painters whose works had often been rejected from the important annual exhibitions organized by the French Academy gathered together to hold an independent display. These disparate artists, who became known as the Impressionists, included Claude Monet, Pierre-Auguste Renoir, Edgar Degas, and the American expatriate Cassatt. They held only eight group shows over the next twelve years, but their impact was enormous. Painters from around the world experimented with their new style. Impressionism became particularly popular in the United States, where academic standards were less firmly entrenched. The large-scale historical and biblical subjects that were promoted by the academy seemed less relevant to America's commercial, mostly Protestant society. Impressionist canvases, in contrast, presented subjects drawn from the everyday world, often depicting moments of daily life in the artists' families, glimpses of city streets, or fleeting atmospheric effects in the countryside (see fig. 24). These images appealed to many American artists and collectors. Beginning in the 1880s they were displayed frequently in exhibitions in the United States, and Americans bought so many Monets that the artist complained that too much of his work was going to "the land of the Yankees." Painters enthusiastically adapted the French style to their own distinctly American subjects.

Although artists had always been interested in light and color, the Impressionists emphasized them, seeking to create novel ways of representing the world that would be appropriate to their modern age. They took advantage of recent developments in science, which offered innovations in the study of vision and of color perception as well as a rainbow of new and brilliant paints (an outgrowth of the chemical dye industry). Artists used their pigments freely, laying them down side by side on the canvas rather than mixing them on the palette, thus creating much more vivid optical effects. The Impressionists also became fascinated with Japanese art, incorporating Asian objects into their pictures

and sometimes employing non-Western compositional strategies — for instance, flattening and compressing their representation of three-dimensional space, allowing surface design and pattern to play an important role in their work. In addition, they were interested in photography, which also offered a cropped and compressed perspective of the natural world.

Impressionism was as controversial in its time as some contemporary art is today. The ideas that subject matter and storytelling were not of primary importance and that paintings were abstract arrangements and not simply windows into another world were radical. Likewise, the loose brushwork and bright colors the artists favored, and the way they used light to dissolve form, were regarded as extreme. The Impressionists were accused of being unskilled and incapable of creating the tightly finished, realistic depictions favored by traditionalists. Although artists from the United States flocked to Paris in the decades after the Civil War, with the exceptions of Cassatt (who joined the French Impressionist group) and Whistler (who allied himself with the avant-garde and believed in independent explorations of atmosphere and mood), Americans initially ignored the new paintings. Instead, they sought to perfect their training in the academic tradition. One of the few American artists to attend an Impressionist exhibition in Paris wrote that he thought it was "worse than a chamber of horrors."

Nonetheless, younger American painters soon began to embrace Impressionism enthusiastically. A group of artists traveled to Giverny, Monet's home since 1883, helping to found an American colony there that remained popular until the outbreak of World War I. Cosmopolitan artists like John Singer Sargent experimented with Impressionism at this time and helped to bring it to the attention of progressive painters and patrons. Just as they had in France, however, more traditional artists and academies in the United States resisted the style and refused to include such modern paintings in their exhibitions. In consequence, a group of American Impressionists who called themselves the Ten American Painters (often referred to simply as the Ten) — including Frank Weston Benson, William Merritt Chase, Thomas Wilmer Dewing, Childe Hassam, and Edmund

fig. 24. Claude Monet, *Camille Monet and a Child in the Artist's Garden in Argenteuil*, 1875.

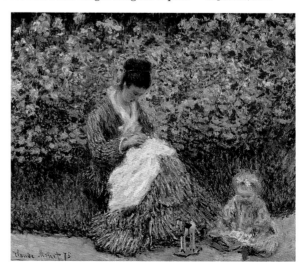

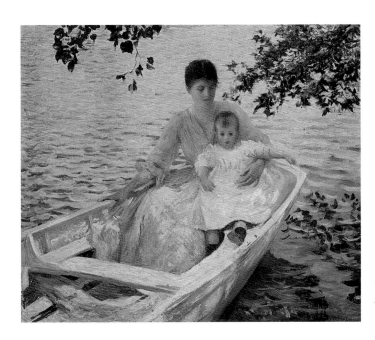

fig. 25. Edmund Charles Tarbell,
Mother and Child in a Boat, 1892.

Charles Tarbell — seceded from the Society of American Artists, one of the important artists' groups in New York, and started to show their paintings independently in 1898. Through their additional activities as teachers, writers, and advisers, they helped to turn Impressionism into an established and accepted style.

By the early twentieth century, Impressionism was firmly ensconced in the United States and found adherents from Maine to California. American painters adapted French Impressionism to their own taste. Although they used bright colors and unblended brushwork, they did not allow the figures they depicted outdoors to dissolve in light, preferring to give them weight and substance (see fig. 25). They most often selected attractive subjects, creating images of sunlit gardens and girls dressed in white, and they infrequently explored the grittier subjects of industry or urban life. Theirs was a powerful vision of optimism, well suited to a country that considered itself destined to be a natural leader on the world stage.

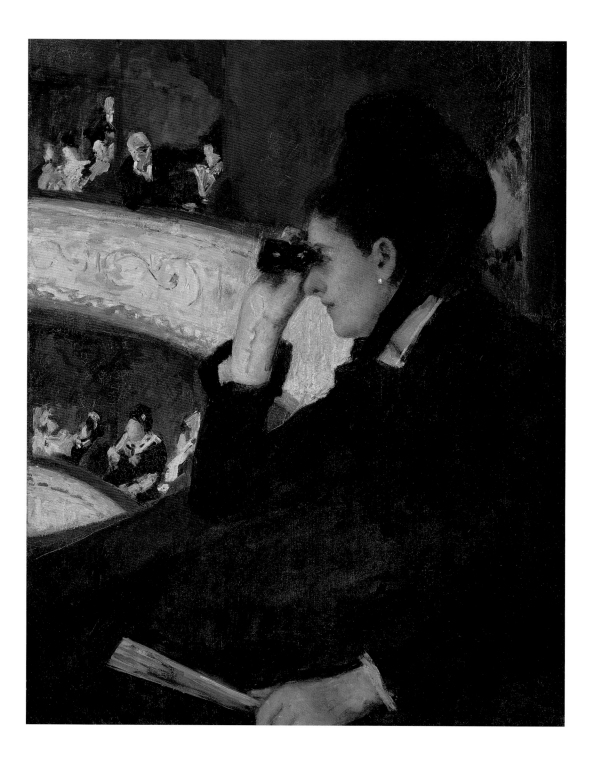

Mary Stevenson Cassatt
1844–1926
In the Loge, 1879

Cassatt, raised near Pittsburgh and first trained as a painter in Philadelphia, became nineteenth-century America's most modern painter. Like many of her contemporaries, Cassatt felt that her artistic education in the United States was inadequate, and she traveled to Europe soon after the Civil War. She studied in both Italy and France, and by 1873 she had made Paris her home. Whereas most of her compatriots were proud of the education they had received in the art schools of the French capital, Cassatt soon tired of the conservative approach taught in those academies and perpetuated by the exhibitions they organized. She felt strongly that painting needed to break free of old methods and adapt to the modern world.

Cassatt found the answer to her demand for a new kind of painting in the work of the Impressionists. She approved of their disdain for juried exhibitions and soon adopted their experimental techniques and their preference for images of contemporary life. In 1877 Degas invited her to show her work with the group. Cassatt thus became one of only three women, and the only American, ever to join the French Impressionists.

In the Loge was the first of Cassatt's Impressionist paintings to be displayed in the United States, where critics described the picture as a promising sketch (but not, as Cassatt intended, as a finished painting). It depicts a fashionable lady dressed for an afternoon performance at the Français, a theater in Paris. Entertainments like theater, opera, and the racetrack were extremely popular among Parisians, who enjoyed such diversions not only for the show but also for the opportunity to see — and to be seen by — their peers. The Impressionists delighted in painting these spectacles of modern life, and the theater, with its dazzling variety of lights and reflections, was an especially appealing subject. Many male artists, including Renoir and Degas, had painted beautiful women in theater boxes, where they appeared as if they were on display in a gilded frame. Cassatt gave her female figure a noticeably more dynamic role, for she peers avidly through her opera glasses at the row of seats across from her. In the background at the center, a man trains his gaze on her. The viewer, who sees them both, completes the circle. Cassatt's painting explores the very act of looking, breaking down the traditional boundaries between the observer and the observed, the audience and the performer.

Oil on canvas
81.3 x 66 cm (32 x 26 in.)
The Hayden Collection. Charles Henry Hayden Fund 10.35

James Abbott McNeill Whistler

1834–1903

Nocturne in Blue and Silver: The Lagoon, Venice,
1879–80

Like Cassatt, Whistler lived an expatriate life abroad.
One of the nineteenth century's most influential
painters, Whistler was also one of its most colorful
personalities. He ignored his roots in Lowell, Massa-
chusetts, preferring to give the impression that he
had been born in Russia, where his father had been
an engineer. He first earned acclaim in 1863 in Paris,
where he had worked with some of the city's most
avant-garde painters, including the Realist champion
Gustave Courbet. Whistler shocked the art establish-
ment when his *Symphony in White* (1862, National
Gallery, Washington, D.C.) was exhibited at the infa-
mous Salon des Refusés, a display of paintings that
had been rejected from the official Salon exhibition.
Many found his forthright image of a woman with
her hair down — standing on a fur rug with a bouquet
discarded at her feet — indecent and incomprehensi-
ble. Whistler relished the controversy and courted
such opportunities throughout his career.

The artist's only trip to Venice came at the close of
another such episode. John Ruskin, one of Britain's

most influential critics, had accused Whistler of
defrauding the public by exhibiting an abstract
image of fireworks at night. In 1878 Whistler sued
Ruskin for libel, and although he won his case, he
was awarded only one farthing in damages. Whistler
was bankrupt, and in consequence he took a commis-
sion the following year from London's Fine Art Soci-
ety to produce a series of prints of Venice. He spent
about fifteen months in the watery city, living in
reduced circumstances and borrowing many of his
supplies from the admiring community of young
American painters he befriended there. Although he
made more than fifty Venetian etchings and ninety
pastels, Whistler produced only three paintings in
oil, including *Nocturne in Blue and Silver: The
Lagoon, Venice.*

Venice's mysterious elegance was particularly
suited to Whistler's style. He rejected meticulous
representation, preferring to paint mood and atmos-
phere. Fascinated with the art of Japan, Whistler
explored flattened pictorial space and subtle
arrangements of color and shape. He likened his
paintings to music, often naming them after
particular musical forms such as the nocturne, popu-
larized by Frédéric Chopin. In this composition,
painted from the piazzetta near the Royal Gardens,

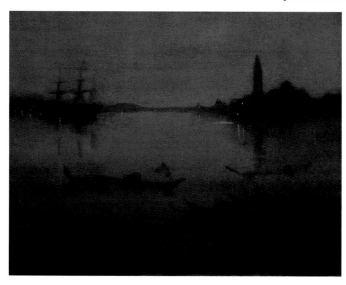

the sparkling colors of Venice are
reduced to an ethereal blue and
grayish silver that seem to mimic the
city's elusive structure. In the back-
ground, the silhouette of the Church
of San Giorgio Maggiore hovers
insubstantially, and the distant lights
of the strand at the Lido glimmer
along the horizon. Here Whistler has
captured Venice in the way the poet
Lord Byron described it, as a "fairy
city of the heart."

Oil on canvas
50.2 x 65.4 cm (19¾ x 25¾ in.)
Emily L. Ainsley Fund 42.302

Childe Hassam
1859–1935
*Boston Common at
Twilight*, 1885–86

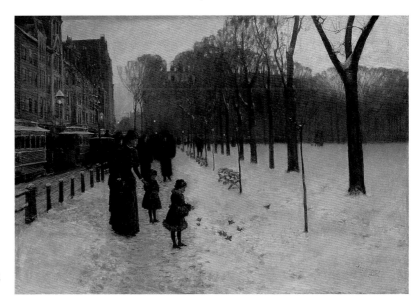

Hassam, the son of a
Dorchester hardware
merchant, had made only
one trip to Europe before
painting *Boston Common
at Twilight*. He studied
the French art in Boston
collections and was
familiar with the popular
work of painters active in
Paris like Jean Béraud and
Giuseppe de Nittis, who
took modern life as their main subject and frequently
depicted fashionable young women in city settings.
Hassam adapted their French aesthetic to his native
city and began a series of large canvases represent-
ing several of Boston's developing neighborhoods —
the Back Bay, the South End, and Park Square.

Originally an open field for cattle grazing and
military parades, the Boston Common had been
transformed into an oasis of elm trees and graceful
promenades by the time Hassam painted it in the
mid-1880s. Hassam chose a view of the Tremont
Street Mall, one of five broad tree-lined walkways
that provided Boston pedestrians with an elegant
alternative to the city's noisy thoroughfares. The
artist doubtless enjoyed it himself, for his studio was
just across the street.

Despite the old-fashioned charm *Boston Common
at Twilight* presents to viewers today, in Hassam's
time this scene was distinctly modern. Once an area
of elegant residential row houses, many of the streets
around the common had been transformed into a
lively business district. The red brick buildings visi-
ble at left were mostly new; the traffic of trolley cars
and carriages on the road marks the bustling com-
merce of late afternoon; and artificial light glows
from streetlights and storefronts. Hassam enhanced
his impression of the fast pace of city life by using a
perspective scheme in which the vertical lines of the
fence, the lampposts, and the trees recede rapidly
into the distance, coming closer and closer together.

Hassam contrasted the hurried movement at left
with the calm of the snowy park. A stylishly dressed
young mother and her children pause to feed the
birds while other figures stroll through the rosy
dusk. Hassam used a variety of reds to unify his
composition, bringing the rusty brick buildings, the
glow of the lamps, and even the brilliant end of a lit
cigarette in the hand of a passer-by into harmony
with the sunset sky and the pinkish snow. The artist's
interest in contemporary subjects and in different
kinds of light ally this painting with Impressionism,
but in Hassam's gentle vision of the city, nature
humanizes the modern world.

Oil on canvas
106.7 x 152.4 cm (42 x 60 in.)
Gift of Miss Maud E. Appleton 31.952

John Singer Sargent

Born Italy, 1856–1925

The Daughters of Edward Darley Boit, 1882

Described by a close friend as an "accentless mongrel," Sargent felt at home in many lands. Born in Italy to American expatriates from Philadelphia, he began his career in France, established it in England, and earned his greatest acclaim in the United States. Although eager to prove himself as a portraitist, Sargent always set himself new artistic challenges. In Paris, London, and New York, he exhibited a deliberate succession of different kinds of paintings that announced both his skill and his audacity. He showed *The Daughters of Edward Darley Boit* at the Paris Salon in 1883.

The exact circumstances surrounding Sargent's commission to paint this portrait remain unknown. Edward Boit was a well-to-do Bostonian who had studied law before deciding to pursue a career as a painter. He and his wife, Mary Louisa Cushing Boit, lived in Boston and Paris with their four daughters — Mary Louisa, who was eight years old when Sargent painted her, Florence (age fourteen), Jane (twelve), and Julia (four). The Boits met Sargent in Paris, and although they may have first approached him to create a traditional portrait, they supported his ambition to paint a bold masterpiece, even allowing him to obscure Florence's features.

Sargent, like many artists of his age, greatly admired the work of the seventeenth-century Spanish master Diego Velázquez. In composing this painting, Sargent recalled Velázquez's *Las Meninas,* a famous portrait of a young princess with her maids, which he had copied during a trip to Spain.

Sargent adapted Velázquez's mysterious spaces, his silvery gray palette, and the way his princess directly confronts the viewer. Sargent posed the Boit girls in the elegant interior of their Parisian apartment, using as props the two large Japanese porcelain vases that traveled with the family back and forth across the Atlantic. The daughters are dressed in casual clothes, but only the youngest engages the viewer; the older girls recede progressively into the shadows, becoming increasingly indistinct.

Whereas some have interpreted Sargent's strategy as a poignant comment on the fickle nature of childhood and adolescence, writer Henry James described the picture as a "happy play-world of a family of charming children" when he saw it at the Salon. Other critics were perplexed by Sargent's composition, with its large open spaces that leave some of the girls scattered in the background. The painting masterfully transcends portraiture, presenting not only a likeness but also a brilliant meditation on openness and enigma, on light and shadow. Sargent's interest in the effects of light and in the psychology of modern life, already evident here, led him to explore Impressionism more fully, and he would soon become one of its important advocates.

Oil on canvas

221.9 x 222.6 cm (87 3/8 x 87 5/8 in.)

Gift of Mary Louisa Boit, Julia Overing Boit, Jane Hubbard Boit, and Florence D. Boit in memory of their father, Edward Darley Boit 19.124

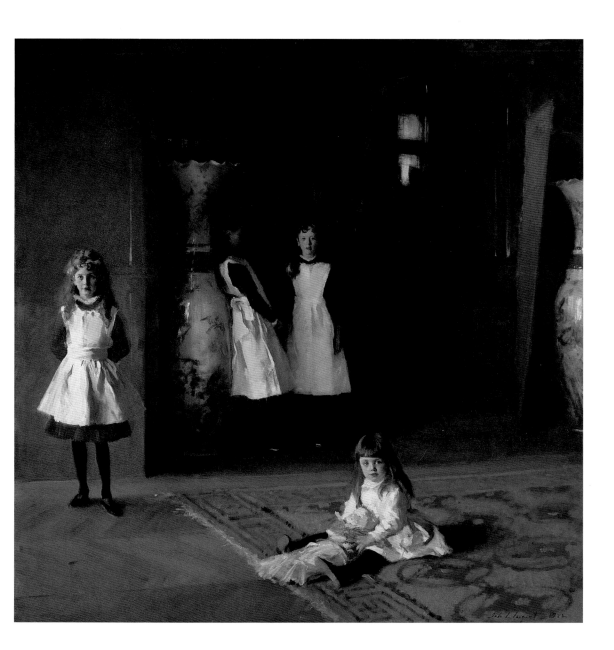

Dennis Miller Bunker

1861–1890

The Pool, Medfield, 1889

Dennis Miller Bunker was one of the earliest Americans to apply all of the stylistic ingredients of the radical new painting style of Impressionism to his native landscape. Like most artists of his generation, Bunker had been trained as a figure painter, instructed to value traditional compositions and accurate drawing. After polishing his academic education in Paris, he accepted a teaching position in Boston, where he soon became admired for his sophisticated portraits. Bored with conventional approaches to art, Bunker continued to experiment. In 1887 he met the adventurous painter John Singer Sargent, and the two young men, both interested in modern French art, theater, and music, became close friends. They spent the summer of 1888 working together in the English countryside, exploring the bright colors and individual brushstrokes of Impressionism.

By the time Bunker returned to Boston, he had fully mastered the new style. Like his French contemporary Monet — whose paintings were rapidly entering Boston collections — Bunker preferred anonymous landscapes to well-known sites. He spent the summer of 1889 in Medfield, Massachusetts, painting a series of images of the lush marshy fields near the source of the Charles River. In *The Pool, Medfield*, Bunker placed the horizon line high on his canvas, a device that serves to flatten the composition, emphasizing its two-dimensional design. Upon this surface, he crafted a dense network of long unblended strokes of color that echo the shapes of the reeds and grasses and the flow of the clear blue water. Bunker's *Pool* is a dazzling view of a sun-filled meadow, but it is equally an exploration of the physical act of painting.

Although some conservative critics greeted Bunker's Impressionism with disdain, his innovative combination of American subjects and French techniques soon became the leading style in American art. Bunker did not live to enjoy its success; he died just a year later, two months after his twenty-ninth birthday.

Oil on canvas
47 x 61.6 cm (18 ½ x 24 ¼ in.)
Emily L. Ainsley Fund 45.475

William Merritt Chase
1849–1916
Park Bench, about 1890

An Indiana native, Chase became one of the most accomplished interpreters of Impressionism in the United States. At first he adopted a fluid painterly style in Munich, where he, like many other painters from the Midwest (where German influence was strong), trained in the 1870s. After 1885 he shifted away from the dark figurative subjects that had earned him early recognition and began to experiment with images drawn from modern life. Like Bunker, Chase brought together the bright colors and animated brushwork of the French style with subjects that were recognizably American. He became known both for sun-filled scenes of women and children outdoors and for subtle, opalescent interiors.

Park Bench is a casual image of a woman resting in the bucolic setting of a city oasis. It was one of many pictures Chase made of urban parks in Brooklyn and Manhattan, and it is probably the painting he first exhibited with the title *An Idle Hour in the Park — Central Park.* The location would have been readily identifiable to his audience, who could detect with only a glance the rocky landscape and rusticated furniture of New York's largest park. The preserve had been many years in the making — calls for protecting the land in the metropolis had begun in the 1830s. Twenty years later, spurred by the vanishing opportunity to create a great urban park on a par with those of London and Paris, the city bought the land and organized a competition for its design. The commission was awarded to Frederick Law Olmsted and Calvert Vaux, who developed the landscape of gentle hills, wooded glens, lakes, and carriage drives still familiar today. The park was an immediate success with city residents, who enjoyed its recreational offerings in all seasons.

Chase used his series of intimate park scenes to establish himself as an innovative painter of modern subjects. He was doubtless familiar with the views of Parisian parks, which had been exhibited in Paris and New York by John Singer Sargent and the Italian painter Giovanni Boldini. He also knew the urban landscapes of Hassam, including *Boston Common at Twilight* (p. 143). In *Park Bench,* Chase combined public and private worlds — his solitary model is lost in thought as if alone in one of Chase's contemplative interiors, but the setting is clearly outdoors and therefore shared with others. Chase gives the viewer a mere glance at this ephemeral scene, for either the woman will move or the observer will continue walking on the path. In this way, along with the quick flickering brushstrokes he used to define both the woman and the landscape, Chase brought the instantaneity of Impressionism to American shores.

Oil on canvas
30.5 x 40.6 cm (12 x 16 in.)
Gift of Arthur Wiesenberger 49.1790

Cecilia Beaux

1855–1942

Charles Sumner Bird and
His Sister Edith Bird Bass, 1907

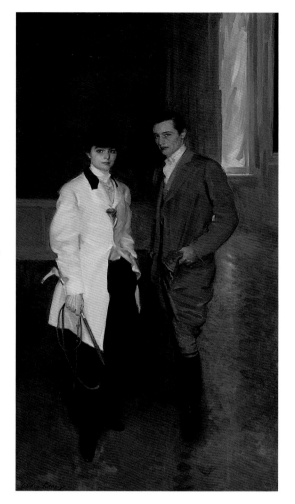

Cecilia Beaux was renowned for her elegant depictions of America's elite, and along with John Singer Sargent, she was acclaimed as one of the most brilliant portraitists of her generation. Beaux was first trained in Philadelphia and then in Paris. Most of her compatriots spent some time in the French capital, but Beaux, whose father was French, felt particularly at home there and maintained French affinities throughout her life. She centered her career in Philadelphia and won national recognition, becoming a role model for aspiring women artists and one of the first women to teach at the Pennsylvania Academy of the Fine Arts. In 1905 she built a summer home and studio on Eastern Point in Gloucester, Massachusetts, naming it Green Alley. The house soon served as a favorite gathering spot for the artistic community that came to Boston's North Shore each season. It also became the setting for many of Beaux's portraits of New Englanders, including this elegant image of Charles Sumner Bird and his sister Edith.

The Bird family had made their fortune in the manufacture of paper, and they owned a 194-acre estate, called Endean, in East Walpole, Massachusetts, overlooking the Neponset River. One of their passions was horses, and their property included polo grounds, stables, and fields where elaborate hunts took place. Charles and Edith wear riding clothes in this elegant image, linking it to a long European heritage of full-length portraits of landed gentry dressed for the hunt. Beaux's format is traditional, and in this commissioned portrait, she painted more conservatively than she did in other works, where her interest in Impressionism is more evident. Even so, her treatment is unconventional. Instead of allowing her sitters to dominate their surroundings, she selected an elevated vantage point, silhouetting them against the shimmering studio floor and walls. The shadowy interior, which Beaux rendered with broad strokes of her brush, seems a strange and mysterious setting for two sitters who so clearly enjoyed an active outdoor life. That tension, along with Beaux's energetic paint handling, enlivens and enriches this portrait.

Oil on canvas
240.4 x 135.9 cm (94 ⅝ x 53 ½ in.)
Gift of Mrs. Charles Sumner Bird 1981.720

Frederick Carl Frieseke
1874–1939
The Yellow Room, about 1910

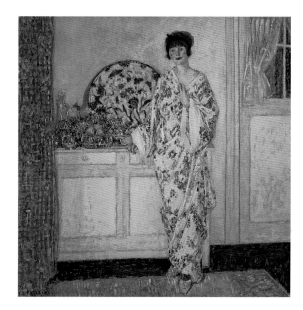

Like several American Impressionists, Michigan-born Frieseke spent most of his life in France, sending his paintings home to the United States for exhibition and sale. He had first traveled to Paris in 1897, enrolling at the Académie Julian, long a popular program for aspiring American artists. Frieseke also studied with the renowned American expatriate painter Whistler at his short-lived school, the Académie Carmen. Whistler's passion for Japanese art, for decoration, and for distinctive color arrangements had a lasting influence on Frieseke's work. Frieseke also admired the French Impressionist Monet, particularly for his brilliant use of color and his interest in the effects of sunlight. From 1906 to 1919 Frieseke spent his summers in Giverny, the small village in Normandy that had been Monet's home since 1883, joining a significant colony of American artists there.

In *The Yellow Room* Frieseke fused bold color juxtapositions and careful formal design, bringing together the qualities he most admired in the work of Monet and Whistler. He posed his model in the living room of his own house in Giverny, which itself was one of his artistic creations. Frieseke had painted the walls lemon yellow and ornamented the room with blue rugs and curtains, a striking color combination that Monet had also employed in his home. Against this backdrop Frieseke posed a costumed model, arranged Japanese ceramics, and massed containers of fruit and flowers to create a panoply of color and pattern. The large Imari-style plate and the model's kimono reflect the artist's interest in Asian art, with its emphasis on two-dimensional design and ornament. The wealth and variety of patterns Frieseke employed, as well as the way in which the figure is not given precedence but instead merges into its surroundings, also recall paintings by Pierre Bonnard and Edouard Vuillard. Like these modern French artists, Frieseke created intimate domestic interiors with bold decorative arrangements to explore the shifting relationship between paintings as representations of the real world and paintings as independent abstract designs. These concerns would preoccupy many American artists throughout the twentieth century.

Oil on canvas
81.3 x 81 cm (32 x 31 ⅞ in.)
Bequest of John T. Spaulding 48.543

The Boston School

Although superseded by New York as a commercial center in the decades after the Civil War, Boston still considered itself the intellectual capital of the nation. Boston artists, like many other American painters, not only polished their training abroad by studying at European academies and visiting museums but also sought to improve the status of the arts within the United States. Many of them helped to organize exhibitions, taught at newly founded art schools, contributed their expertise to new magazines and journals, advised collectors, and decorated public buildings. In 1870 a group of Boston's leading citizens founded the Museum of Fine Arts. Its charter included the establishment of an art school, which began offering classes in 1877, just six months after the Museum's galleries had opened to the public. Also in 1870 the state legislature passed the Massachusetts Drawing Act, which required that drawing be taught in the public schools. To train the necessary teachers, the state inaugurated the Massachusetts Normal Art School (now Massachusetts College of Art). The two schools (both of which thrive today) based their curricula on the academies of Paris, giving their students a firm foundation in the techniques and history of traditional art. They attracted students from New England and across the country. Their programs were particularly popular with women, who had never before had equal access to an art education. The city's finest art teachers became the leading members of a group of local painters that came to be called the Boston School.

Boston's painters united traditional academic standards of representation with the intense interest in light effects that the French Impressionists explored. In the 1890s they were among the leaders of the American Impressionist movement; Tarbell and Benson were founding members of the New York-based group the Ten, which sought to reinterpret the radical French style using distinctly American subjects. Like their colleague Chase, Tarbell and Benson often painted their own families outdoors, creating images of sun-filled, care-

fig. 26. William McGregor Paxton,
The New Necklace, 1910 (see p. 160).

free lives that were hailed as an ideal vision of America. With such appealing images, their new style of painting soon won acceptance.

By the end of the decade, art in Boston had begun to develop a distinct character. Tarbell and many others started to bring Impressionism indoors. In the studio they could control light carefully, using it to highlight or to obscure detail, as they preferred. They increasingly turned to the art of the past for inspiration, admiring especially the opalescent interiors of the seventeenth-century Dutch masters Jan Vermeer and Pieter de Hooch. Using such paintings as their guide, they sought to infuse their art with similar harmony and grace. They also were consummate craftsmen, working with care to ensure that their paintings were not only well designed but also well made. Boston artists frequently chose distinctive handmade frames for their work, emphasizing their kinship with the Arts and Crafts Movement (fig. 26). That group, which started in England but attracted many devotees in the United States, found moral and spiritual values in both artistic beauty and fine workmanship.

Boston painters favored certain kinds of subjects — portraits, impeccably arranged still lifes, images of healthy women and children outdoors, and studies of women in refined interiors. Narrative genre scenes, depictions of people at work, and city views were rare. Painters of the Boston School were interested in realism, but neither the Social Realism preferred by their New York contemporaries of the Ashcan School nor the expressive, emotional realism explored by European modernists and their American followers attracted them. Instead the Bostonians sought to render objects faithfully, not only by painting their forms

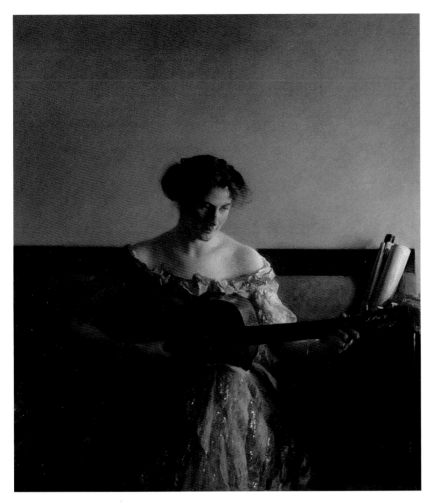

fig. 27. **Joseph Rodefer DeCamp,**
The Guitar Player, 1908.

and textures perfectly but also by enveloping them in light and atmosphere (fig. 27). Boston's artists, both men and women, earned national reputations, exhibiting their work across the country and winning prizes from New York to San Francisco. They created a legacy that continues to mark Boston taste, inspiring later generations with their belief in craftsmanship and beauty.

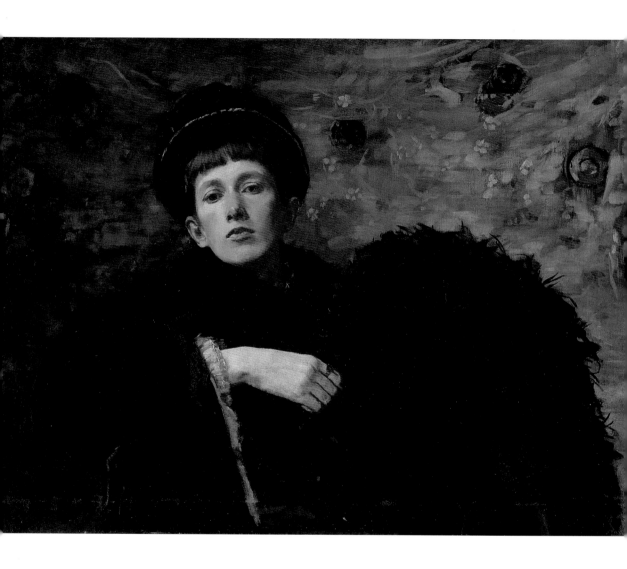

Ellen Day Hale
1855–1940
Self-Portrait, 1885

Ellen Day Hale was one of an increasing number of professional women artists who flourished in the United States during the decades following the Civil War. The daughter of the prominent Unitarian minister, writer, and abolitionist Edward Everett Hale, Ellen Hale grew up in a family noted for its accomplished women, among them authors Harriet Beecher Stowe and Charlotte Perkins Gilman and reformer Catharine Beecher.

Hale first studied art in Boston, taking advantage of the early educational opportunities that were offered to aspiring women artists by Rimmer and Hunt. Like most ambitious young painters of her day, she completed her training in Paris. She enrolled at the Académie Julian, an institution favored by Americans that also offered classes for women, who were not permitted to study at the most prestigious art school in Paris, the Ecole des Beaux-Arts, until 1897. In Paris, Hale perfected her skills as a figure painter, and this assertive self-portrait demonstrates her success. She selected an unusual horizontal format, silhouetted her figure against an ornamental fabric backdrop, and concentrated her attention on her firmly modeled face and hands.

Hale's forthright presentation, her strong dark colors, and the direct manner in which she engages the viewer recall the work of one of the French painters she most admired, Edouard Manet. Manet had been known for his confrontational images, strongly painted and without subtle nuances of light and shadow. A large retrospective exhibition of his work was held in Paris after his death in 1884, a show Hale most likely saw. It was unusual for a woman artist to adopt such bold qualities in her art, for they were often characterized as masculine and therefore unsuitable. Hale showed this self-portrait in Boston in 1887, and when one local critic declared that she displayed "a man's strength," he meant it as a compliment.

Hale continued to paint throughout her life, later developing a looser, lighter style more influenced by Impressionism. Like many of her Boston colleagues, she did not compromise her dedication to painting the human form, and she often depicted elegant women in interiors.

Oil on canvas
72.4 x 99.1 cm (28 ½ x 39 in.)
Gift of Nancy Hale Bowers 1986.645

Frank Weston Benson

1862–1951

Eleanor, 1907

A sparkling icon of wholesome American girlhood, Benson's *Eleanor* depicts the painter's daughter on the porch of their summer home in North Haven, Maine. Benson won national acclaim for his sunny scenes of healthy children enjoying an outdoor country life, and *Eleanor* is one of his most beloved images. It was purchased for the Museum of Fine Arts' collection almost immediately after it was finished.

At the time, Benson, along with his friend Tarbell, was one of the chief instructors of painting at the School of the Museum of Fine Arts. He was also an alumnus who, like many of his contemporaries, went on to complete his artistic education in Paris. In the 1890s Benson developed his characteristic style, the bright colors and fluid brushwork of French Impressionism with the firm foundation in academic figure painting he had learned at the Académie Julian. In 1898 Benson and Tarbell became founding members of the Ten. This band of American painters was dedicated to promoting and exhibiting their work outside the traditional system of juried exhibitions. These young artists had become frustrated with the conservative juries that controlled most of the major annual exhibitions, and they held independent shows in New York — and occasionally Philadelphia and Boston — until 1919. *Eleanor* was included in their 1908 display.

Benson's portrait of his daughter is a textbook example of the manner in which most American artists adapted Impressionism. Benson esteemed his academic training and never dissolved his figures into light to the degree that French artists allowed. He used a small brush to define Eleanor's features, painting her realistically with an authentic sense of weight and volume. But Benson gave himself much more freedom in other parts of the composition. The shimmering sea and leaves seem to vibrate with intensity, Eleanor's pink dress is loosely painted with broad strokes, and the details of her hat are abbreviated. The whole effect is vital and effervescent, much like an ideal summer day.

Oil on canvas
64.1 x 76.8 cm (25 ¼ x 30 ¼ in.)
The Hayden Collection. Charles Henry
Hayden Fund 08.326

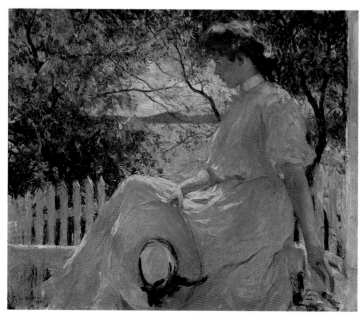

Edmund Charles Tarbell

1862–1938

New England Interior, 1906

Tarbell was the leading figure in the group of
painters who came to be called the Boston School.
He was both an alumnus of the School of the
Museum of Fine Arts and an important teacher
there. Between his studies at the Museum School
as an aspiring young artist and his appointment
as the school's chief instructor of painting in 1890,
he honed his education in Paris. There he familiar-
ized himself with both the academic tradition
and the new Impressionist style. Like his friend
Benson, Tarbell first earned success with brilliant
outdoor studies of his family, sunlit scenes of
leisure that brought him national acclaim
(see fig. 25, p. 139).

At the end of the 1890s Tarbell began to bring
Impressionism inside, creating images of elegant
women in interiors suffused with light. As one
critic remarked, within his studio Tarbell became
"the master and not the slave of nature." At first
Tarbell drew inspiration from the cropped
asymmetry of Degas's scenes of dancers, but *New
England Interior* and other works like it mark
a definitive shift in his art. Rather than using modern
painting as his model, Tarbell began to turn to the
art of the past. He especially admired the seven-
teenth-century Dutch masters Vermeer and de Hooch.
American collectors increasingly prized the work
of both artists, and they became a topic for scholarly
study — for example, Tarbell's Boston friend and
colleague Philip Hale wrote the first American mono-
graph on Vermeer. From the Dutch painters, Tarbell
borrowed his quiet, contemplative subjects, balanced
compositions, and subtle harmonies of light and
color. His interiors, like theirs, often include door-
ways opening to other rooms and paintings within
paintings. But Tarbell did not create historical scenes
— his models wear contemporary clothes and the

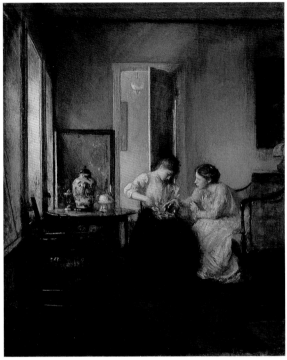

settings are modern, often furnished with antiques,
Japanese prints, and copies after Old Master paint-
ings. In works like *New England Interior*, Tarbell
inculcated the present with the values of the past,
employing careful craftsmanship and creating
exquisite beauty.

Oil on canvas
77.2 x 64.1 cm (30⅜ x 25¼ in.)
Gift of Mrs. Eugene C. Eppinger 1985.66

Laura Coombs Hills
1859–1952
The Nymph, 1908

Laura Coombs Hills began her art education under the influence of Hunt, whose student Helen Knowlton had continued teaching his classes after his death. Hills's earliest known works are unspecified landscapes of the marshes and dunes near her native Newburyport, Massachusetts, loosely rendered after the manner of her teachers, with special attention given to light and atmosphere. In 1893, during a trip to England, she first saw modern artists making miniatures in watercolor on ivory, a medium that had been popular in the late eighteenth and early nineteenth centuries (see, for example, pp. 41 and 65). The technique, used mostly for intimate and tranportable portraits of family members, had all but disappeared after the invention of photography in 1839. Like many handicrafts that had almost vanished with the industrial age, it was revived during the late nineteenth century. Hills, who had always enjoyed making tiny drawings and decorations, became fascinated with miniature painting and was one of the leaders in the art's rebirth in the United States.

The Nymph, like most revival miniatures, is much larger in scale and looser in handling than its eighteenth-century predecessors. Hills used an oval piece of specially prepared ivory and a tiny brush, employing traditional techniques to render her model's face realistically with minute strokes of watercolor. In the rest of the picture, however, Hills allowed herself considerable freedom, using layers of freely brushed colors to indicate the girl's diaphanous gown and to decorate the background. The effect is opalescent and dazzling, like a precious jewel.

Hills made figure compositions like *The Nymph* for exhibition and display. They were immensely popular and sold very well, enabling her to build her own house and studio in Newburyport. They also inspired many Bostonians to commission portrait miniatures from Hills. She made more than three hundred miniatures during her career, although after 1910 she began to earn even more acclaim for her delicate pastel still lifes of flowers. Hills was one of Boston's most popular painters, and she held annual exhibitions of her work until she was eighty-eight years old.

Watercolor on ivory
14.6 x 11.4 cm (5¾ x 4½ in.)
Purchased from the Abbott Lawrence Fund 26.30

Lilian Westcott Hale

1880–1963

L'Edition de Luxe, 1910

Women artists found Boston to be a particularly supportive environment for their professional activities, and Lilian Westcott was no exception. She came to the city from Hartford, Connecticut, with a scholarship to study painting at the School of the Museum of Fine Arts. She worked with Tarbell for two years but left the program when she married Philip Hale, a professor of drawing there. He supported her career even after their daughter Nancy was born in 1908, and Lilian Westcott Hale became an integral part of Boston's closely knit community of like-minded artists. Many of them were women; one of Lilian's best friends was another woman painter — her sister-in-law, Philip Hale's older sister, Ellen Day Hale (p. 154).

Lilian Hale's ethereal images of contemplative women in interiors won her much critical and popular acclaim, and collectors sought them avidly. She staged them with models in her studio, sometimes creating both charcoal and oil versions of the same theme. A related and highly finished charcoal drawing entitled *Spring Morning*, dated 1908, is also in the Museum's collection. It employs a composition similar to this one, but it substitutes a bowl of daffodils for the branch of cherry blossoms seen here.

In *L'Edition de Luxe* Hale posed her favorite model, Rose Zeffler (called Zeffy), with a book in front of a window and allowed its soft light, filtered by curtains, to bathe the image in a rosy glow. These pink tones echo in the delicate flowers, the polished table, and Zeffy's coppery hair. Carefully balanced and exquisitely rendered, the whole composition is an "edition de luxe," just like the luxurious volume the young woman holds and to which the painting's title refers. The composition reflects Hale's belief

in the importance of beauty and craftsmanship. Her traditional artistic ideals, however, did not prevent her from pursuing an active and successful professional career. Hale's images of quiet women earned her national recognition.

Oil on canvas
58.4 x 38.4 cm (23 x 15 ⅛ in.)
Gift of Miss Mary C. Wheelwright 35.1487

William McGregor Paxton

1869–1941

The New Necklace, 1910

William McGregor Paxton first studied art with Dennis Miller Bunker at the Cowles Art School in Boston, one of several independent academies that modeled themselves after the educational institutions of Paris. Paxton followed his teacher's example and continued his training in France at the Ecole des Beaux-Arts under the tutelage of one of the most famous French academicians, Gérôme. There he perfected his technical knowledge of the human form and his preference for tightly painted, highly finished figure compositions. Upon his return to Boston, Paxton joined his older colleagues Tarbell and Benson as an instructor at the School of the Museum of Fine Arts.

Like many of his Boston colleagues, Paxton found inspiration in the work of the seventeenth-century Dutch painter Vermeer. Paxton was fascinated not only with Vermeer's imagery but also with the system of optics he had employed. He studied Vermeer's works closely and discovered that only one area in his compositions was entirely in focus; the rest was somewhat blurred. Paxton ascribed this peculiarity to "binocular vision," crediting Vermeer with recording the slightly different point of view that each individual eye sees and combines in human sight. He began to employ this system in his own work, including *The New Necklace*, where only the gold beads are sharply defined while the rest of the objects in the composition have softer, blurrier edges.

Paxton crafted his elaborate compositions with models in his studio, and the props he used, particularly the pink Chinese jacket, appear in several paintings. Here he has implied a narrative, involving the letter and the necklace. But Paxton allows each viewer to fashion his or her own story; he does not indicate whether the jewelry is a gift from an admirer or a purchase, or what the girl in green might advise her friend. In this way, he also emulates Vermeer, whose narratives are often ambiguous. Paxton enhanced his connection to Dutch art by including paintings within his painting and by selecting for *The New Necklace* a contemporary hand-carved frame in a Dutch style made by Foster Brothers, of Boston (see p. 152). His image, carefully composed and crafted, was meant to bring beauty and tradition to its lucky owner.

Oil on canvas
91.8 x 73 cm (36 ⅛ x 28 ¾ in.)
Zoë Oliver Sherman Collection 22.644

Gretchen Woodman Rogers

1881–1967

Woman in a Fur Hat, about 1915

Like her friend and colleague Lilian Hale, Gretchen Woodman Rogers studied at the School of the Museum of Fine Arts with Tarbell. She became an accomplished figure painter, much admired during her own time but little known today. She apparently abandoned her career during the 1930s, unable to earn her living as an artist during the Depression and unwilling to paint only as an amateur.

Something of Rogers's professional determination might be gleaned from *Woman in a Fur Hat.* Although it was never exhibited as such, contemporary critics noted that this image was her self-portrait. The figure's steady, appraising gaze is typical of such works, which are most often made by looking into a mirror. But Rogers gives the viewer no hint that the woman she depicts is an artist, for she wears the elegant winter hat and fur wrap of a well-bred lady and there are no brushes or palette to be seen.

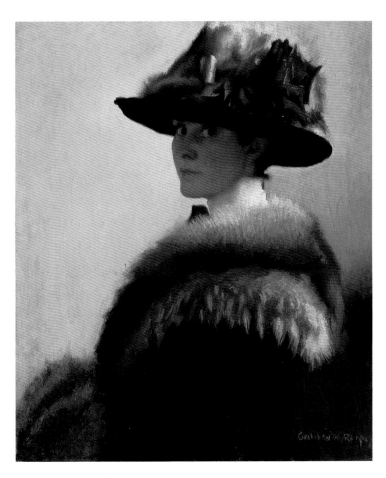

Despite her apparent modesty, Rogers's likeness is a tour-de-force of painting. She includes a variety of textures and materials — velvet, wool, fur, and flesh, each one rendered with absolute verisimilitude. Like many of her Boston School colleagues, Rogers respected the long history and tradition of painting. Her thoughtful, unpretentious woman, surrounded by a gentle, radiant light, is reminiscent of Vermeer's *Girl with a Pearl Earring* (about 1665–66, Mauritshuis), one of the Dutch artist's most mesmerizing pictures. By referring to this well-known painting in her image of a contemporary woman, Rogers links past and present, projecting an exquisite and timeless impression of strength and confidence.

Oil on canvas
76.2 x 64.1 cm (30 x 25 ¼ in.)
Gift of Miss Anne Winslow 1972.232

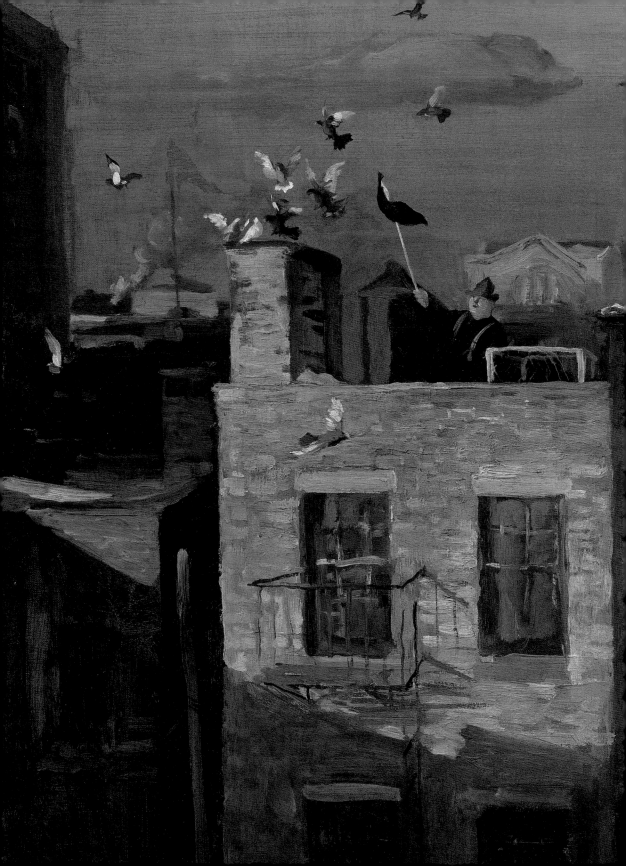

The Twentieth Century: Modern America

Early-Twentieth-Century Realism

One of the watersheds in twentieth-century American painting occurred in 1908, when eight artists held an independent exhibition at Macbeth Galleries in New York City. Robert Earle Henri, Arthur Bowen Davies, William James Glackens, Ernest Lawson, George Luks, Maurice Prendergast, Everett Shinn, and John Sloan promoted themselves, and were characterized in the press, as a band of independents forging a new style in opposition to that sanctioned by the conservative jurors of the National Academy of Design. Henri, a compelling teacher with a charismatic personality, served as the dynamic leader of the group, which came to be known as the Eight. His influential book *The Art Spirit* (1923) declared their break with the old-world traditions of academic art by proclaiming: "New York is better than Paris for artists. Stop studying water pitchers and bananas and paint every day New York life — a Hester Street pushcart is a better subject than a Dutch windmill." Their defiance caused the *New York Herald* to label them "Men of Rebellion," who had instituted a "new Salon." Philanthropist and sculptor Gertrude Vanderbilt Whitney rallied to their cause, hosting exhibitions of their work at her New York studio, established in 1907. Her efforts to promote their work through the Whitney Studio Club led to the formation of the first museum in New York City specifically devoted to American art.

United in their commitment to painting in a style that reflected modernity, the majority of the group (as well as those who shared their sympathies, including Jerome Meyers and George Wesley Bellows) concerned themselves with realist scenes of urban boulevards, barrooms, and rooftops. Although Luks declared that the group aspired to create an American art and not make bad copies of European works, it is clear that in many of their compositions they imitate the fluid brushstrokes of the Impressionists and portray the same parks, entertainments, and fashionable individuals that had preoccupied their French counterparts several decades earlier (see fig. 28). Their preference for the seamier underside of subjects explored by the Impressionists and their unflinching look

at the back alleys of city life led later critics and art historians to refer to these painters as the Ashcan School. The realism they embraced was also consistent with their staunch support of leftist politics through publications like the *Masses*, to which Sloan and his comrades contributed illustrations.

The modernity and solidarity of the Ashcan School derived from their shared experiences in the United States and abroad. Five members of the original Eight — Henri, Luks, Sloan, Glackens, and Shinn — began their careers in Philadelphia, where they received their initial artistic education at the Pennsylvania Academy of the Fine Arts with Thomas Anshutz. Four of the artists — Luks, Sloan, Glackens, and Shinn — also traced their formative artistic experiences to illustration, which served them well in handling the press and in portraying the individual types that populated the urban scene. All but Sloan traveled to Europe (see fig. 29), where they had an opportunity to study and emulate firsthand works by Old Masters and French avant-garde artists. The technical brilliance of many of the artists associated with the Ashcan School, especially Henri and Luks, reflects their admiration for the virtuoso brushwork of seventeenth-century Dutch painter Frans Hals and eighteenth-century Spanish painter Francisco Goya. Yet they were also deeply inspired by the French Impressionists' and Realists' ability to reinvent traditional academic subjects — landscape, portraiture, and still life — through their innovative technique and perspective on modern life.

The transformation of New York City during the early decades of the twentieth century offered ample opportunities for Ashcan artists to celebrate modern life. The vast influx of foreign immigrants and the rapid rise of tenements transformed street life in many American cities, particularly New York. The skyscrapers that began to dominate New York's skyline afforded artists a glimpse of the city and its inhabitants from new vantage points (see, for example, p. 170). Photographer Alfred Stieglitz characterized New York as the heroic "City of Ambition." The fluidity of American society offered hope for rags-to-riches

fig. 28. **Robert Earle Henri,** *Sidewalk Café*, about 1899.

fig. 29. **William James Glackens**
Flying Kites, Montmartre, 1906.

ascents like those of the novelist Horatio Alger's characters. The realists were keenly attuned to the prospect of social mobility afforded by a city in which the wealthy and the penniless lived cheek by jowl. Artists depicted the grand boulevards of Fifth Avenue or city parks (Washington Square, Central Park, and Union Square) and the hand-to-mouth existence of immigrants in the squalor of con-

fig. 30. **Ernest Lawson**, *New York Street Scene*, before 1910.

gested tenement districts on the Lower East Side and in Hell's Kitchen (see fig. 30). As the modern city became increasingly diverse and its experiences intensely alienating, Ashcan artists sought both to portray personality types from all walks of life and to express the essence of their individuality. Although the vision of the Eight and their circle was challenged by the fascination with European abstraction and the new dominance of modernism, they continued to paint. Their clarion call for realism was later heeded by the artists who painted the rural and industrial landscapes of the American Scene during the 1930s and 1940s.

George Luks
1866–1933
The Wrestlers, 1905

After studying with Thomas Anshutz at the Pennsylvania Academy of the Fine Arts and furthering his training abroad at the Düsseldorf Academy in Germany, Luks traveled throughout Europe, returning to the United States in 1894. Initially employed as a newspaper illustrator for Philadelphia journals, Luks was soon encouraged by fellow illustrators who had also studied with Anshutz (Henri, Sloan, and Shinn) to relocate to New York City in 1896.

Criticized for his poor handling of human anatomy, Luks answered his detractors by rendering this complex scene of two nude wrestlers. The artist's perspective was radical for the time. Luks's composition effectively presses the viewer to the edge of the wrestling pit, thereby emphasizing the down-at-heels setting. The jarring vantage point also evokes the sweaty underbelly of modern urban life, a theme for which he and fellow members of the Ashcan School would become known.

Luks's scene of entangled human flesh under duress is reminiscent of the sporting scenes that fellow Philadelphian Eakins painted, in particular Eakins's *Wrestlers* (1899, Columbus Museum of Art). Whereas Eakins depicted a wrestling hold with the impassive eye of a painter rendering a studio model, Luks conveys the passion exuded by the heaving torsos. Eakins applied carefully blended strokes of pigment, building up solidly modeled forms in the manner of his studio training with the French academic painter Gérôme. Luks, in contrast, enlivens his figures with energetic brushwork and thick impasto. The artist's familiarity with the popular press, gained from his work for illustrated periodicals, may have inspired the sense of immediacy he suggests — brilliantly illuminated flesh is thrown into relief against the dark background as though caught in a reporter's flash bulb.

The opponent at the left also recalls the terrifying visages of Goya's Black Paintings (1820–24, Prado Museum), in which human faces are transformed into ghouls. Luks portrays a distinctive type among the multitudes in New York City, in this case an aggressive athlete. His training as a newspaper illustrator undoubtedly honed Luks's astute sensitivity to physiognomy, and here the thickly furrowed brow, devilish eyes, and flushed complexion suggest the bellicose personality befitting a pugnacious wrestler.

Oil on canvas
122.9 x 168.6 cm (48⅜ x 66⅜ in.)
The Hayden Collection. Charles Henry Hayden Fund 45.9

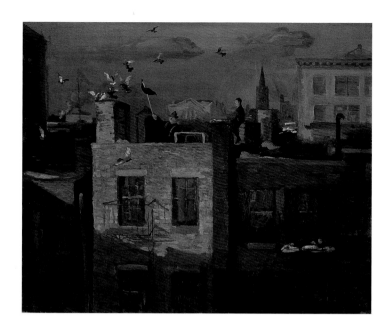

John Sloan
1871–1951
Pigeons, 1910

After attending Central High School in Philadelphia, Sloan taught himself etching, and by 1891 he was making his living as a commercial illustrator. In 1892, while a full-time staff artist for the *Philadelphia Inquirer*, Sloan began taking drawing classes at the Pennsylvania Academy. There he met Henri, who encouraged him (and Glackens, Shinn, and Luks) to take up painting. Sloan stubbornly refused to travel to Europe with the others and remained in Philadelphia until 1903, when he joined his colleagues in New York City.

From the vantage point of his studio on West Twenty-third Street, Sloan worked in a range of media to depict the scenes of daily life he witnessed on the rooftops. Etchings like *Roofs, Summer Night* (1906) and *Love on the Roof* (1914) and paintings such as *Sunday, Women Drying Their Hair* (1912, Addison Gallery) convey a sense of the freedom and escape from the suffocating confines of New York tenement living that roofs provided. Here Sloan depicts the then popular pastime of raising pigeons, which were let loose every day to fly for exercise. Witnessed by their trainer and a young boy perched on the tenement wall, the birds circling above seem to give visual expression to the men's dreams of a flight of fancy high above the city.

Sloan described his desire to capture the golden light of evening that illuminates the skyline so brilliantly, an interest reminiscent of the French Impressionists' concern with the effects of light at different times of day. He noted that the fleeting quality of light before sunset was present for only twenty minutes, and he recalled halting his work each day when the warm orange glow of sunset disappeared from view. The dwindling daylight suggests the passage of time, and in similar fashion, New York's skyline delineates the transformation of the urban scene at the dawn of the new century. At the right a church steeple is clearly visible, and illuminated behind the pigeon trainer, the construction of Pennsylvania Station appears. The new building was symbolically replacing the old, a modern temple of progress in a rapidly expanding city.

Oil on canvas
66.4 x 81.3 cm (26 ⅛ x 32 in.)
The Hayden Collection. Charles Henry Hayden Fund 35.52

William James Glackens

1870–1938

Italo-American Celebration, Washington Square,
about 1912

After studying at the Pennsylvania Academy at night and making his living with Sloan, Luks, and Shinn as an illustrator at the *Philadelphia Press*, Glackens continued his artistic education abroad. Cycling through northern Europe with Henri in 1895, Glackens returned to Paris (see fig. 29, p. 167), where he had ample opportunity to study French painters, particularly the works of Manet, Degas, and Renoir, whom he greatly admired. Although he shared Henri's passion for the dark palette of Manet, by the time he painted this work, Glackens had adopted the lighter tones and loose brushwork of Renoir.

Glackens established himself in New York City by 1896, and in 1910 he began a series of paintings depicting the Washington Square area. By then the park represented the demarcation between the old and new communities of New York. Some of the most prominent New York families who traced their ancestry to the seventeenth-century Dutch settlers still resided in the brick townhouses along the north side of the square, which are visible through the trees on the right. However, the less fashionable neighborhoods around Washington Square attracted newly arrived immigrants who worked in the factories and sweatshops nearby and artists (including Glackens) who were drawn to the bohemian lifestyle of the district.

When Glackens painted this scene of the parade celebrating Christopher Columbus's discovery of America, Italian-Americans constituted the largest immigrant population in Manhattan. Columbus became a role model for many ethnic and religious groups, and Glackens suggests the international flavor of the celebration by painting a variety of flags visible through Washington Square Arch. The juxtaposition of the Old World and the New is further enhanced by the prominence of the Italian and American flags standing side by side in the lower foreground. The American dream of a rapid transformation from immigrant to respected community leader is suggested by the modestly dressed onlookers who observe both the decorated men in top hats seated under the arch and those successful citizens spirited away above the throng in a carriage. Rendered with lively brushwork to enhance the festive and breezy atmosphere, the composition presents a distinctly American spectacle of Italian-American revelers and their pride of place in the urban scene.

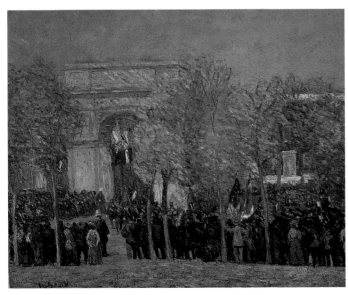

Oil on canvas
65.4 x 81.3 cm (25¾ x 32 in.)
Emily L. Ainsley Fund 59.658

Robert Earle Henri

1865–1929

Irish Girl (Mary O'Donnel), **1913**

The son of a notorious riverboat gambler who changed his name when his family fled the vigilante justice system and started anew on the East Coast, the adventuresome Henri would prove charismatic to many of his colleagues at the Pennsylvania Academy of the Fine Arts, where he studied from 1886 to 1888. Henri traveled extensively in Europe, first between 1888 and 1890 in the company of Glackens, and he attended the Académie Julian in Paris. Later he established himself in New York City, where he became the leading figure among the Ashcan painters and a dynamic teacher at the New York School of Art and the Art Students League.

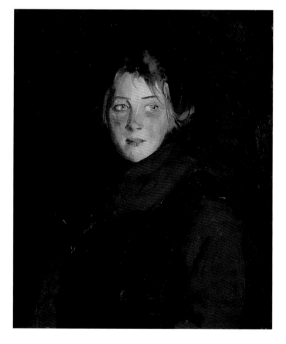

Henri was fascinated by the diverse personalities he encountered in the city, and he became well known for his ability to capture a sitter's personality in his portraits and for his virtuoso handling of pigment. Although he painted a variety of individuals from all walks of life, Henri was especially attracted to children, who were ideally suited to his spontaneity of execution. In the compendium of quotations from his lectures and essays entitled *The Art Spirit* (1923), Henri advocated finishing portraits as quickly as possible, "all in one sitting." His work also recalls the art of the past, which he had encountered in Europe. Here his subject emerges from a dark background in a manner reminiscent of portraits by Velázquez. Henri's confident and lively brushwork further reveals his admiration for Hals.

In a letter to Boston collector John Spaulding, who acquired this painting in 1921, Henri wrote that he met the sitter, Mary O'Donnel, while spending the summer in Ireland. Consistent with his observation in *The Art Spirit* that the "color in her cheek is no longer a spot of red, but is the culminating note of an order which runs through every part of the canvas signifying her sensitiveness and her health," Henri enhanced the ruddiness of the girl's complexion with her brilliant red sweater. The artist also noted her shyness, which he suggested by her averted glance and her nervously pursed lips, defined with touches of yellow pigment. Maintaining that "the look of the eye has its correspondence in every part of the body," Henri rendered Mary's sparkling irises by allowing the lighter weave of the canvas to show through the palest blue stain of pigment.

Oil on canvas
61 x 51 cm (24 x 20 in.)
John T. Spaulding Collection, Bequest of John T. Spaulding
48.562

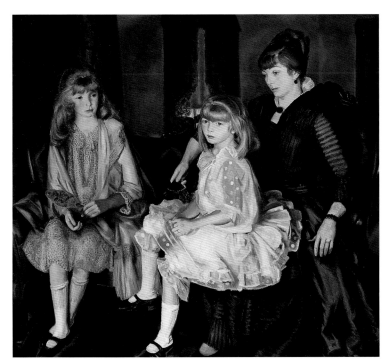

George Wesley Bellows
1882–1925
Emma and Her Children, 1923

Although he did not exhibit with the original Eight, Bellows shared the ideals of the group and concentrated on urban themes, including the excavation for Pennsylvania Station, the underworld of New York prizefighting contests, and tenement life on the Lower East Side. Closely associated with the leading Ashcan figures, Bellows began his formal training with Henri at the New York School of Art in 1904 and between 1913 and 1917 collaborated with Sloan as an illustrator for the socialist magazine the *Masses.*

Emma and Her Children was painted toward the end of Bellows's career during a productive summer he spent in Woodstock, New York, a favored art community in the Hudson River valley. The composition recalls Renoir's large portrait *Madame Charpentier and Her Children* (1878), which entered the Metropolitan Museum of Art to great acclaim in 1907. Bellows poses his wife, Emma, and their two daughters in an elaborately conceived arrangement that evokes bourgeois respectability. In contrast to the elegant nonchalance of the Renoir, the Bellows portrait appears strained. In a letter of 1943, Emma recalled the tension during their portrait sittings. Although Bellows's portrayal of her and their younger daughter, Jane, went very well "from the start," she noted that it was more difficult to incorporate their twelve-year-old daughter, Anne. With maternal protectiveness, Emma's arm encircles Jane, who sits unabashedly with legs askew and surrounded by billowing crinolines. In contrast, Anne, on the cusp of maturity, exhibits a distinct ennui in the pose of her hands and a sense of adolescent self-consciousness in her stiffly crossed ankles.

Writing to Henri in 1923, Bellows described the technical innovations that he developed, which afforded him the same freedom in painting that he experienced in drawing. By laying out the composition in two colors at the outset, as seen in the purple and orange that dominate the MFA's related study of his family, Bellows achieved "the fresh first excitement" of the composition. Seeking to emulate the spontaneity of Renoir, the French Impressionists, and his teacher Henri, Bellows hoped to establish the essential idea of the composition in one day of painting.

Oil on canvas
150.5 x 166.1 cm (59 x 65 in.)
Gift of the Subscribers and by purchase from the John Lowell Gardner Fund 25.105

Maurice Prendergast
Born Canada, 1858–1924
Sunset, about 1915–18

Although he exhibited with the Eight, Prendergast, along with Arthur Bowen Davies, preferred to depict the pleasant and carefree aspects of modern life. Born in Newfoundland, and raised in Boston, Prendergast first traveled abroad in 1886 and later spent three years in Paris, from 1891 to 1894. There he studied with Jacques Courtois at Atelier Colarossi before attending the life class at the Académie Julian. While in Paris he formed a close friendship with fellow Canadian painter James Morrice, who introduced him to a wide circle of artists and theorists. The experience was crucial and formative for Prendergast. He rapidly absorbed the innovations of contemporary French painting, especially the brushwork of Paul Cézanne and the colorful palette of Henri Matisse and the Fauves, or Wild Beasts, as they were called by their critics.

Prendergast renewed his intense interest in French painting after the turn of the century. He modified a decorative style inspired by the Post-Impressionists Georges Seurat and Paul Signac, who had earlier experimented with a painting technique called pointillism, small discrete strokes of color resembling a colorful mosaic or pattern of dots. In *Sunset* Prendergast combines the vivid and opaque paints of the Fauves with a variety of short touches of color inspired by Signac, using them to render the textures of the costumes, trees, and sky.

In contrast to the exuberant scenes of Americans at leisure that Prendergast created at the turn of the century, *Sunset* belongs to a more static group of images produced late in his career. The silhouettes of figures, horses, and dogs arranged in a shallow foreground plane are reminiscent of ancient Egyptian or Assyrian reliefs. This elegiac scene of leisure also recalls the sense of longing and nostalgia evoked by the great bathers of Cézanne and Matisse. Painted during the turmoil of the Great War, *Sunset* suggests a fading era of innocence and carefree pursuits. Many of the grand resort hotels and amusement parks the artist had depicted in earlier paintings, drawings, and prints had by then fallen into ruin or been destroyed by fire and vandals. Although a sense of loss is evident in comparison with his earlier images, Prendergast's bold technique and colorful palette in *Sunset* convey the intensity of his remembrance of times past.

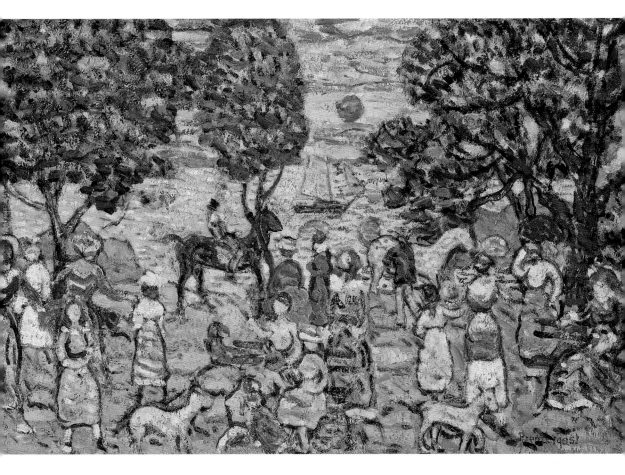

Oil on canvas

53.3 x 81.3 cm (21 x 32 in.)

Emily L. Ainsley Fund, Bequest of Julia C. Prendergast in

memory of her brother, James Maurice Prendergast and

Gift of Mrs. W. Scott Fitz, by exchange 1989.228

Modernism

In the first decades of the twentieth century, when Impressionism had become the dominant style and artists of the Ashcan School had begun to explore urban life with coarse realism, other American painters and collectors began to experiment with modernism. Modernism was an international movement that took many forms. In general, it rejected traditional methods of representing the world (linear and atmospheric perspective, foreshortening, and modeling in three dimensions) in favor of abstraction. One technique, called Fauvism, developed in Paris in the first years of the century and emphasized color for its own sake. Around the same time in Germany, radical artists of Der Blaue Reiter and Die Brücke used highly keyed color and exaggerated forms to convey emotion. Cubism, considered the most influential of all modernist styles, created a wholly new pictorial space based on fragmented images seen from multiple viewpoints.

Photographer Alfred Stieglitz played a seminal role in the introduction of modernism to the United States. Beginning in 1905, he promoted international avant-garde art at a series of galleries he ran in New York, of which the best known was the Little Galleries of the Photo-Secession (also called 291 for its address on Fifth Avenue). He also published a progressive journal, *Camera Work*, which addressed contemporary debates about the nature of art and reproduced modern paintings, sculpture, and photography. Stieglitz's original mission had been to promote photography as a fine art at a time when museums and galleries paid that medium little attention. Within a few years, however, Stieglitz expanded his efforts, introducing both European and American modernists, including Arthur Garfield Dove, John Marin, and Marsden Hartley. He presented drawings and watercolors by Pablo Picasso, paintings, prints, and sculpture by Matisse, watercolors by Cézanne, and sculpture by Constantin Brancusi, among others. Stieglitz showed these European avant-garde artists even before they appeared in the 1913 Armory Show in New York (the controversial exhibition of

some thirteen hundred works that is traditionally credited with bringing modern art to America).

By the mid-1910s Stieglitz had begun to promote American artists almost exclusively, seeking to create a supportive environment for the development of an indigenous modernism in this country. To that end, he acted as tireless advocate, financier, teacher, adviser, and father figure to painters as diverse as George Grosz, Charles Sheeler, and Stanton Macdonald-Wright. Soon he came to favor a group of artists — Georgia O'Keeffe, Hartley, Dove, Charles Demuth, Paul Strand, and Marin — who rooted their abstraction in the natural world. In different ways, each of these artists focused on the American landscape, which they used as a vehicle to express a personal vision. The group was canonized in Stieglitz's landmark exhibition of 1925, which he called "Alfred Stieglitz Presents: Seven Americans" (Stieglitz himself was the seventh artist in the show). The show included paintings, watercolors, and photography, presenting them as equally valid explorations of a new American aesthetic (see figs. 31–32).

In spite of determined efforts by Stieglitz and others, Americans did not immediately embrace modernism. Stieglitz's gallery was maligned by one writer as a "bedlam of half-baked philosophies and cockeyed visions." By the late 1910s and early 1920s, though, some bold collectors sought out work by the fledgling American modernists. New York lawyer John Quinn, who first owned masterpieces by the French artists Seurat, Cézanne, and Picasso, began to acquire paintings by Marin, Sheeler, and Hartley. Katherine Dreier, who had worked with

fig. 31. **Alfred Stieglitz,** *Songs of the Sky in Five Pictures (No. 2),* 1923.

fig. 32. **Arthur Garfield Dove,** *Clouds,* 1927.

artists to form the Société Anonyme, Inc., in 1920, a group devoted to promoting modern art, formed a significant collection that she later donated to Yale University. Duncan Phillips, originally a collector of Impressionism and Post-Impressionism, by the 1920s became an advocate for modernism, acquiring works by O'Keeffe, Hartley, Marin, and most of all Dove, whom he supported for years with a monthly stipend. In 1921 Phillips opened his home in Washington, D.C., to the public as the first museum in this country dedicated to modern art, now known as the Phillips Collection. Of the early collectors of modernism, Ohio industrialist Ferdinand Howald put together perhaps the most comprehensive group of American pictures, including almost three dozen Demuths, thirty Marins, and twenty Hartleys, which now form the core collection at the Columbus Museum of Art.

In the next generation, one of the greatest champions of American modernist art was the Massachusetts manufacturer William H. Lane. Lane especially admired artists of the Stieglitz Circle; his collection is particularly strong in landscapes and still lifes by Dove and O'Keeffe (fig. 33). Like Stieglitz, Lane believed passionately in the equal validity of all media. To that end, he collected both paintings and photographs by the American modernist Sheeler. The ninety paintings and works on paper in the Lane Collection use the language of abstraction to express a poetic vision of the natural world, a constant trend in American art since the mid-nineteenth century.

fig. 33. Georgia O'Keeffe, *Deer's Skull with Pedernal*, 1936.

Marguerite Zorach
1887–1968
Whippoorwills, 1917

Oil on canvas
50.8 x 61 cm (20 x 24 in.)
Arthur Gordon Tompkins
Fund 1993.867b

Marguerite and William Zorach spent the winter
seasons in New York City. There, they soaked up the
avant-garde ideas in paintings and sculpture shown
at Stieglitz's 291 and elsewhere, while seeking exhibi-
tion opportunities for their own art. The warm
months were for rejuvenation; between 1915 and
1918, the Zorachs spent several summers in New
Hampshire. Although each would later specialize in
other media (Marguerite became well known as a tex-
tile artist, and William was one of the leading sculp-
tors of the modernist generation), during this period
they were active as painters. Their styles, based on
their experiences as art students in Paris a few years
earlier, combined the vivid palette of Fauvism with
Cubist compositional structure. Each of them turned
to the landscape of the surrounding White Mountains
as subject matter. In this case, the results are found
on both sides of a single canvas: on the back of
Marguerite's 1917 *Whippoorwills* is William's *Ran-
dolph, New Hampshire*, painted two years earlier.

William Zorach
Born Lithuania,
1889–1966
Randolph,
New Hampshire, 1915

Oil on canvas
50.8 x 60.7 cm (20 x 23⅞ in.)
Arthur Gordon Tompkins
Fund 1993.867a

It is not known why the Zorachs chose to paint on both sides of a single piece of canvas. They were extremely poor in those years and may have been driven to work in this unusual manner for reasons of economy. But the double-sided canvas is also an expression of the collaborative spirit that marked their careers and their marriage. They frequently held joint exhibitions; Marguerite drew embroidery motifs from images in William's paintings, and William based sculptural elements on her needlework designs. A number of Marguerite's embroidered pictures were worked on (and signed) by both of them.

Both sides of this painting reflect the pleasure the Zorachs took in their summer sojourns in New Hampshire, where they lived rent free and relatively carefree in handsomely situated, if dilapidated, farmhouses that were lent to them by generous patrons. William presented New Hampshire as Arcadia, with sensuous, Matisse-like nudes lounging in a bucolic landscape. He used bold, bright colors reminiscent of French Fauvism. Marguerite's response to their surroundings was much more direct. The rolling hills, leafy woodlands, little waterfalls, and houses nestled in the valleys shown here are an accurate portrayal of the cozy landscape near Plainfield, New Hampshire, where they lived in 1917. The warm earth tones emphasize the organic quality of her picture. She molded the hills and trees into flat, decorative shapes, creating a tapestry-like pattern. Her technique also resonates with her work in textiles, for she painted thinly so that the canvas weave creates a background texture for her design. At the same time, she is a keen observer of nature: she accurately portrays the whippoorwills as having short, rounded wings and rounded tails. Nocturnal birds, they soar by on the surface of the picture, beneath a crescent moon.

Arthur Garfield Dove
1880–1946
The Sea I, 1925

Dove was among the earliest American artists to experiment with abstraction. During a 1908–9 trip to France, he adopted a vibrant but still realistic style influenced by the Fauves. In about 1910, he turned in a different direction and made a series of completely nonrepresentational pastels. In 1912 he became the first American to exhibit abstract work publicly at Stieglitz's gallery 291 (Stieglitz would continue to encourage and support Dove throughout the artist's life). Dove derived his organic compositions of carefully applied color from natural and manmade landscapes. After creating these groundbreaking images, however, he spent the next decade working only intermittently, largely due to financial constraints. He began to devote himself to painting again in the early 1920s.

Dove always pushed himself to investigate and to experiment with a variety of media, and in 1924 and 1925 he produced a remarkable group of some two dozen collages. By 1912 Picasso had begun to incorporate pieces of newspaper, fabric, wallpaper, rope, and even chair caning into his pictures, creating some of the earliest mixed-media collages. The materials that Dove used ranged from magazine cutouts, pages torn out of books, wood, velvet, corduroy, denim, and needlepoint to more three-dimensional objects such as shells, rocks, twigs, steel wool, bamboo, and in one case earrings, a watch, stockings, and even garden gloves. Humorous "portraits" and figurative subjects make up the largest number of his collages, but Dove also made still lifes and landscapes in this medium. Dove's collages, which he called "things," were unprecedented in American art.

The Sea I is one of Dove's most beautiful collages. He glued paper, sand, and gauze onto a sheet of scratched aluminum, creating a delicately moody evocation of light on the water. The silvery tone of the metal, which shifts slightly when viewed through the applied gauze, conveys the humid sheen of sky and sea. Real sand marks the beach. By using these simple materials sparingly, Dove created an image of great subtlety.

Collage (gauze, sand, and paper) on aluminum
33.7 x 54 cm (13 ¼ x 21 ¼ in.)
Gift of the William H. Lane Foundation 1990.404

Helen Torr
1886–1967

Evening Sounds, about 1925–30

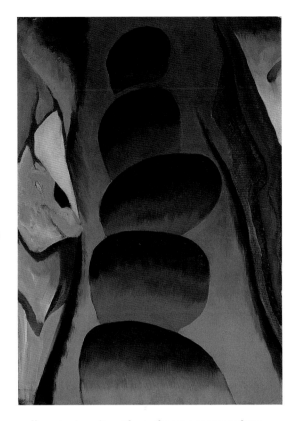

"I find something coming into the abstract work of certain Americans — particularly O'Keeffe and Helen Torr — which is emotionally very moving," wrote historian Sheldon Cheney in his 1924 *Primer of Modern Art.* O'Keeffe was already well known and would soon become even more famous; Torr, then as now, was obscure. But her gentle and intimate abstractions from the 1920s and 1930s were admired by the most forward-looking painters and critics of the day: *New York Sun* reviewer Henry McBride, who praised her use of color; O'Keeffe, who included several works by Torr in an exhibition she organized in 1927; and above all, her husband, Arthur Dove.

Philadelphia-born Torr was trained at the Pennsylvania Academy of the Fine Arts and was living near Westport, Connecticut, when she met Dove. By 1920 they lived together on a houseboat; subsequently they moved to a small sailboat moored on Long Island Sound. Torr and Dove had very little money, and living on a boat was cheap. Their work from this period is generally small in scale, because their boat provided only very cramped work space.

Torr's paintings from the late 1920s tended to be abstract, though they generally contained poetic references to nature. *Evening Sounds*, painted in soft secondary tones of lavender, maroon, and orange against a gray background, has no obvious subject, yet it is evocative and full of feeling. The key motif is the rhythmic progression of lavender ovals that have the measured repose of rocks in a Zen garden seen at close range; at the same time they seem to drift off into a silvery space.

This presentation of the harmonies of nature in an abstract and therefore universal language was a principal concern of artists associated with Stieglitz, even if that association was through marriage. Stieglitz, who gave Dove solo exhibitions at his gallery, An American Place, almost every year from 1926 on, showed Torr only once, in 1933. At the same time, Torr's silvery tones and — as this painting's evocation of sound through color suggests — her interest in synesthesia remind us how closely she was working with her husband. His 1927 painting *George Gershwin — I'll Build a Stairway to Paradise* (MFA, Boston), with its metallic colors and jazzy shapes, is as ebullient as Torr's *Evening Sounds* is serene; together they reveal artists working in tandem.

Oil, possibly with wax, on composition board
36.19 x 25.4 cm (14 ¼ x 10 in.)
The Hayden Collection. Charles Henry Hayden Fund
1998.15

Georgia O'Keeffe

1887–1986

White Rose with Larkspur No. 2, **1927**

By the age of twelve O'Keeffe had determined to become an artist. Beginning in 1907 she studied at the Art Students League in New York City under the Impressionist William Merritt Chase, and then later at Columbia University's Teachers College with the painter, printmaker, photographer, and art theoretician Arthur Wesley Dow. While taking classes with Dow in the mid-1910s, she began to experiment with abstraction, creating her first series of nonrepresentational works, which she called "Specials." O'Keeffe then applied her new approach to landscapes and figural studies and, by the end of the decade, to fruit and floral still lifes. At this time, her work came to the attention of Stieglitz (whom she would marry in 1924); he displayed a series of her abstract drawings for the first time in an exhibition at his gallery 291 in 1916.

O'Keeffe eventually returned to representation, using simplified forms, close-ups, and both bold and subtle color juxtapositions. She painted *White Rose with Larkspur No. 2* in 1927, a year in which enlarged images of flowers, including poppies, petunias, and calla lilies, dominated her output. She later wrote that she felt she had executed some of her best work in 1927. That year she produced five canvases of white roses (only two of which included larkspur), all close-ups that vary in their degree of abstraction.

White Rose with Larkspur No. 2 is a masterly study of subtle color. O'Keeffe carefully manipulated the range of whites in the rose petals, and her tones shift from green to gray to yellow. The flowers themselves are both recognizable and abstracted, and by their very scale O'Keeffe makes the viewer consider them in a new way. As she wrote in 1939, "[N]obody sees a flower — really . . . I'll paint what I see — what the flower is to me but I'll paint it big and they will be surprised into taking time to look at it — I will make even busy New Yorkers take time to see what I see of flowers."

Oil on canvas
101.6 x 76.2 cm (40 x 30 in.)
Henry H. and Zoë Oliver Sherman Fund 1980.207

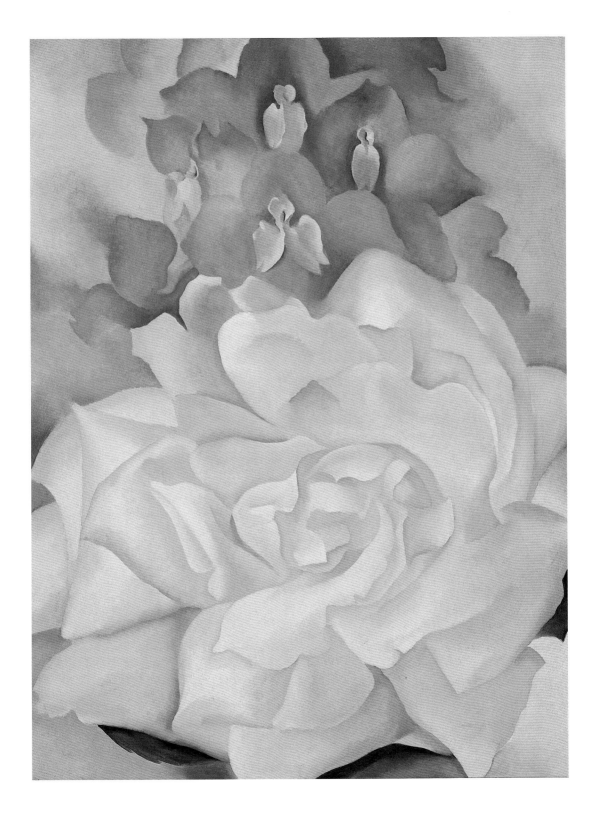

Charles Demuth

1883–1935

Longhi on Broadway, 1928

In spite of his deteriorating health due to diabetes, Demuth was extremely prolific during the 1920s. Building on his success of the previous decade, he produced a large number of watercolors by working in his own delicate modernist style, which was based on the Cubist form and Expressionist color he had studied during a series of trips to Europe as a student. Still lifes, especially floral ones, continued to be Demuth's specialty, although he had also made figurative and architectural compositions in the 1910s. Demuth had begun his career as a painter in oils and had trained at the Pennsylvania Academy of the Fine Arts under Anshutz, but he did not return to the medium until 1920, when he focused on industrial subjects of his native Lancaster, Pennsylvania.

In 1923 Demuth embarked on a series of "portraits" made in homage to his avant-garde friends, including

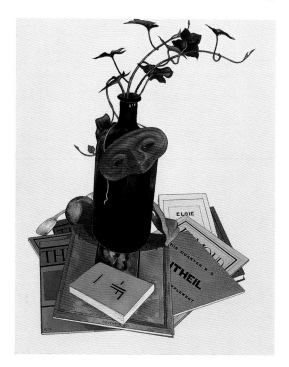

artists Marin, Hartley, Dove, and O'Keeffe and the writers Gertrude Stein and William Carlos Williams. Demuth's images were not likenesses but still lifes containing objects that he associated with his subjects. Other modernists — writers, composers, and artists including Francis Picabia, Virgil Thomson, Marcel Duchamp, Stein, Hartley, O'Keeffe, and Dove — had also made these kinds of symbolic portraits in words, music, photography, caricature, collage, and paintings. The resulting works were often appreciated only by a small circle who were able to decipher the allusions. For his portraits, Demuth fused his modernist style with elements of commercial advertising, using flat shapes, lettering, and highly keyed color. The results were little understood, and when four of them were exhibited by Stieglitz in 1925 (Demuth's first exhibition there), one critic complained that they were done "in a code for which we have not the key." Scholars have suggested that *Longhi on Broadway*, with its arts publications and masks (traditional symbols of the theater), is a portrait of the playwright Eugene O'Neill, whom Demuth had first met in Provincetown, Massachusetts. The title refers to the eighteenth-century painter Pietro Longhi, who included dancing masked figures in his images of the Venetian aristocracy.

Oil on board
86.1 x 68.6 cm (33⅞ x 27 in.)
Gift of the William H. Lane Foundation 1990.397

Charles Sheeler
1883–1965
View of New York, 1931

Sheeler contributed to early modernism both as a painter and as a photographer. A Philadelphia native, he trained at the School of Industrial Art and then went to the Pennsylvania Academy of the Fine Arts, where he studied with the Impressionist Chase. His earliest paintings show the influence of his teacher's style, but a 1908 trip to Paris and an encounter with the paintings of Cézanne sent his work in a different direction. Sheeler started to explore form and structure in his paintings rather than the fleeting effects of light on transitory subjects. In 1911 he began to correspond with Stieglitz, also an admirer of Cézanne, although Stieglitz never exhibited Sheeler's work. To support himself, Sheeler took up photography in 1912. He made images for commercial use, enjoying the financial security of producing photographs for magazine publishers and advertising firms. Sheeler also garnered critical acclaim for his photographs as works of art, and he began to experiment with film.

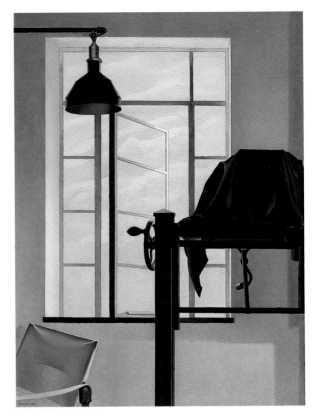

During the teens and the 1920s, Sheeler was still struggling to gain respect as a painter. His dealer, aware of the secondary status that photography held among many collectors and critics, recommended that he restrict himself to the brush. With no guarantees of the same kind of success in painting that he had realized in photography, Sheeler embarked on the next phase of his career with uncertainty.

View of New York was executed the year that Sheeler made the difficult decision to set aside photography. The painting's title is ironic, for it does not depict a cityscape at all; rather it shows the interior of the artist's studio in New York. Through the open window, Sheeler painted a cloudy sky instead of the skyscrapers and crowded streets that had occupied an earlier generation (see, for example, p. 171). The balanced, geometric structure of the composition and the limited palette of grays, pale blues, and maroon underscore the stillness of the interior, as do the objects pictured: the empty chair, the unlit lamp, and a covered and unused camera. The enigmatic, almost funereal mood of this work space alludes to Sheeler's own ambivalence. He called the image "the most severe picture I ever painted," but it was also one of his most personal.

Oil on canvas
121.9 x 92.4 cm (48 x 36⅜ in.)
The Hayden Collection. Charles Henry Hayden Fund 35.69

Joseph Stella
Born Italy, 1877–1946
Old Brooklyn Bridge, about 1941

Completed in 1883 and hailed as an engineering won-der, the Brooklyn Bridge was recognized as a symbol of the modern city by artists and writers alike. Walt Whitman, Marin, Hart Crane, Lewis Mumford, and O'Keeffe, for example, all paid homage to this struc-ture. The bridge was viewed as more than an icon of the industrial age, though, for its design and con-struction fused the new technology of its innovative cable suspension with historical references to the past: the great Gothic arches of its towers linked the Old World and the New.

Joseph Stella was twenty when he emigrated from Italy to New York. He began to study art in the United States, then traveled back to Europe in 1909, where he saw a variety of avant-garde styles. In Paris he encountered Futurism, a method of painting that attempted to express the intangible properties of motion and speed. Although he would experiment with a variety of approaches throughout his career, Stella pioneered Futurism in the United States upon his return to New York in 1912. He settled in Brooklyn about 1919 and began to paint the bridge

with this new vocabulary, using its flashing lights and rush of crisscrossed wires to indicate movement through space.

The Brooklyn Bridge was a recurring theme in Stella's work, and he became identified with the subject. He made numerous small studies of the span and five major oils; *Old Brooklyn Bridge* was one of the last. His richly colored, fractured composition not only reflects his modernist approach but also recalls the stained glass windows of Gothic architec-ture. Stella himself alluded to this marriage of the new and the old, describing the bridge as a "shrine containing all the efforts of the new civilization of AMERICA."

Oil on canvas
193.7 x 173.4 cm (76 ¼ x 68 ¼ in.)
Gift of Susan Morse Hilles in memory of Paul Hellmuth
1980.197

John Marin

1870–1953

Movement — Sea or Mountain
As You Will, 1947

Marin was one of the first American painters to be shown at Stieglitz's 291, in 1909. He established his reputation as an abstract watercolorist, and Stieglitz opened almost every season at his galleries with a Marin watercolor exhibition. Unusual for a modernist, Marin's work appealed to both an avant-garde and a mainstream audience — for its abstract qualities on the one hand and its accessibility on the other — and he became one of the most widely respected and popular artists of the first half of the twentieth century. By 1948, at the age of seventy-eight, Marin was described in *Look* magazine as America's "Artist No. 1."

Throughout his early career, Marin worked in oils sporadically, exploring the medium in a sustained way only in the late 1920s. He learned to exploit the texture of the oils in much the same way that he had done with watercolor, delighting in the lushness of the thick paint "dragged across the tooth of the canvas," as he put it. His subjects in oil crossed over from watercolor, too, and he would frequently work out similar themes in both media.

Marin produced some of his best oils in the mid-1940s, a time of great personal loss for him — his wife died in 1945, and Stieglitz, who had been a close friend as well as a supporter, died in 1946. In 1947 Marin began a series of abstract seascapes that pushed the limits of both his medium and his representational art. At the time, he said, "Using paint as paint is different from using paint to paint a picture. I'm calling my pictures this year 'Movements in Paint' and not movements of boat, sea or sky, because in these new paintings although I use objects, I am representing paint first of all, and not the motif primarily." He said of the Museum's oil painting, the last in the series, "I am going to call it Sea or Mountain As You Will. The paint is the thing." This belief in the primacy of paint and the evocative potential of the bare canvas would be fully explored by a younger generation of American artists, including Jackson Pollock and Franz Kline.

Oil on canvas
76.8 x 93 cm (30 ¼ x 36 ⅝ in.)
Tompkins Collection 63.1527

 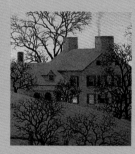 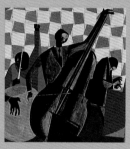 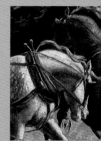

The American Scene

Although Stieglitz and others had begun to introduce modern art to the United States in the first decade of the twentieth century, many Americans viewed European avant-garde paintings and sculpture for the first time at the Armory Show in 1913. More than half a million people saw the exhibition in person, and many more read the outraged reviews in the press — one reviewer in the *New York Times* described the show as "pathological!" Nevertheless, in the 1910s scores of American artists explored these innovative European styles. However, partly as a result of the horrors of World War I (1914–18), many Americans became deeply disillusioned with European affairs and turned their attention toward home. In the 1920s a mood of isolationism surfaced, which lasted until the United States was thrust into another world war by the attack on Pearl Harbor in 1941.

As American society looked inward, some artists and writers tried to redefine the American experience. Critics and artists sought a unique American art that would express distinctive national themes and would not depend on European theories and subject matter. Whereas some artists such as Stuart Davis and Dove explored American subjects in an abstract vein, others began to return to a more representational style. Thus in the years between the world wars, parallel traditions of realism and abstraction existed concurrently in the United States. The realist mode was called the American Scene. The term was first used in the 1920s to describe the work of Charles Burchfield, who depicted provincial America in watercolors. It now refers more broadly to works painted in a realistic manner from about 1920 to the early 1940s. American Scene painting embraced a range of movements, including Regionalism and Social Realism.

Regionalist painters presented distinctively American subjects and often celebrated rural values. The three best-known Regionalists, Thomas Hart Benton, John Steuart Curry, and Grant Wood, were born in the Midwest, and although they used different styles, all three explored the landscape and agricultural activities of that region. They hoped their subjects would be accessible and avail-

able to the masses — rather than to only a select few at the center of the art world — as would be appropriate in a democracy. Their goals were aided by an unusual ally. When the stock market fell in 1929, America was plunged into the decade-long Great Depression, which deepened American self-absorption. In an attempt to provide jobs for artists, President Franklin Delano Roosevelt established the six-month-long Public Works of Art Project (PWAP) in 1934. It was succeeded by the

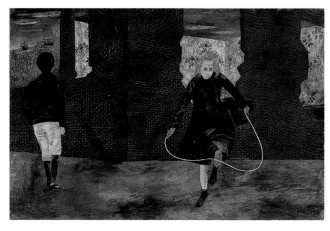

fig. 34. Ben Shahn, *Girl Skipping Rope*, 1943.

Works Progress Administration's Federal Art Project (FAP). The first comprehensive program to support a range of artists including writers, musicians, and actors, the FAP lasted from 1935 until 1943. It funded five thousand artists and thousands of works of art, including some twenty-five hundred murals in public buildings across the country, often depicting scenes from American history. Thus at a time when private support was diminishing because of the Depression, the U.S. government, for the first time ever, became a major patron of the arts and an equal opportunity employer for men and women.

In their murals and other works, the Regionalists frequently displayed a sense of nostalgia and nationalistic pride. They also showed an antiurban bias. Battered by the Depression and suspicious of Eastern centers of finance and culture, Americans welcomed seemingly pure imagery from the heartland. By 1934 Benton was the most famous artist in the country and appeared on the cover of *Time* magazine. Wood's *American Gothic* (1930, Art Institute of Chicago), a fictional representation of an unsmiling farmer and his unmarried daughter in front of a Gothic farmhouse, remains one of the most widely recognized images of all time.

Another aspect of American Scene painting was more urban and politically liberal. Social Realists, including painters, photographers, printmakers, sculptors, and filmmakers, sought to criticize and draw attention to the horrendous everyday conditions of America's poor. Social Realism had its roots both in the implicit criticism of social conditions evident in the paintings of the Ashcan School and in the work of nineteenth-century European artists, particularly Jean-François Millet and Honoré Daumier, who had honored the working class. The great Mexican muralists Diego Rivera, José Orozco, and David Siqueiros also influenced the movement. All three received important commissions in the

United States in the late 1920s and 1930s, and their bold messages of social protest affected many American artists. Social Realists like Ben Shahn, Philip Evergood, and Raphael Soyer painted factory workers, city dwellers (fig. 34), immigrants, and other urban subjects. They did not shy away from political commentary. Shahn, for example, painted a series of images of the controversial Sacco and Vanzetti trial of 1920, in which two Italian immigrant anarchists were convicted of murder, an event many felt was a travesty of justice.

Several important painters of the American Scene were not part of either the Regionalist or the Social Realist movement. Edward Hopper, for instance, was essentially apolitical, creating a singular vision of alienated Americans in both urban (fig. 35) and rural settings. Furthermore, although the Regionalists promoted the idea of glorifying the common man and instilling pride in purely American art, large segments of society were not included in their agenda. The

fig. 35. **Edward Hopper,** *Room in Brooklyn*, 1932.

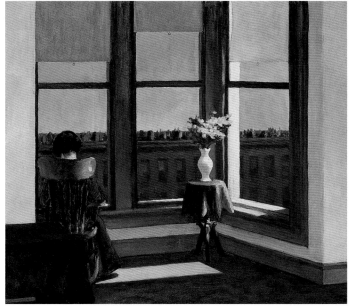

daily lives of rural African-Americans were vividly documented by photographers and printmakers, but such themes were seldom explored in Regionalist paintings. Social Realist Robert Gwathmey did convey the hardships of the black farmer. Independent artists such as Horace Pippin and Jacob Lawrence successfully translated the black experience into paint. Lawrence, in particular, was stimulated by the Harlem Renaissance, a flowering of black literature, music, and art in 1920s New York. Through the vision of all of these artists, Americans gained a better sense of themselves.

Edward Hopper
1882–1967
Drug Store, 1927

Hopper was one of the most important observers of the American Scene beginning in the 1920s. Although he had been a student of Henri and was familiar with the busy social scenes of the Ashcan School painters, Hopper focused his own imagery on the alienation of modern life. He often portrayed solitary and isolated figures that seem to be aching with loneliness or multiple figures that do not interact. Hopper also recorded architectural scenes, both rural and urban, infusing them with a similar feeling of abandonment; he chronicled the ravages of the Depression by depicting forsaken farms and For Sale signs on suburban streets.

In 1927 Hopper delivered a painting entitled *Ex Lax — Drug Store* to his dealer Frank K. M. Rehn in New York City. Peggy Rehn, the dealer's wife, felt that the allusion to a laxative was indelicate, and Hopper was persuaded to change the second *X* to a *C*, which he did in watercolor. Shortly thereafter, however, John T. Spaulding, a Boston lawyer and collector who favored bold images, bought the painting for fifteen hundred dollars and encouraged Hopper to restore the product name. Now known as *Drug Store*, the painting is one of Hopper's early masterpieces. Many of the themes and devices seen in his later work are evident in this striking picture.

In *Drug Store* Hopper utilized the brilliance of electric light, his love of architectural features, and his sense of drama to convey an eerie nocturnal solitude. In many of his nighttime paintings, dazzling light streams from a window surrounded by darkness. Here the bright lights within the pharmacy, the light over the door, and the unseen street lamp combine to produce geometric designs on the pavement and to illuminate architectural elements. In this late-night scene, Hopper's New York City (for surely a similar drugstore existed near his Washington Square studio) is deserted and ominously silent. No people stroll on the sidewalk. No cars crowd the street. The sense of danger lurking in the shadows negates the welcome of the brightly lit window.

As he did in many of his urban paintings, Hopper chose to depict a street-corner building — Silbers Pharmacy is seen from a slightly oblique angle. Hopper explores the repeating rectangles of curb, building, storefront, and signs, and he uses bold lettering to punctuate his formal design. The window of this independent drugstore displays red and green apothecary bottles, like the running lights of ships in the dark. The patriotic colors of the red, white, and blue window decorations are a reminder that in the late 1920s Hopper was one of the foremost painters of the American Scene. However, the pride of patriotism is tempered by the brazen advertisement of a well-known laxative.

Oil on canvas
73.7 x 101.9 cm (29 x 40 ⅛ in.)
Bequest of John T. Spaulding 48.564

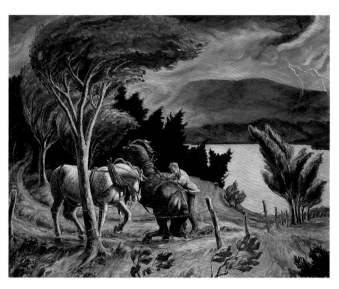

John Steuart Curry
1897–1946
Storm over Lake Otsego, 1929

In contrast to the disquieting stillness of Hopper's paintings, Curry depicted a vigorous and active American landscape. Born on a farm near Dunavant, a small town in Kansas, Curry was well acquainted with the backbreaking work of farming as well as with the ferocious wind and rainstorms that often swept through the state. Farm animals and storms would be important motifs for Curry throughout his career. After studying at the Art Institute of Chicago, Curry worked as an illustrator for popular magazines in the New York area from 1921 to 1926. Following a year of study in Paris (1926–27), where he admired the powerful work of Baroque painters, especially Rubens, Curry moved to the artists' colony in Westport, Connecticut, determined to become a painter rather than an illustrator. During the 1930s he became one of America's best-known Regionalists.

Although many of his paintings reflected life in Kansas, Curry also depicted the area around Cooperstown on Otsego Lake in New York, where he occasionally vacationed. Nineteenth-century writer

James Fenimore Cooper had made the area famous when he celebrated Otsego Lake in his Leatherstocking tales, calling it the Glimmerglass. In *Storm over Lake Otsego* Curry drew on the narrative skills he had learned as an illustrator and on the example of Rubens's highly energized paintings to capture the exertion of a man at the center of a whirlwind trying to control farm horses frightened by wind and lightning. Using somewhat lurid colors and dynamic forms, Curry portrayed the struggle of man against nature, a frequent theme in his work, and he made an ordinary American farmer the hero of the battle. In choosing an American rural scene as his subject matter, Curry exemplified the Regionalists' desire to promote their own national imagery as a worthy theme for great painting. His depiction of an American farmer subduing the forces of nature is evidence of the patriotic pride inherent in the style.

Oil on canvas
101.9 x 127.6 cm (40 ⅛ x 50 ¼ in.)
Gift of Mr. and Mrs. Donald C. Starr 55.369

Horace Pippin

1888–1946

Country Doctor (Night Call), 1935

Pippin was the grandson of slaves and the son of a domestic worker and a laborer. He was not trained as an artist and did not complete his first oil painting until 1930, when he was forty-three years old. Injured in his right shoulder while serving in the all-black 369th Infantry Regiment during World War I, Pippin had to hold the brush in his right hand and move it across the canvas with his left. Using this painstaking technique, he painted pictures about his war experiences, the domestic lives of African-Americans remembered from his childhood, outdoor scenes, still lifes, religious subjects, and portraits (of the great black singer Marian Anderson, for instance), as well as narrative works about two antislavery figures: John Brown and Abraham Lincoln. His works rarely contain overt social commentary, but they vividly capture Pippin's life experiences and those of his heroes.

In *Country Doctor*, also known as *Night Call*, Pippin was able to achieve astonishing effects with a limited palette and an intuitive sense of design. The artist used thin washes of white pigment to convey the heavy snowfall through which a country doctor leads his horse and covered cart, presumably to tend to a patient. Pippin was apparently dissatisfied with the original grayish color of the snow and repainted it a brighter white — the gray is visible around his signature in the lower right corner. The jagged slash of a small creek in the foreground anchors the composition, and the graceful patterns of the bare tree branches emphasize the cold, nocturnal nature of the journey. A clear path leads into the dis-

tance, and footsteps in the snow indicate the progress the doctor and carriage have made. Pippin's painting quietly celebrates the dauntless and gallant country doctor, then an important part of the American rural scene. In the late 1930s Pippin met the famous Philadelphia collector Albert C. Barnes, who became a champion of his work and helped to popularize scenes of black American life by African-American artists.

Oil on canvas
71.5 x 81.6 cm (28 ⅛ x 32 ⅛ in.)
A. Shuman Collection 1970.47

Robert Gwathmey

1903–1988

Sharecropper and Blackberry Pickers, 1941

During the 1930s and 1940s, Gwathmey and other Social Realist painters such as Evergood, Shahn, and Lawrence, as well as photographers Dorothea Lange and Walker Evans, depicted the lives of the destitute and the dispossessed in America with an implicit criticism of the political and economic forces that maintained inequities in wealth and power. Gwathmey, in his paintings, protested the living conditions of poor African-American families in the South. Born to a white family that had lived in Virginia for eight generations, Gwathmey spent most of his adult life in the North. He studied at the Pennsylvania Academy of the Fine Arts from 1926 to 1930 and taught at Cooper-Union in New York for twenty-six years. It was not until he returned to the South after his first year at the Pennsylvania Academy that

he saw how hard life was for the Southern black. His paintings are filled with the unending toil of black men and women and often contain barbed wire, lynching ropes, and other symbols of oppression.

When the MFA purchased *Sharecropper and Blackberry Pickers* in 1941, it was one of the first of Gwathmey's works to enter a major museum's collection. In a letter to the Museum's curator of paintings, Gwathmey, who was teaching at the Carnegie Institute in Pittsburgh, wrote, "I have long been interested in our local scene and always return to my native heath with the coming of summer. The plight of the sharecropper, the evils of the usual one crop farming, with its contingent poverty, and the worn earth have all too long been smothered by a traditional romanticism." Gwathmey's painting rejects such romanticism; his bold designs and simplified forms convey a powerful image of hardship and toil.

Gwathmey was well versed in European art, having won Cresson Fellowships for European travel in 1929 and 1930. Like the French painter Georges Rouault, Gwathmey developed a modern style based on compartmentalized areas of lush color enclosed by angular black lines, resembling the medieval stained glass he had seen in Europe's great cathedrals. He often used the same figure in more than one composition, and an oil painting entitled *Hoeing* (1943, Carnegie Museum of Art) also depicts the figure of the black man wiping sweat from his brow. Gwathmey explained in a 1963 letter: "I make 'working drawings' and then paint from there. When I try to paint directly from the object I'm utterly bound. It being once removed allows me the area of adjustment I need."

Oil on canvas
81.6 x 61.3 cm (32 ⅛ x 24 ⅛ in.)
The Hayden Collection. Charles Henry Hayden Fund 41.688

Marsden Hartley
1877–1943
The Great Good Man, 1942

Although most of the American Scene painters rejected European modernism and radical abstract styles, Hartley embraced abstraction in his early years and found figurative painting near the end of his life. Born in Maine, Hartley had become part of Stieglitz's circle in 1910 and then spent several years traveling in Europe absorbing the modernist styles of Picasso, Matisse, Cézanne, and Wassily Kandinsky. Until 1937, when he resettled in Maine, Hartley traveled in avant-garde circles, moving frequently from place to place in Europe and America. After trying out different subjects and styles throughout his career, he ended up reaffirming his Americanism by painting landscapes in Maine, New Mexico, and Gloucester, Massachusetts. In 1940 he explored that most American of subjects: Abraham Lincoln. Between the world wars, Lincoln's reputation had grown to epic proportions, in part because of Carl Sandburg's folksy biography of him. Hartley painted three portraits in homage to the Civil War president, and he also wrote two poems about him: "American Ikon — Lincoln" and "A. Lincoln — Odd, or Even."

Hartley painted *The Great Good Man* near the end of his career. His portraits of Lincoln were among a series of images of his heroes, including the artist Albert Pinkham Ryder and the seventeenth-century English poet John Donne. Larger than life, *The Great Good Man* is bold and iconic. Basing his painting on an 1862 photograph by Civil War photographer Mathew Brady, Hartley employed Cézannesque brushstrokes to create the planes of the president's face and rough strokes of black paint to convey his features, including the mole on his cheek and his almond-shaped eyes. Although academically trained, Hartley appreciated American folk art, which enjoyed a revival of interest during the early twentieth century. The bold color contrasts and graphic strength of *The Great Good Man* recall similar qualities in folk portraits of the nineteenth century (see p. 88). The palette of black, white, flesh tones, and striking blue for the background, the heroic scale of the painting, and the intentionally crude technique combine to form a memorable image of Lincoln and a triumph for Hartley in the year before his death.

Oil on Masonite
101.3 x 76.5 cm (39 ⅞ x 30 ⅛ in.)
Gift of William H. and Saundra B. Lane and The Hayden Collection. Charles Henry Hayden Fund, by exchange
1990.376

Thomas Hart Benton

1889–1975

New England Editor, 1946

The Regionalist Benton, like Curry and Grant Wood, consciously rejected abstraction in the 1920s and 1930s and developed a narrative style. His primary subject was American social history, and his art contained an element of nostalgia for the past. Benton was most noted for his murals, especially those depicting the history of his native Missouri in the state capitol building in Jefferson City. However, he also painted a series of portraits of old friends after World War II, which were intended to be exemplars of specifically American types. Thus Benton called his portrait of George A. Hough *New England Editor*. Benton had become friends with Hough on Martha's Vineyard, Massachusetts, where both men spent many summers.

Hough worked in the newspaper business in New Bedford, Massachusetts, for fifty years, most of them as editor of the *Evening Standard*. He was known for his high ideals and abhorrence of injustice and was widely admired for his editing skills and his mentoring of young newspapermen and women. Benton painted *New England Editor* with his typical sharp definition and sinuous line. He depicted the newspaperman sitting at a table writing the word *unless* on a paper. Hough was known to proclaim that *unless*

a story was correct, it would not be printed in his newspaper, and *unless* the reporter had exhausted all possible sources, he was not ready to hand in a story. Behind Hough is a painting of the boat *Catalpa*, which did in fact hang in the library of Hough's house on Martha's Vineyard. The *Catalpa* was a New Bedford whaling ship captained by Hough's close friend George S. Anthony. In 1876 Captain Anthony rescued a number of Irish revolutionaries from the British off the coast of Australia. Benton probably included the painting because New Bedford was associated with whaling and because the principled stand taken by Captain Anthony was also typical of the character of George Hough. Benton wrote to the director of the MFA in 1947 that Hough "is one of the finest down to earth Yankees ever to come out of the soil, sharp, witty and smart." Benton's highly polished surface and animated curvilinear forms captured perfectly the dynamism of his friend in this vibrant portrait of an American life.

Oil and tempera on gessoed panel
76.2 x 94 cm (30 x 37 in.)
The Hayden Collection. Charles Henry Hayden Fund
46.1456

Abstraction until 1960

"There are other attributes to modern art," claimed the influential American critic Henry McBride in 1930, "but the ability to feel the abstract is the real test." For many Americans, even those who in the early years of the twentieth century aspired to be new, up-to-date, and modern, abstraction in art was a sticking point. For painters committed to abstraction, acceptance came slowly. Americans had first seen art that had freed itself from the obligation to replicate the external world at Stieglitz's gallery 291 in New York, where Picasso, Braque, Brancusi, and Picabia had their American debuts. Additional exposure to abstraction had come in 1913, when the Armory Show presented works by Duchamp, Jacques Lipchitz, and Picasso, among others. Most startling, perhaps, was Wassily Kandinsky's *Garden of Love (Improvisation #27)* (1912, Metropolitan Museum of Art), the first completely nonrepresentational painting by the artist to be shown in America. Reviled by critics, it remained unsold until the end of the show, when Stieglitz bought it.

By this time a few Americans had begun to experiment with abstraction, and Stieglitz was the first to show their work. Key among them was Dove, who is credited with being the first American to leave representation behind. Dove produced a series of small "Abstractions" in oil about 1910 and, beginning in 1911, a group of pastels that Stieglitz designated the "Ten Commandments." The strategies employed in these pastels — the use of highly simplified shapes, the emphasis on two-dimensionality (rather than the illusion of depth), and the arbitrary, expressive use of color — were adopted by Stieglitz's followers to express the eternal, universal truths in nature.

By the late teens Stieglitz was no longer showing the European avant-garde but promoting young American talent, a nationalist focus that was consistent with the isolationist spirit of the 1920s. The task of presenting the international avant-garde to American audiences was taken over from Stieglitz by a number of other New York art dealers and especially by the Museum of Modern Art

(MoMA), founded in 1929. During the next decade, MoMA would present pioneering shows such as "Cubism and Abstract Art" and "Fantastic Art, Dada, and Surrealism." The Cubists and Surrealists promoted by MoMA used abstraction to express the visual properties of the perceived world (or, in the case of the Surrealists, the world of the subconscious).

fig. 36. **Jackson Pollock,** *Number 10,* 1949.

Other artists — both European and American — used abstract techniques as a way of arriving at art that was pure and only about itself. That is, they sought to make art that had little reference to the external world. For painters such as Patrick Henry Bruce, active in the teens and twenties, the watchword was Cézanne's admonition to "treat nature by means of the cylinder, the sphere, and the cone." For others, especially the generation that came to prominence in the 1930s, the goal was totally nonrepresentational art; they found inspiration in the works of Kandinsky, Fernand Léger, and Piet Mondrian. As controversial as Cubism had been when introduced to Americans at the Armory Show (a critic derided Duchamp's *Nude Descending a Staircase #2* [1912, Philadelphia Museum of Art] as "an explosion in a shingle factory"), this new art, bewildering because of its lack of describable subject matter, was more suspect still. Nonetheless, the American abstractionists — among them Ilya Bolotowsky, George L. K. Morris, Esphyr Slobodkina, and Burgoyne Diller — were militant in their quest to win acceptance for pure abstraction, forming the Association of American Abstract Artists in 1936 and picketing the Museum of Modern Art in 1940 to protest its lack of support for nonobjective art created by painters and sculptors working in the United States.

Although the works of these artists appear to be exercises in pure form, they were in fact prompted by the contemporary cultural climate. Many artists reacted to the economic and social distress brought on by the Depression by painting realistic (if emotionally charged) scenes of American life. At the same time, however, with the collapse of so many institutions — especially banks and businesses — on which Americans had long felt they could depend, and with the government's seeming inability to stem the crisis, art characterized by strin-

gently organized lines and geometric shapes in pure color was intended to express stability and order in a world that otherwise seemed out of control.

With the outbreak of World War II, many prominent European artists came to America. Some — especially Mondrian — reinforced the American Abstract Artists' nonobjective program. Others — including Max Ernst, Yves Tanguy, and the Chilean-born Roberto Matta Echuarren — heightened the interest in Surrealism, the art of dream and fantasy, of intuition and automatic writing. A number of these artists worked in a hyperreal manner; others constructed their paintings from abstract shapes (although organic, rather than geometric) and line guided by chance and the promptings of the subconscious. The presence of these artists in New York in the early 1940s and the emergence of such original painters as Pollock (fig. 36), Mark Rothko, Adolph Gottlieb (fig. 37), and Willem de Kooning, were catalysts for the formation of a new style, Abstract Expressionism. Their work was encouraged by a number of key patrons and dealers who also returned from Europe at that time. Prime among them was Peggy Guggenheim, whose Art of This Century Gallery in New York gave solo exhibitions to Pollock, Hans Hofmann, Clyfford Still, and others. By the late forties, New York had supplanted Paris as the center of the Western art world.

Among the many ingredients of Abstract Expressionism were the desire to render on canvas the contents of the subconscious (the imagery of dreams and nightmares in Arshile Gorky's and Pollock's work reflect this goal) and a dedication to gesture, to painting as a physical act. Beginning in the early 1950s, artists such as Hofmann, Pollock, and Kline were producing art that was heroic in scale and built of dramatic strokes, splatters, and skeins of paint that represented the direct outpouring of emotion. Their form of abstraction — what Pollock explained as "energy and motion made visible — memories arrested in space" — became the most powerful original style in the history of art in the United States.

fig. 37. Adolph Gottlieb, *Alkahest of Paracelsus*, 1945.

Patrick Henry Bruce
1881–1936
Forms (Peinture), about 1919

Like others of the "lost generation" who left the United States at the start of the twentieth century in search of a more bohemian and modern lifestyle, Patrick Henry Bruce went to Paris in 1904 and remained there for more than thirty years. His first heroes were Matisse and Cézanne; his early work explores the sights and forms of France with a coloristic exuberance inspired by Matisse and a search for structural rigor motivated by Cézanne.

By the end of World War I, however, Bruce's world had contracted, as the international community of artists and collectors he had found so stimulating drifted apart. He began painting still life, a solitary and contemplative genre, concentrating on the objects gathered in his spartan apartment near the Ecole des Beaux-Arts. His subject matter has been identified from photographs of the apartment. Here, on the tilted top of an antique table, Bruce has arranged carpenter's tools, scrolled pieces of wood and architectural moldings (he supported himself by dealing in antique furniture), and possibly a piece of fruit. In emulation of Cézanne, who advocated rendering nature by means of simple shapes, Bruce reduced his commonplace objects to abstract geometric forms. These he painted as weighty solids that nonetheless seem to interact dynamically. He constructed them with a carefully calibrated perspectival accuracy but undermined their stability by

showing each of his forms from a different vantage point. They threaten to tumble over one another and spill out of the picture. Bruce painted meticulously, using careful gradations of color. Here he employed a whole spectrum of blues, augmented with deep green, a salmon hue, and black and white. Preoccupied by these color relationships, Bruce painted layer over layer. As he revised one area, he saw the tonal balance of the whole composition shift, obliging him to then alter other areas (for example, all the black areas in this painting were previously blue), resulting in a thickly built up surface.

By the 1930s lack of recognition, increasing isolation, and the elusiveness of the perfection he sought in his art drove Bruce to despair. He destroyed many of his works, and in 1936, shortly after returning to New York, he committed suicide. His tragic intensity and his belief that his art could provide an opening onto the realms of the imagination are revealed in a poignant letter he wrote in 1928 to his friend the novelist Henri-Pierre Roché: "I am doing all my traveling in the apartment on ten canvases. One visits many unknown countries that way."

Oil on canvas
60 x 92.4 cm (23⅝ x 36⅜ in.)
Gift of the William H. Lane Foundation 1990.386

Arthur Garfield Dove
1880–1946
That Red One, 1944

In the late 1930s, after nearly two decades of makeshift living, first on a houseboat then in ramshackle farmhouses, and finally even in a former roller-skating rink, Dove and his wife, Helen Torr, moved again, this time to an abandoned post office in Centerport, Long Island. Shortly thereafter Dove, who was approaching sixty, fell ill. His health often prevented him from working altogether; at other times his world consisted only of what he could see through the windshield of his car as he drove from his house to Centerport Harbor, a half mile away. Nonetheless, during these years he produced some of the most powerful and affirming pictures of his career.

The genesis of *That Red One* was a tiny watercolor, about three by four inches, which Dove most likely painted while sitting in his car. Like the landscape painters of the nineteenth century, Dove sketched from nature constantly, and these sketches (and the large paintings he based on them) reflect his translation of what he saw into simple colors and shapes. By the 1940s he had moved from a biomorphic, linear style to forms that were geometric and colors that were bold, flat, and clear. *That Red One*, with its brownish purple oval hovering over two red bars and its angled shapes of intense yellow, orange, and blue, probably represents a mundane subject — a view through trees across a pond at sunrise. The result, however, was triumphant. Dove spoke about wanting to show the "point where abstraction and reality meet," and in doing so he created an icon of modern art, a vision of nature that is both evocative and timeless.

Oil and wax on canvas
68.6 x 91.4 cm (27 x 36 in.)
Gift of the William H. Lane Foundation 1990.408

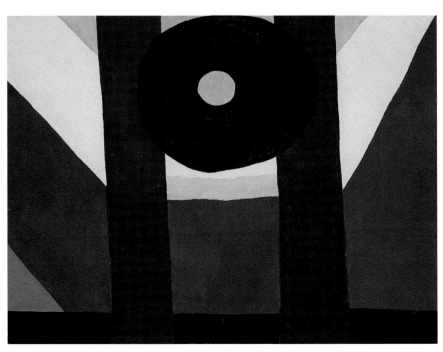

George L. K. Morris

1905–1975

Composition with Birch Bark, 1939

Morris's modernist credentials are impeccable: he was one of the founding members of the American Abstract Artists group in 1936, a frequent exhibitor at Albert E. Gallatin's pioneering Gallery of Living Art, and, beginning in 1937, the first art critic for the progressive cultural magazine *Partisan Review.* At the same time, he is something of a rarity among twentieth-century American painters, an abstractionist with a sense of humor. While he shared the conviction of many of his American Abstract Artist colleagues that pure form was the avenue to great art, he filled his canvases with witty combinations of gleeful shapes, jazzy smiling lines, and unlikely materials.

Morris began painting in 1929. He studied in Paris with Fernand Léger, from whom he absorbed principles of Cubist structure and a sense of the canvas as an animated, plastic surface. But he quickly recast those French ideas into an American idiom. Paralleling the Cubists' interest in African and Oceanic art, Morris found a connection between Native American artifacts and the abstract shapes essential to modernism. In some paintings, he included stylized representations of Indians. Here, alluding to Native American culture, he used pieces of birch bark as part of a collage of organic shapes. These shapes curl around two polka-dotted forms whose saucy contours seem to dance before our eyes like amoebas under a microscope. Although the use of such shapes links Morris to the international movement toward biomorphic abstraction headed by Hans Arp and Joan Miró, his vocabulary is nonetheless fresh and individual. Holding the whole composition in place — pinning it down, as it were — are a dozen nails (and not just any nails but rather old, handmade nails). Arranged in a random pattern, they cast shadows that parallel the pale striations of the birch bark. Their heads echo the polka dots, lifting the jaunty rhythm of the picture into the third dimension.

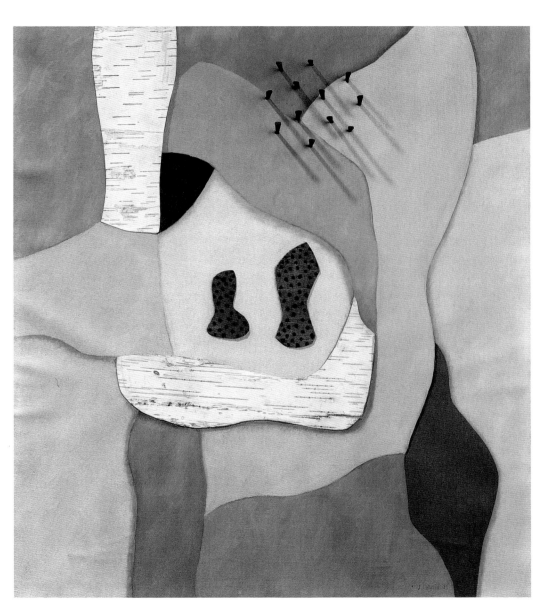

Oil, birch bark, and nails on canvas
69.2 x 63.8 cm (27 ¼ x 25 ⅛ in.)
Gift of the William H. Lane Foundation 1990.428

Stuart Davis

1892–1964

*Hot Still-Scape for Six Colors –
Seventh Avenue Style,* **1940**

Davis's *Hot Still-Scape for Six Colors
– Seventh Avenue Style* captures
the heady, sensory experience of the
modern city. One of the undisputed
masterpieces of twentieth-century
American painting, the image is
the visual equivalent of the synco-
pated rhythms of jazz, an art form
also considered both indigenous
and new. Davis evokes the energy
of both jazz music and city life
through his innovative composition
of lively shapes and lines and his
palette of vibrant color.

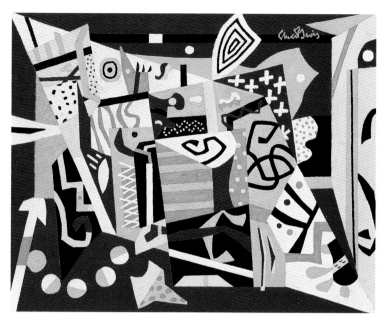

From the outset of his career, Davis was associated
with avant-garde artistic movements. Beginning in
1909 he studied with Henri in New York; his earliest
subjects were the seamy urban scenes favored by the
Ashcan School. The 1913 Armory Show introduced him
to European modernism, which made him determined
to alter the direction of his own work. Over the next
few decades, he experimented with simplified,
abstracted forms, multiple perspectives, and collage,
and he also started to incorporate words into his
paintings. He used everyday objects and references to
popular culture as points of departure, and the places
he lived in or visited — New York City, Paris, and
Gloucester, Massachusetts — recur as themes in his
paintings. In the 1920s Davis's pictures bordered on
the completely abstract, the objects in them often
unrecognizable. His compositions became legible
again in the 1930s, and at that time he also painted
murals and made prints under the auspices of the
Works Progress Administration's Federal Art Project.
Toward the end of the decade he turned once more to
abstraction. Through it all, his work often retained
an underlying sense of humor.

Hot Still-Scape is a masterpiece of Davis's late
abstract style. Its enigmatic title provides clues to its
content. The term "still-scape" was the artist's own
invention: a combination of abstract landscape and
still-life elements he had used in other paintings,
coupled with those he had made up. "Hot," according
to the artist, described the dynamic mood created by
the juxtaposition of the six colors — white, yellow,
blue, red, orange, and black. The designation Seventh
Avenue refers to the street on which Davis had his
studio for fifteen years. It was in the heart of a
bustling West Village neighborhood with lively street
life and noisy automobile traffic (indicated by the syn-
copated street signs in the picture), and just blocks
from a number of the hot jazz clubs in the Village. A
month after he finished the picture, he wrote, "It is the
product of everyday experience in the new lights,
speeds, and spaces of the American environment."

Oil on canvas
91.4 x 114 cm (36 x 44⅞ in.)
Gift of the William H. Lane Foundation and the M. and M.
Karolik Collection, by exchange 1983.120

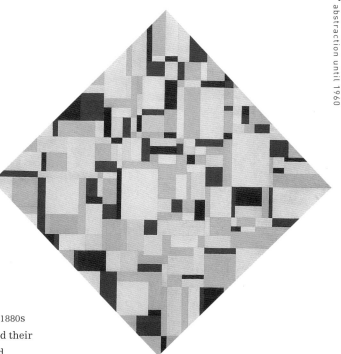

Ilya Bolotowsky
Born Russia, 1907–1981
Spiral Movement (Small Configurations within a Diamond), **1951**

The generation of American artists born in the 1880s — including Sheeler, Demuth, and Bruce — found their greatest inspiration in the work of Cézanne and Matisse. For many of the artists of the next generation, those born shortly after the turn of the century, a critical stimulus was the art of Miró and Mondrian. Their dedication to abstraction set them apart from the Social Realists and Regionalists who dominated the American art scene in the 1930s. Bolotowsky, whose family was forced to flee Russia and came to the United States via Constantinople in 1923, was among the most talented of these abstract painters.

Bolotowsky studied at the National Academy of Design in New York. Like many young artists who began their careers at the outbreak of the Depression, his first work as a professional artist was produced for the federal government's Public Works of Art Project; by the mid-thirties he was painting abstract murals for the Works Project Administration in New York. In 1936 he was a founding member of the American Abstract Artists, and his work from this period often included free-floating, Miró-like lines and biomorphic shapes.

By the 1940s, however, his style had changed again, now reflecting the influence of Mondrian. *Spiral Movement (Small Configurations within a Diamond)*, with its diamond shape and lively grids of small blocks of primary color, is particularly reminiscent of Mondrian's celebrated *Victory Boogie Woogie* (1941–44, Gemeentemuseum, The Hague), which the Dutch artist painted and exhibited shortly after his immigration to the United States. Bolotowsky not only absorbed the formal ideas in Mondrian's pictures but also subscribed to the search for purity, for a universal significance — a kind of aesthetic utopia — that was behind those pictures. For Bolotowsky this striving came out of personal experience. As he stated in a 1974 interview, "After I went through a lot of violent historical upheavals in my early life, I came to prefer a search for an ideal harmony and order which is still a free order, not militaristic, not symmetrical, not goose-stepping, not academic."

Oil on canvas
71.8 x 71.8 cm (28 ¼ x 28 ¼ in.)
Tompkins Collection 1980.208

Arshile Gorky (Vosdanig Manoog Adoian)
Born Armenia, 1904–1948
Good Hope Road, 1945

In 1920 sixteen-year-old Vosdanig Manoog Adoian arrived in the United States. He studied briefly at the Rhode Island School of Design in Providence and at the New England School of Design in Boston before moving to New York City in 1924. As he embarked on his artistic career, he changed his name to Arshile Gorky, claiming kinship with the Russian novelist Maxim Gorky. *Gorky* means "bitter one" in Russian, and his choice was also a poignant reference to his horrific childhood in Armenia during the Turkish invasion. Gorky's memories of Armenia (especially of his mother, who would die of starvation there), coupled with his lyrical response to nature, would be the main ingredients of his art.

Good Hope Road was painted during a rare period of emotional security and domestic comfort. For about nine months in 1945, Gorky lived on Good Hope Road in Roxbury, Connecticut. There, he and his wife and children enjoyed a happy family life — the life that had been wrenched from him in Armenia — in bucolic surroundings. His career was also flourishing: that same year he was taken on by the Julien Levy Gallery, the premier gallery for avant-garde art in New York. His paintings sold well, and the influential critic Clement Greenberg, writing for the *Nation* in 1946, described the solo show in which this painting appeared as featuring "some of the best modern painting ever turned out by an American."

Gorky titled a second painting from 1945 *Good Hope Road* (it is also known as *Hugging*; Thyssen-Bornemisza Collection), which shows two figures embracing in an interior lit by firelight. The MFA painting probably depicts a landscape, perhaps with a figure reclining in front of a tree. Together, these paintings summarize his feelings of contentment. In them, Gorky emphasized drawing to a greater degree than he had earlier; long beautiful lines, biomorphic shapes, and patches of diluted color float across the picture, only occasionally intersecting one another. They create an atmospheric, dreamy world that appeals as much to the heart as to the mind. Gorky's paintings of the 1940s added a profound spiritual component to the language of abstraction and paved the way for the work of artists such as Pollock and Kline.

Oil on canvas
86.7 x 111.8 cm (34 ⅛ x 44 in.)
Gift of the William H. Lane Foundation and Museum purchase 1990.375

Jackson Pollock
1912–1956
Troubled Queen, 1945

In 1949 *Life* magazine published an article with the headline, "Jackson Pollock: Is He the Greatest Living Painter in the United States?" Calling the thirty-seven-year-old artist "the shining new phenomenon of American art," *Life* not only celebrated Pollock's rapid rise among the avant-garde but also acknowledged Abstract Expressionism — of which Pollock was the leading representative — as the premier American style. *Troubled Queen* is a masterly transitional work between the Regionalist paintings of Pollock's early years and the passionate "drip" paintings for which he is best known (see fig. 36, p. 206).

Born in Wyoming, Pollock was trained in art schools in California before enrolling in the Regionalist painter Thomas Hart Benton's classes at New York City's legendary Art Students League. His earliest works were in the Romantic landscape tradition, populated with stylized figures that echo Benton's. But both the literalism and the rhythmic flowing shapes of these pictures soon gave way to a more turbulent style, marked by jagged lines, harsh, acidic colors, and above all imagery that was symbolic, enigmatic, and abstract. The sources for these images were the works of Picasso (whose landmark exhibition at the Museum of Modern Art in 1939 made a strong impression on Pollock), primitive art, and the theories of psychoanalyst Carl Jung (Pollock had begun analysis in the late thirties). But Pollock's approach was stunningly original.

By the mid-forties Pollock had evolved a style that drew images from his subconscious, images that were rendered in a highly textured bravura technique. As *Troubled Queen* shows, Pollock had begun to work on a very large scale by this time; his paint was dragged over, dripped on, and flung at the canvas. His subject matter was no less highly charged: emerging from the churning coils and jagged lines of this life-size canvas are two facelike forms, one a leering mask, the other a one-eyed diamond shape. Their nightmarish presence reflects not only Pollock's agitated psyche but also the years of violence that had torn the world apart. In a few years, all traces of the figure would drop out of Pollock's work, and as *Life* predicted, his style — overlapping skeins of paint expressing deep feeling — would make New York the center of the international avant-garde.

Oil and enamel on canvas
188.3 x 110.5 cm (74 ⅛ x 43 ½ in.)
Charles H. Bayley Picture and Painting Fund and Gift of Mrs. Albert J. Beveridge and Juliana Cheney Edwards Collection, by exchange 1984.749

Hans Hofmann
Born Germany, 1880–1966
Twilight, 1957

When Hofmann came to New York from Germany in 1931 and took a position on the faculty of the Art Students League, he brought with him direct experience of the main schools of modern abstraction. Born in a small town near Munich in 1880, he was of the same generation as Picasso and Braque, whom he knew; he had sketched alongside Matisse and befriended Robert Delaunay and Kandinsky. Hofmann became one of the twentieth century's most influential art teachers, leading celebrated art schools in New York; Berkeley, California; and Provincetown, Massachusetts. He especially influenced the pioneers of Abstract Expressionism.

Hofmann produced his most important works in the 1950s, when he was in his seventies. *Twilight*, a masterly painting, brings together the stylistic impulses he had acquired from European modernism with his own contribution to the American avant-garde. Intense, exuberant color — the primaries blue, yellow, and red and the complementary green — reflects the legacy of Fauve colorists such as Matisse and Delaunay. The careful surface structure, made up of rhythmically arranged, interlocking rectangles of paint, is a compositional method that originated with Cézanne and the Cubists. Hofmann's legacy to younger American artists (who for two decades had been inspired by his example) is found in the paint that fills the entire surface in an energetic application that takes full advantage of accident and coincidence. Note the muddy passage at center left that resulted from painting layers of red and green on top of one another, which proved to be a pivotal area in the picture, and the complete absence of recognizable subject matter. Hofmann was greatly admired for his

touch. In *Twilight* he applied paint with both brush and palette knife, and he scraped, blended, and layered pigment to produce a vigorously textured surface. His joyful sense of execution belies the slightly melancholy suggestion of the title, which may simply indicate that the painting was inspired by the changes of color and light at dusk.

Oil on plywood
121.9 x 91.4 cm (48 x 36 in.)
Gift in name of Lois Ann Foster 1973.171

Franz Kline
1910–1962
Probst I, 1960

Probst I was painted in 1960, the year Kline was awarded a prize at the Venice Biennale and ten years after he abandoned figuration for his signature gestural style. Kline's artistic training had been conventional: he had studied at Girard College in Philadelphia, at Boston University, and then at Heatherly's Art School in London. However, the excitement surrounding the "action painting" of such artists as Pollock and especially his close friend Willem de Kooning in the late 1940s and early 1950s influenced Kline's interest in abstract painting, and his larger-than-life black-and-white canvases are now considered major monuments of Abstract Expressionism.

Unlike the restless lyricism of Pollock or the density and ambiguity of de Kooning's canvases from the fifties, Kline's paintings are composed of clear open shapes. His works are dramatic, confident, and forceful. His massive black strokes — often applied with a six-inch house painter's brush — are sometimes associated with Asian calligraphy, a connection Kline denied, stating: "The Oriental idea of space is an infinite space; it is not painted space, and [mine] is. . . . Calligraphy is writing, and I'm not writing. . . . I paint the white as well as the black, and the white is just as important."

Kline's pictures are muscular, strong, and above all exultant; they attempt to capture, in an abstract language, the dynamism of contemporary life. His shapes are architectural, evoking buildings, bridges, or, in the words of his friend Elaine de Kooning, "the old-fashioned engines that used to roar through the town where he was born." The titles of many of Kline's paintings allude to his upbringing in the Pennsylvania coal country; others

reflect his surroundings in Greenwich Village. *Probst I* refers to Jack (Yoachim) Probst, an artist friend from the Village. The painting is both monumental and subtle, gaining luminosity from the delicate passages of yellow and pale salmon and depth from an undergirding of rich dark brown behind the slashing black strokes.

Oil on canvas
272.4 x 202.6 cm (107 ¼ x 79 ¾ in.)
Gift of Susan Morse Hilles 1973.636

Suggestions for Further Reading

General

Craven, Wayne. *American Art: History and Culture*. Boston: McGraw-Hill, 1994.

Hughes, Robert. *American Visions: The Epic History of Art in America*. New York: Alfred A. Knopf, 1997.

Museum of Fine Arts, Boston. *American Paintings in the Museum of Fine Arts, Boston*. 2 vols. Boston: Museum of Fine Arts, 1969.

————. *M. and M. Karolik Collection of American Paintings, 1815 to 1865*. Cambridge, Mass.: Published for the Museum of Fine Arts by Harvard University Press, 1949.

Novak, Barbara. *American Painting of the Nineteenth Century: Realism, Idealism, and the American Experience*. New York: Praeger, 1969.

Pohl, Frances K. *Framing America: A Social History of American Art*. New York: Thames and Hudson, 2002.

Taylor, Joshua C. *The Fine Arts in America*. Chicago: University of Chicago Press, 1979.

Troyen, Carol, et al. *American Paintings in the Museum of Fine Arts, Boston: An Illustrated Summary Catalogue*. Boston: Museum of Fine Arts, 1997.

Portraiture in the Colonial Era

Craven, Wayne. *Colonial American Portraiture*. Cambridge, England: Cambridge University Press, 1986.

Fairbanks, Jonathan L., and Robert F. Trent. *New England Begins: The Seventeenth Century*. Exh. cat. Boston: Museum of Fine Arts, 1982.

Miles, Ellen G., ed. *The Portrait in Eighteenth-Century America*. Newark: University of Delaware Press, 1993.

Portraiture and the American Revolution

Miller, Lillian B., ed. *The Peale Family: Creation of a Legacy, 1770–1870*. Exh. cat. New York: Abbeville Press in association with the Trust for Museum Exhibitions and the National Portrait Gallery, Smithsonian Institution, 1996.

Rebora, Carrie, et al. *John Singleton Copley in America*. Exh. cat. New York: Metropolitan Museum of Art, 1995.

Saunders, Richard H., and Ellen G. Miles. *American Colonial Portraits, 1700–1776*. Exh. cat. Washington, D.C.: Smithsonian Institution Press, 1987.

History Painting

Gerdts, William H., and Mark Thistlethwaite. *Grand Illusions: History Painting in America*. Exh. cat. Fort Worth, Tex.: Amon Carter Museum, 1988.

Wilmerding, John. *American Marine Painting*. New York: H. N. Abrams, 1987.

Portraiture before the Civil War

Cooper, Wendy A. *Classical Taste in America, 1800–1840*. Exh. cat. Baltimore: Baltimore Museum of Art, 1993.

Frank, Robin Jaffee. *Love and Loss: American Portrait and Mourning Miniatures*. Exh. cat. New Haven: Yale University Art Gallery, 2000.

Quick, Michael. *American Portraiture in the Grand Manner, 1720–1920*. Exh. cat. Los Angeles: Los Angeles County Museum of Art, 1981.

Landscape Painting

Miller, Angela L. *The Empire of the Eye: Landscape Representation and American Cultural Politics, 1825–1875*. Ithaca and London: Cornell University Press, 1993.

Novak, Barbara. *Nature and Culture: American Landscape and Painting, 1825–1875*. New York: Oxford University Press, 1980; revised 1995.

Wilmerding, John, et al. *American Light: The Luminist Movement, 1850–1875*. Exh. cat. Washington, D.C.: National Gallery of Art, 1980.

Wilton, Andrew, and Tim Barringer. *American Sublime: Landscape Painting in the United States, 1820–1880*. Exh. cat. London: Tate Publishing, 2002.

Folk Painting

Lipman, Jean, and Thomas Armstrong, eds. *American Folk Painters of Three Centuries*. Exh. cat. New York: Hudson Hills Press in association with the Whitney Museum of American Art, 1980.

Rumford, Beatrix T., and Carolyn J. Weekley. *Treasures of American Folk Art from the Abby Aldrich Rockefeller Folk Art Center*. Exh. cat. Boston: Little, Brown in association with the Colonial Williamsburg Foundation, 1989.

Vlach, John Michael. *Plain Painters: Making Sense of American Folk Art*. Washington, D.C.: Smithsonian Institution Press, 1988.

Ward, Gerald W. R., et al. *American Folk: Folk Art from the Collection of the Museum of Fine Arts, Boston*. Exh. cat. Boston: Museum of Fine Arts, 2001.

Genre Painting

Burns, Sarah. *Pastoral Inventions: Rural Life in Nineteenth-Century American Art and Culture*. Philadelphia: Temple University Press, 1989.

Hills, Patricia. *The Painters' America: Rural and Urban Life, 1810–1910*. Exh. cat. New York: Praeger in association with the Whitney Museum of American Art, 1974.

Johns, Elizabeth. *American Genre Painting: The Politics of Everyday Life*. New Haven: Yale University Press, 1991.

Nineteenth-Century Still-Life Painting

Bolger, Doreen, Marc Simpson, and John Wilmerding, eds. *William M. Harnett*. Exh. cat. Fort Worth, Tex.: Amon Carter Museum and H. N. Abrams, 1992.

Gerdts, William H. *Painters of the Humble Truth: Masterpieces of American Still Life, 1801–1939*. Exh. cat. Columbia: University of Missouri Press, 1981.

Wilmerding, John. *Important Information Inside: The Art of John F. Peto and the Idea of Still-Life Painting in Nineteenth-Century America*. Exh. cat. Washington, D.C.: National Gallery of Art, 1983.

Painting after the Civil War

Burke, Doreen Bolger, et al. *In Pursuit of Beauty: Americans and the Aesthetic Movement*. Exh. cat. New York: Metropolitan Museum of Art and Rizzoli, 1986.

Burns, Sarah. *Inventing the Modern Artist: Art and Culture in Gilded Age America*. New Haven: Yale University Press, 1996.

Weinberg, H. Barbara. *The Lure of Paris: Nineteenth-Century American Painters and Their French Teachers*. New York: Abbeville Press, 1991.

American Impressionism

Gerdts, William H. *American Impressionism*. New York: Abbeville Press, 1984.

Hiesinger, Ulrich W. *Impressionism in America: The Ten American Painters*. Munich: Prestel-Verlag, 1991.

Weinberg, H. Barbara, et al. *American Impressionism and Realism: The Painting of Modern Life, 1885–1915*. Exh. cat. New York: Metropolitan Museum of Art, 1994.

The Boston School

Fairbrother, Trevor J. *The Bostonians: Painters of an Elegant Age, 1870–1930*. Exh. cat. Boston: Museum of Fine Arts, 1986.

Hirshler, Erica E. *A Studio of Her Own: Women Artists in Boston, 1870–1940*. Exh. cat. Boston: MFA Publications, 2001.

Early-Twentieth-Century Realism

Henri, Robert. *The Art Spirit*. Philadelphia: Lippincott, 1923. Reprint, New York: Harper and Row, 1984.

Milroy, Elizabeth. *Painters of a New Century: The Eight and American Art*. Exh. cat. Milwaukee: Milwaukee Art Museum, 1991.

Zurier, Rebecca, et al. *Metropolitan Lives: The Ashcan Artists and Their New York*. Exh. cat. Washington, D.C.: National Museum of American Art in association with W. W. Norton, New York, 1995.

Modernism

Corn, Wanda M. *The Great American Thing: Modern Art and National Identity, 1915–1935*. Berkeley: University of California Press, 1999.

Greenough, Sarah, ed. *Modern Art and America: Alfred Stieglitz and His New York Galleries*. Exh. cat. Washington, D.C.: National Gallery of Art, 2000.

Stebbins, Theodore E., Jr., and Carol Troyen. *The Lane Collection: Twentieth-Century Paintings in the American Tradition*. Exh. cat. Boston: Museum of Fine Arts, 1983.

Lane, John R., and Susan C. Larsen, eds. *Abstract Painting and Sculpture in America, 1927–1944*. Exh. cat. Pittsburgh: Museum of Art, Carnegie Institute, in association with H. N. Abrams, New York, 1983.

Sandler, Irving. *The Triumph of American Painting*. New York: Praeger, 1970.

The American Scene

Baigell, Matthew. *American Scene: American Painting of the 1930s*. New York: Praeger, 1974.

Brown, Milton W. *American Painting from the Armory Show to the Depression*. Princeton, N.J.: Princeton University Press, 1970.

Heller, Nancy, and Julia Williams. *The Regionalists*. New York: Watson-Guptill Publications, 1976.

Patton, Sharon F. *African-American Art*. Oxford and New York: Oxford University Press, 1998.

Abstraction until 1960

Haskell, Barbara. *The American Century: Art and Culture, 1900–1950*. Exh. cat. New York: Whitney Museum of American Art in association with W. W. Norton, 1999.

Figure Illustrations

All works are from the
Museum of Fine Arts, Boston

1. John Singleton Copley
1738–1815
Galatea, about 1754
Oil on canvas
94 x 132.7 cm (37 x 52 ¼ in.)
Picture Fund 12.45

2. Winslow Homer
1836–1910
Boys in a Pasture, 1874
Oil on canvas
40.3 x 58.1 cm (15⅞ x 22⅞ in.)
The Hayden Collection. Charles
Henry Hayden Fund 53.2552

3. Mary Cassatt
1844–1926
The Tea, about 1880
Oil on canvas
64.8 x 92.1 cm (25½ x 36¼ in.)
M. Theresa B. Hopkins Fund 42.178

4. Steve Wheeler
1912–1992
Man Menacing Woman, about 1943
Oil on canvas
76.2 x 63.5 cm (30 x 25 in.)
Sophie M. Friedman Fund 2002.127

5. Unidentified artist (Freake-Gibbs
painter)
Active late 17th century
Robert Gibbs at 4 ½ Years, 1670
Oil on canvas
101.9 x 83.8 cm (40⅛ x 33 in.)
M. and M. Karolik Fund 69.1227

6. Robert Feke
About 1707–about 1751
Self-Portrait, about 1741–45
Oil on canvas mounted on aluminum
75.6 x 65.7 cm (29¾ x 25⅞ in.)
M. and M. Karolik Fund 1970.499

7. John Singleton Copley
1738–1815
Rebecca Boylston, 1767
Oil on canvas
128 x 102.2 cm (50⅜ x 40 ¼ in.)
Bequest of Barbara Boylston Bean
1976.667

8. John Singleton Copley
1738–1815
Paul Revere, 1768
Oil on canvas
89.2 x 72.4 cm (35 ⅛ x 28 ½ in.)
Gift of Joseph W. Revere, William B.
Revere and Edward H. R. Revere
30.781

9. Nicolas Poussin
French (working in Rome), 1594–1665
Discovery of Achilles on Skyros,
about 1650
Oil on canvas
97.5 x 131.1 cm (38 ⅜ x 51 ⅝ in.)
Juliana Cheney Edwards Collection
46.463

10. Gilbert Stuart
1755–1828
Washington at Dorchester Heights,
1806
Oil on panel
275 x 180.3 cm (108 ¼ x 71 in.)
Deposited by the City of Boston 30.76a

11. Gilbert Stuart
1755–1828
*Anna Powell Mason (Mrs. Patrick
Grant)*, about 1807
Oil on panel
83.5 x 67.6 cm (32 ⅞ x 26 ⅝ in.)
Lucy Dalbiac Luard Fund and Seth K.
Sweetser Fund 1978.183

12. Chester Harding
1792–1866
*Mrs. Abbott Lawrence (Katherine
Bigelow)*, about 1855
Oil on canvas
69.5 x 56.8 cm (27⅜ x 22⅜ in.)
Gift of the Misses Aimée and
Rosamond Lamb 61.240

13. Thomas Cole
Born England, 1801–1848
*View of the Round-Top in the Catskill
Mountains*, 1827
Oil on panel
47.3 x 64.5 cm (18⅝ x 25⅜ in.)
Gift of Martha C. Karolik for the M. and
M. Karolik Collection of American
Paintings, 1815–1865 47.1200

14. Frederic Edwin Church
1826–1900
Cayambe, 1858
Oil on canvas
30.5 x 45.7 cm (12 x 18 in.)
Gift of Martha C. Karolik for the M. and
M. Karolik Collection of American
Paintings, 1815–1965 47.1237

15. Erastus Salisbury Field
1805–1900
Joseph Moore and His Family,
about 1839
Oil on canvas
209.2 x 237.2 cm (82⅜ x 93⅜ in.)
Gift of Maxim Karolik for the M. and M.
Karolik Collection of American Paint-
ings, 1815–1865 58.25

16. Winthrop Chandler
1747–1790
Battle of Bunker Hill, about 1776–77
Oil on panel
88.6 x 136.2 cm (34⅞ x 53⅝ in.)
Gift of Mr. and Mrs. Gardner
Richardson 1982.281

17. Jesse D. Bunting
Active 1840–1870
*View of Darby, Pennsylvania, After the
Burning of Lord's Mill*, about 1862–67
Oil on canvas
106.7 x 130.2 cm (42 x 51¼ in.)
Gift of Maxim Karolik for the M. and M.
Karolik Collection of American Paint-
ings, 1815–1865 62.264

18. James Goodwyn Clonney
Born England, 1812–1867
In the Woodshed, 1838
Oil on canvas
43.2 x 35.3 cm (17 x 13⅞ in.)
Gift of Martha C. Karolik for the M. and
M. Karolik Collection of American
Paintings, 1815–1865 47.1193

19. John George Brown
Born England, 1831–1913
Tuckered Out — The Shoeshine Boy,
about 1888
Oil on canvas
61.6 x 41 cm (24¼ x 16⅛ in.)
Bequest of Maxim Karolik 64.467

20. Severin Roesen
Born Germany, 1815/16–1872 or after
Still Life — Flowers in a Basket, 1850s
Oil on canvas
76.2 x 102.2 cm (30 x 40¼ in.)
M. and M. Karolik Fund 69.1228

21. Worthington Whittredge
1820–1910
Apples, 1867
Oil on canvas
38.7 x 30.8 cm (15¼ x 12⅛ in.)
Bequest of Martha C. Karolik for the M.
and M. Karolik Collection of American
Paintings, 1815–1865 48.490

22. Winslow Homer
1836–1910
*Art Students and Copyists in the
Louvre Gallery, Paris*, 1868
Wood engraving
23.2 x 34.9 cm (9⅛ x 13¾ in.)
Gift of W. G. Russell Allen 38.830

23. Museum of Fine Arts, Boston,
Copley Square, about 1895
Photograph
Archives of the Museum of Fine Arts,
Boston

24. Claude Monet
French, 1840–1926
*Camille Monet and a Child in the
Artist's Garden in Argenteuil*, 1875
Oil on canvas
55.3 x 64.7 cm (21¾ x 25½ in.)
Anonymous Gift in memory of Mr. and
Mrs. Edwin S. Webster 1976.833

25. Edmund Charles Tarbell
1862–1938
Mother and Child in a Boat, 1892
Oil on canvas
76.5 x 88.9 cm (30⅛ x 35 in.)
Bequest of David P. Kimball in memory
of his wife, Clara Bertram Kimball
23.532

26. William McGregor Paxton
1869–1941
The New Necklace, 1910
Oil on canvas
91.8 x 73 cm (36⅛ x 28¾ in.)
Zoë Oliver Sherman Collection 22.644

27. Joseph Rodefer DeCamp
1858–1923
The Guitar Player, 1908
Oil on canvas
126.4 x 114.9 cm (49¾ x 45¼ in.)
The Hayden Collection. Charles
Henry Hayden Fund 08.204

28. Robert Earle Henri
1865–1929
Sidewalk Café, about 1899
Oil on canvas
81.6 x 65.7 cm (32⅛ x 25⅞ in.)
Emily L. Ainsley Fund 59.657

29. William James Glackens
1870–1938
Flying Kites, Montmartre, 1906
Oil on canvas
60.3 x 81.3 cm (23¾ x 32 in.)
The Hayden Collection. Charles Henry
Hayden Fund 38.7

30. Ernest Lawson
1873–1939
New York Street Scene, before 1910
Oil on canvas
81.6 x 61 cm (32⅛ x 24 in.)
The Hayden Collection. Charles Henry
Hayden Fund 1972.919

31. Alfred Stieglitz
1864–1946
Songs of the Sky in Five Pictures (No. 2),
1923
Photograph, gelatin silver print
9.2 x 11.7 cm (3 ⅝ x 4 ⅝ in.)
Gift of Alfred Stieglitz 24.1733.2

32. Arthur Garfield Dove
1880–1946
Clouds, 1927
Oil and sandpaper on sheet metal
38.1 x 50.8 cm (15 x 20 in.)
Gift of the William H. Lane Foundation
1990.401

33. Georgia O'Keeffe
1887–1986
Deer's Skull with Pedernal, 1936
Oil on canvas
91.4 x 76.5 cm (36 x 30 ⅛ in.)
Gift of the William H. Lane Foundation
1990.432

34. Ben Shahn
Born Lithuania, 1898–1969
Girl Skipping Rope, 1943
Tempera on board
40.3 x 60.7 cm (15 ⅞ x 23 ⅞ in.)
Gift of the Stephen and Sybil Stone
Foundation 1971.702

35. Edward Hopper
1882–1967
Room in Brooklyn, 1932
Oil on canvas
74 x 86.4 cm (29 ⅛ x 34 in.)
The Hayden Collection. Charles Henry
Hayden Fund 35.66

36. Jackson Pollock
1912–1956
Number 10, 1949
Oil, enamel, and aluminum paint on
canvas mounted on panel
46.1 x 272.4 cm (18 ⅛ x 107 ¼ in.)
Tompkins Collection and Sophie M.
Friedman Fund 1971.638

37. Adolph Gottlieb
1903–1974
Alkahest of Paracelsus, 1945
Oil and egg tempera on canvas
152.4 x 111.8 cm (60 x 44 in.)
Tompkins Collection 1973.599

Index

*Page numbers in italics indicate
illustrations.*

Credits